SCHOFIELD INTERNATIONAL IMPRESSIONIST

September 18, 2014–January 25, 2015

Woodmere Art Museum

TELLING THE STORY OF PHILADELPHIA'S ART AND ARTISTS

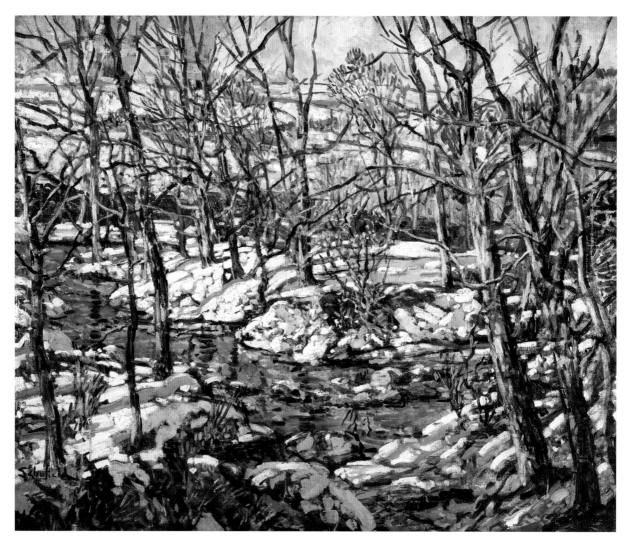

Mid-Winter, Pennsylvania, c. 1940, by Walter Elmer Schofield (Private Collection)

For their generous support of the catalogue and exhibition, Woodmere extends thanks and appreciation to the William Penn Foundation; Dr. Dorothy J. del Bueno; Margaret E. Phillips; Jim Alterman; Stratton Management Company; Lucille and Walter Rubin, whose gift is made in memory of Mrs. Enid Schofield; Joyce and Bob Byers; Harriet and Larry Weiss; and Carol and Louis Della Penna.

CONTENTS

FOREWORD

Early in his career, Walter Elmer Schofield (American, 1866–1944) was identified as a leader among the artists who came to be known as the Pennsylvania Impressionists. He was also a central figure in the broader phenomenon of American Impressionism. However, we have chosen to call our exhibition *Schofield: International Impressionist* because both terms, with "Pennsylvania" and "American" as qualifiers to "Impressionism," seemed inadequate when applied to Schofield. Many of the paintings in our exhibition were made en plein air, in Schofield's studio in Philadelphia, or elsewhere in Pennsylvania. But roughly twice as many were made in other places, conveying the artist's sensitivity to the character of the specific sites he visited in New England, California, Arizona, the United Kingdom, the Netherlands, and France. Schofield made friends easily, and the relationships that fueled his creativity and intellect were as encompassing as his travels. With the word "international" in our title, we call attention to the broad, trans-American and transatlantic nature of Schofield's career.

Upon assuming the directorship of Woodmere four years ago, I was thrilled to find five magnificent paintings by Schofield in the Museum's collection. Three of them—*March Snow* (1906; ill. p. 49), *Hill Country* (c. 1913; ill. p. 58), and *Morning Tide—Coast of Cornwall* (c. 1920; ill. p. 70)—are large, significant works that we show frequently and lend regularly; the artist himself selected them in his lifetime to represent him in many prestigious exhibitions. I was interested to learn the circumstances through which these paintings came to Woodmere, and the history that linked the artist to our Museum.

Through our research related to this exhibition we learned that, by the 1920s, Chestnut Hill had become Schofield's home in the United States. Although he also lived with his wife and children in Cornwall, United Kingdom, his marriage had become strained. His brother Albert's impressive family abode at 408 West Moreland Avenue was where the artist stayed in the fall and winter of most years, and served as his home base whether he was painting on the Wissahickon or participating in exhibitions across the country.

Edith Emerson, Woodmere's director and curator from the early 1940s through 1978, also lived nearby. As Schofield's close friend, she worked in collaboration with the artist's family—especially his niece, Sarah Phillips—to organize the memorial exhibition at Woodmere that took place a year after the artist's death. As far as can be surmised from Woodmere's archives, *Memorial Exhibition of Oil Paintings by W. Elmer Schofield N.A.*, of 1945, may be considered this museum's first "special exhibition." The art collection of Charles Knox Smith, Woodmere's founder, was taken down from the curved walls of the grand rotunda and its balcony, now the Catherine M. Kuch Gallery and Dorothy J. del Bueno Balcony Gallery, respectively. In its place were hung thirty-five carefully selected works by Schofield. We are delighted that many of these paintings are making a repeat appearance in the present exhibition.

Out of the close relationship between Emerson, Phillips, and the artist's two sons, Sydney and Seymour Schofield, it was decided that Woodmere would be chosen to preserve the artist's legacy through stewardship of the selected paintings.

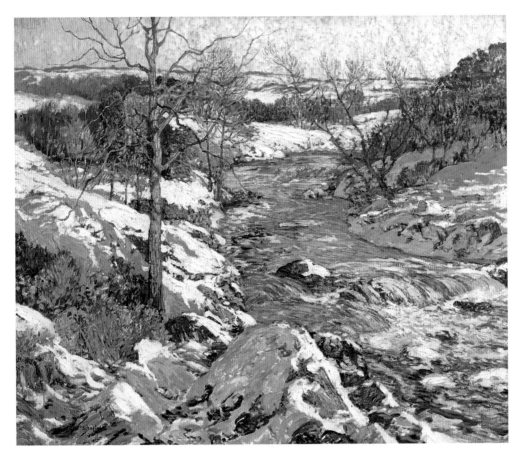

The Rapids in Winter, c. 1919, by Walter Elmer Schofield (Collection Jim's of Lambertville) Photograph courtesy of Jim's of Lambertville

We have been gratified to do so for the past seventy years and are honored to again work with the Phillips family on *International Impressionist*. We are especially grateful to Margaret E. "Peg" Phillips, Sarah's daughter, who has provided generous financial support for the exhibition. Peg has worked throughout her life as a dedicated teacher, and she shared with us her many years of thinking about the significance of her great-uncle's paintings, helping us share his accomplishments for the interest and enjoyment of today's audiences.

Peg's godson, the artist's great-grandson, James D. W. Church, is equally dedicated to Schofield's legacy, and has been a font of expertise without which the exhibition would have been impossible. We thank you, James, for your contributions to this catalogue, for your work on all aspects of the exhibition, and for becoming an honorary member of Woodmere's staff, as well as a friend. If the "Conversation about the Artist" that appears in these pages is a contribution to scholarship, it is because we have been able to place your specific knowledge about Schofield's work in a

dynamic exchange of ideas with leading scholars and curators. We thank Therese Dolan, Thomas Folk, Kathleen A. Foster, Valerie Livingston, and Brian Peterson for participating in this discussion. I would like to express special appreciation to Valerie, who has dedicated her professional career to the study of Schofield and has been generous with information and supportive of this project from the beginning. It was a thrill for Rachel McCay, Woodmere's newly appointed assistant curator, and for me to share ideas about Schofield that emerged in the evolution of the exhibition with such an illustrious group of individuals.

We must also extend thanks and appreciation to the many others who contributed generously to the realization of this exhibition, particularly Dr. Dorothy J. del Bueno. Early on, Dorothy stepped forward and volunteered to be an intern on the exhibition. In that capacity, she researched paintings, assembled a history of the scholarship on the artist, initiated the chronology that appears in these pages, and traveled with me to visit collections that include important works by Schofield. As if that weren't enough, she made an early and critical gift of financial support, which allowed us to move forward with requests to borrow paintings that would be coming from far and wide. When paintings travel, the expenses are great. Dorothy's support allowed us to think big and to organize this exhibition without limiting the scope of our ideas because of the expense associated with the transportation of art.

Lucille and Walter Rubin have been generous to Woodmere and to this exhibition specifically, and lent many beautiful paintings from their collection. Their friendship with Schofield's daughter-in-law Mrs. Enid Schofield served as another link to the life of the artist. We are honored that Joyce and Bob Byers and Carol and Louis Della Penna likewise stepped forward as both lenders and supporters of the exhibition. Jim Alterman, who pointed me in the direction of several key paintings in private collections, is another lender and supporter. The proprietor of Jim's of Lambertville, he possesses a gift that every art professional needs: a great eye. Many paintings by Schofield and other artists have been plucked from obscurity and brought back to a condition of splendor due to Jim's efforts, restoring a sense of value to works that were once highly esteemed but had fallen out of fashion. Museums are in the business of stewarding precious assets, and Woodmere is also grateful to the Stratton Management Company, investment advisors, for recognizing the value of this exhibition and being our generous partner.

Harriet and Larry Weiss have continuously supported our efforts at Woodmere. Their gift to this exhibition comes in addition to their contribution in support of the catalogue, which, like all our catalogues, was printed by their company, CRW Graphics. The high quality of the illustrations in this book is due to the finesse of their color separation processes, and the expertise and collaborative spirit of their excellent staff.

Woodmere is also profoundly grateful to the William Penn Foundation. Philadelphia's cultural institutions are fortunate to enjoy the partnership and support of a leading foundation that is dedicated to sustaining and advancing creativity in civic life. Thank you, William Penn Foundation, for understanding that *Schofield: International Impressionist* is an exhibition that propels Woodmere forward and makes us stronger in long-lasting ways.

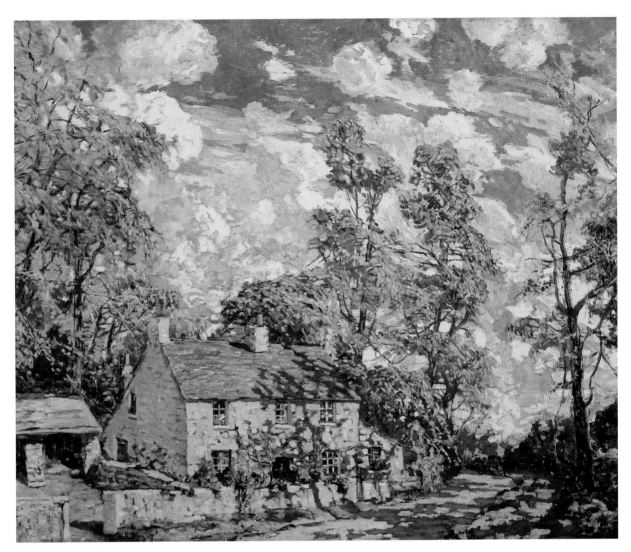

June Morning, c. 1923, by Walter Elmer Schofield (Collection of Karen and Thomas Buckley)

Requests for loans were met with enthusiasm for the timeliness of our exploration of Schofield's place in the evolution of twentieth-century art. It has been wonderful to experience the interest of colleagues across the museum field as well as private collectors who are lending their treasures. I must thank Elizabeth Broun at the Smithsonian American Art Museum for her extra effort, which made possible the loan of *The Rapids* (c. 1914; ill. p. 5), an important work by Schofield that has not been seen in public for several decades.

International Impressionist is the most ambitious endeavor that Woodmere has undertaken to date, and every member of our staff rose to the challenge. Assistant Curator Rachel McCay served as the point person for the exhibition, coordinating

the extensive research and writing that went into the exhibition and its catalogue. The catalogue itself was more than a year in the making, during which Rachel worked with our A-list team of free-lance partners, editor Gretchen Dykstra and her assistant Lucy Medrich, and graphic designer Barb Barnett. Sally Larson, Deputy Director for Collections and Registrar, who along with other contributions to the project masterfully handled the logistics of securing loans from across the country, oversaw the conservation of Woodmere's paintings by our great friend Steven B. Erisoty. Hildy Tow, The Robert L. McNeil Jr., Curator of Education; Sarah Mitchell, Associate Curator of Education; Noel Hanley, Classical Music Coordinator; Bonnie Brown, Volunteer Coordinator; and Charlie Head, Jr., president of our docent council, worked together to mine the exhibition and create a rich season of related lectures and programs. We thank our docents and volunteers, and kiss the ground they walk on, because without them, we could do nothing. Rick Ortwein, Deputy Director for Exhibitions, brought his great flair for design to our installation, implementing the physical realization of the exhibition together with Thomas Durnell, Building and Grounds Superintendent, and Dave Gramm, Building and Grounds Assistant. Woodmere's development office, led by Carol von Stade, Director of Development, with Pamela Loos, Director of Foundation and Government Relations, and Natalie Greene, Director of Member Relations, ensured that we had the funds to do the project right. Emma E. Hitchcock, Woodmere's Collections Manager and Director of Communications, has gotten the word out about the exhibition in partnership with Megan Wendell and her team at Canary Promotion, our PR consultants. Emma also manages the exhibition's presence on our website, which, increasingly, is the "front door" to everything we do. I must thank my Executive Assistant, Diane Pastella, for keeping me sane and on schedule, as well as Nick Yzzi, Director of Finance, and Anne Wood, Bookkeeper, for managing the flow of money that made the exhibition and all else possible. Woodmere's frontline efforts are managed by Renee Giannobile, Director of the Museum Store and Visitor Services. Those who work in our Museum Store and visitor services, Vivian Culler, Stephen Kerzner, Joseph Pompilii, Ryan Spalding, and Bernadine Young, will be extra busy through the run of this exhibition, as will our unflappable security staff, Michael DeGennaro, Brian Chepulis, and Sierre McClain.

My main job as director of Woodmere is to create an environment in which we can undertake our mission—telling the stories of Philadelphia's art and artists—with the kind of intelligence and creativity that leads to an enriching visitor experience. This happens at Woodmere because the exemplary team of individuals named above is motivated by a passion for art and an understanding of the value of each person's specific contribution to the larger, collective effort. Thank you all.

WILLIAM R. VALERIO, PHD
The Patricia Van Burgh Allison Director and CEO

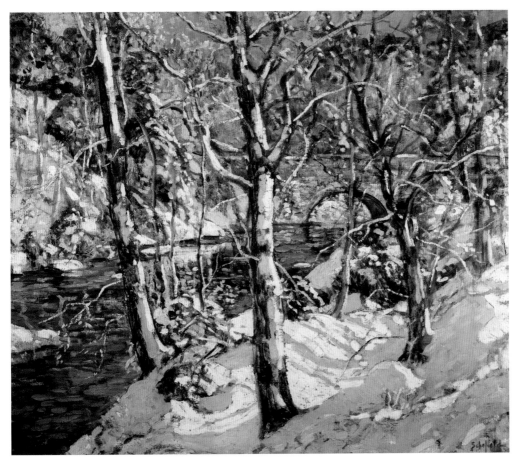

Winter in the Park,
c. 1922, by Walter
Elmer Schofield
(Collection of Lucille
and Walter Rubin)

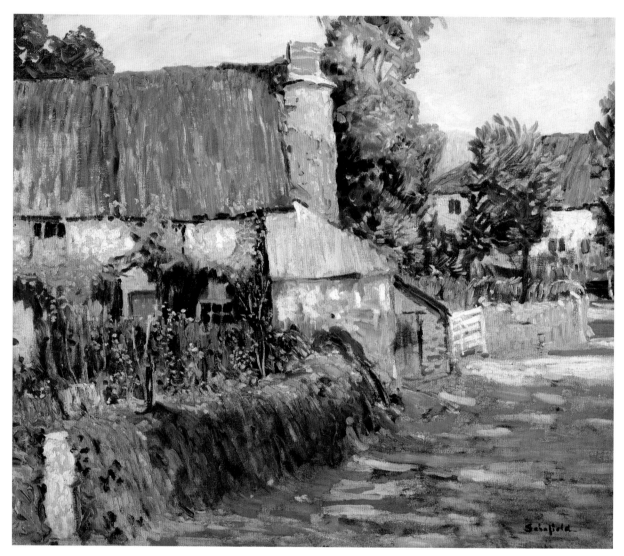

On the Road to Perranporth, 1914, by Walter Elmer Schofield (Private Collection)

A GREAT-GRANDSON'S ACKNOWLEDGMENTS

On behalf of the extended Schofield family, I am pleased to express my gratitude to the many individuals who, for the love of art and of my great-grandfather Elmer's paintings, welcomed my explorations into his professional achievements. Thank you for giving generously of your time, answering questions, sending me newspaper clippings, and sharing relevant stories. Elmer was gregarious, and these many layers of information—some documentary, some anecdotal—have led me to an understanding of his life.

Many individual collectors and staff members of museums answered innumerable questions, created new photography, and investigated stickers and mysterious scrawls on the backs of frames and canvases. Many of the discoveries recorded in these pages would not otherwise have been possible.

Additional thanks must be made to family friend and Schofield enthusiast Chip Goehring, who drove me across a substantial portion of the United States in search of Elmer's paintings. Valerie Livingston was a mentor to me, and selflessly shared her research and ideas.

I must also thank my friend Raymond Smith, bookseller and photographer, for providing me with rare books and contemporary articles pertaining to Elmer, and for putting me in contact with Bill Valerio at Woodmere. My involvement in this project began because of a chance phone conversation between Ray and Dr. Dorothy J. del Bueno, a member of Woodmere's "family" who had called to inquire about the purchase of a book. As a result of that phone conversation, I met Bill.

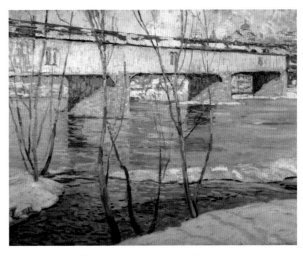

The Old Covered Bridge, 1910, by Walter Elmer Schofield (Collection of Rockford Art Museum, IL) Photograph courtesy of Rockford Art Museum, IL

A special tribute must be made to my godmother and cousin, Margaret E. Phillips, and my grandmother, the late Mrs. Mary Schofield. They kept the flame alive, and it is to them that I owe my appreciation of Elmer's work and character. I must also thank my uncle John Schofield, who clambered around Godolphin with me, tracking down the viewpoints of a number of Elmer's paintings.

Finally, without the curiosity and patience of Woodmere's impressive staff this exhibition would not be taking place. Looking to the future, I am equally glad to have become acquainted with the terrific group of curators and scholars—Tom Folk, Kathy Foster, Therese Dolan, and Brian Peterson—who care so much about Schofield's paintings and participated in the great exchange of ideas that appears in this catalogue.

JAMES D. W. CHURCH

On Wednesday, October 16, 2013, Margaret E. Phillips, great-niece of artist Walter Elmer Schofield, and James D. W. Church, the artist's great-grandson, spoke about Schofield's career with William R. Valerio, Woodmere's Patricia Van Burgh Allison Director and CEO, and Rachel McCay, Assistant Curator. The conversation has been edited, with clarifications added by Ms. Phillips.

WILLIAM R. VALERIO: Peg, it's wonderful to be with you in your home, together with your godson, James, on Skype, to talk about your Uncle Elmer, the artist we know as Walter Elmer Schofield. The last time I was here you shared many interesting stories, and I thought it would be terrific if we could record them. Could you start by telling us who his friends were and what his personality was like? Was he an extrovert or an introvert?

MARGARET E. PHILLIPS: He was a complete extrovert: wonderful, a lot of fun, and always game for anything. From the 1920s onward he stayed

Portrait of Walter Elmer Schofield, 1931. Photograph courtesy of Margaret E. Phillips. Photograph by Bates, Philadelphia

with us when he was in the US in the fall and winter, using our house as a sort of home base. His ship would sail into New York, and he would come down to Philadelphia by train. We would meet him and say, "We're going to the movies today," and he would respond—with luggage in hand—"Oh, fine!" And off we'd go. I'm sure he could have murdered us cheerfully, but he never refused to do anything. He was, of course, the youngest in his family. And his brother, Albert, who was my grandfather, was his closest sibling in terms of age. They were the two youngest in the family, and they had a slew of sisters.

VALERIO: I think of your family as being genteel, cultivated, and sophisticated. And there was a family business, the Delph Spinning Company, which made yarn and thread. Your great-uncle's father, Benjamin, ran the company, and Albert ran it after him, correct?

PHILLIPS: Yes, Benjamin was a man of business. He was strict, and he did not play around. He believed that women should not date, or meet men, or go out, or do anything with them, really. My grandfather Albert was like Benjamin in his dedication to business, but he was more a person of the modern age.

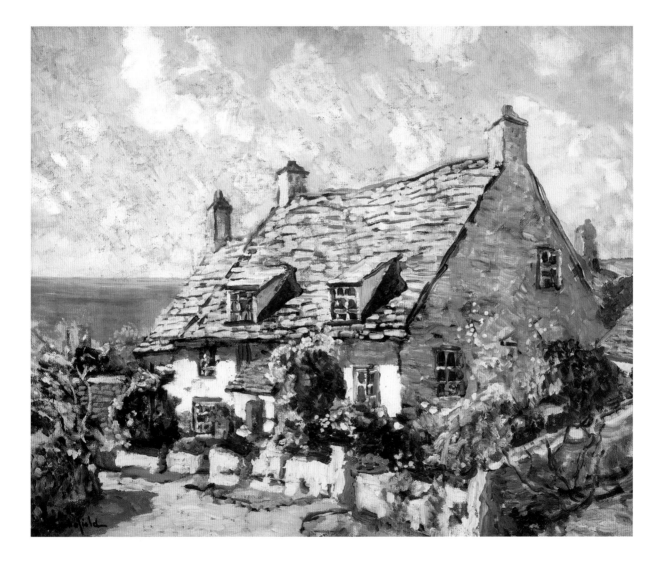

Cottage in Cornwall, c. 1930, by Walter Elmer Schofield
(Collection of Margaret E. Phillips)

VALERIO: Now I have to ask a question. You mentioned that your great-uncle was always up for going to the movies. I think something that's often forgotten when we talk about artists is that they're people, like the rest of us, who enjoy life's diversions. What kinds of movies did he like?

PHILLIPS: It was the early Hollywood movies in those days, the late 1920s and '30s. He and my father used to go to town—my father had a special tie he wore on those days. They'd eat someplace peculiar, and then they'd go to the movies, just to have a day off for themselves.

VALERIO: Did he ever go to museums in Philadelphia?

PHILLIPS: Not with my father. Uncle Elmer was a diabetic and didn't always take good care of himself. My mother—his niece Sarah—was glad that her husband would often go with Uncle Elmer, because if anything happened and he collapsed on the side of the road, my father would presumably be able to get him home.

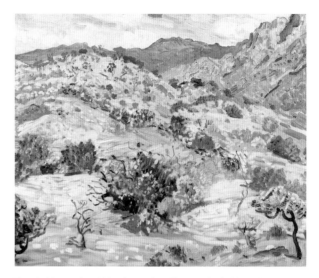

Purple Mountains, 1934, by Walter Elmer Schofield (Collection Brandywine River Museum of Art. Gift of Margaret E. Phillips, 2003) Photograph courtesy of Brandywine River Museum of Art

VALERIO: What kinds of books did he read?

PHILLIPS: I was young, but to be honest, I never saw him read, not a newspaper or a book. If he had time in the middle of the day, he would look for somebody to talk to, visit with, or go paint with. He was a talker, an extrovert in every way, and he filled his time by spending it with people. I thought he was the greatest thing that came down the pike. And my grandfather—his brother—was such a pill. My grandfather lived a very precise life. He ate every meal a certain way and, at the very end of it, he drank a glass of water.

VALERIO: But your great-uncle wasn't like that?

PHILLIPS: No, Uncle Elmer wasn't a bit like that. He was a free spirit. It wasn't unusual for him to come down to breakfast and announce that he was planning a trip to some other part of the country. The rest of us lived in conventional ways, but Uncle Elmer did not. We all thought it was great that he went to Arizona and California and came home with paintings of purple mountains and great canyons. He didn't go alone. He always went with friends. Who they were, I don't know. When Uncle Elmer came to Chestnut Hill, he

Sarah Mitchell Phillips, Margaret E. Phillips's mother and Schofield's niece, 1945. Photograph courtesy of the Schofield Family. Photograph by Rafters

would sit on the couch and my grandfather would sit in his chair. They would enjoy being in the same room with each other. It was marvelous to see them together. They adored each other.

VALERIO: Did your great-uncle ever talk about his paintings or his career?

PHILLIPS: Not to me. I was too young.

RACHEL MCCAY: Do you ever remember him sketching or painting?

PHILLIPS: I watched him paint one time. It was a seascape, but he told me it was a "marine painting," so I sat there and watched him paint. The marine never showed up! I was expecting a sailor—a US marine. I said, "Where is the marine?" And, of course, it was a water painting, a seascape.

MCCAY: That's a great story. I think I would've been confused by that myself, when I was younger.

VALERIO: Can we talk about World War I? My understanding is that your great-uncle's service in the war was a horrific experience that changed his perspective on art and life thereafter.

PHILLIPS: Uncle Elmer thought the United States should have entered the war sooner, so, back in Cornwall, he volunteered for the British Army. He took himself down and enlisted as a buck private, but his friends in St. Ives [Cornwall, United Kingdom] thought that wouldn't do. Somehow they made him an officer. I don't know what their connection was.

JAMES D. W. CHURCH: He had volunteered for the infantry—the Royal Fusiliers—and it was his friend Julius Olsson who got him a commission as second lieutenant in the Cornwall Royal Garrison Artillery. Olsson was an artist in St. Ives; he pulled some strings to get Elmer the initial commission.

Top: **Marines Oct 3-18**, 1918, by Walter Elmer Schofield (Collection Brandywine River Museum of Art. Gift of Mary Schofield, 1990, in appreciation of the work of the Brandywine Museum); bottom: **6-2-18**, 1918, by Walter Elmer Schofield (Collection Brandywine River Museum of Art. Gift of Mary Schofield, 1990, in appreciation of the work of the Brandywine Museum). Both photographs courtesy of Brandywine River Museum of Art

VALERIO: Do you have a sense, Peg, of how your great-uncle's experience of the war changed his outlook on the world?

PHILLIPS: We'll get to that, but remember that I was born in the 1920s in Brooklyn. My mother, father, brother, and I moved to Philadelphia, into Albert's house on West Moreland Avenue in Chestnut Hill, when I was three. My grandmother had died, and my grandfather needed my mother

to run the house. Once a year—sometime in the fall—Uncle Elmer would just appear on the scene. We had a big house with plenty of room. I imagine Uncle Elmer got the same room every year.

VALERIO: And did he have a painting studio there?

PHILLIPS: No. The only time I saw him paint anything in that house was when he made the marine painting. That was on the billiard table up on the third floor. When his paintings were in exhibitions in the US, the house on West Moreland was his return address. Anything on exhibition got returned to us, even after Uncle Elmer had left for England in the spring. When the paintings arrived, my mother found places to hang them on our walls. She loved his paintings and would say, "Your paintings were returned, but you're not going to get them back because I like them too much." They still had protective glass on them, which was the norm back then. Mother wouldn't take the glass off because she thought Uncle Elmer put it there.

VALERIO: What about the paintings you still own?

PHILLIPS: *Covered Bridge over the Schuylkill at Norristown (The Red Bridge)* (by 1911) was one of the paintings returned to us from an exhibition. It didn't sell, and Uncle Elmer wasn't pleased with it for some reason. He was about to put a palette knife through it when my grandfather stopped him, saying, "I'll take it." So he took it and hung it at the top of the stair landing. That's where it was the whole time I was a child. I later donated

Covered Bridge over the Schuylkill at Norristown (The Red Bridge), by 1911, by Walter Elmer Schofield (Collection Brandywine River Museum of Art. Gift of Margaret E. Phillips, 2003) Photograph courtesy of Brandywine River Museum of Art

Wissahickon in Winter, c. 1920, by Walter Elmer Schofield (Collection of Margaret E. Phillips)

it to the Brandywine River Museum of Art, and it's now in their collection. *Wissahickon in Winter* (c. 1920) came along later; it was installed on a lower landing of the stairs in the house. I know that one day Uncle Elmer was walking on the Cresheim Trail with my parents and saw an art student painting. He stopped and said to her, "It seems to me, if you do this and this, the painting will work out better." And then he went on—he didn't introduce himself or anything. My mother ran along behind and said to the student, "You'd better listen to him, he's the foremost landscape painter in America."

VALERIO: *Wissahickon in Winter* is a real beauty. Do you remember anything about the circumstances in which your great-uncle made it?

PHILLIPS: I don't remember when it was made, but I'll tell you a funny story. I brought it to the conservation lab at the Clark Art Institute in Williamstown (Massachusetts) for a cleaning. It was cleaned beautifully. When I went to pick it up, the nice conservator told me it was a really good painting, and he would be glad to tell me about Schofield. It made me laugh that he wanted to be sure I knew something about the artist! [laughs]

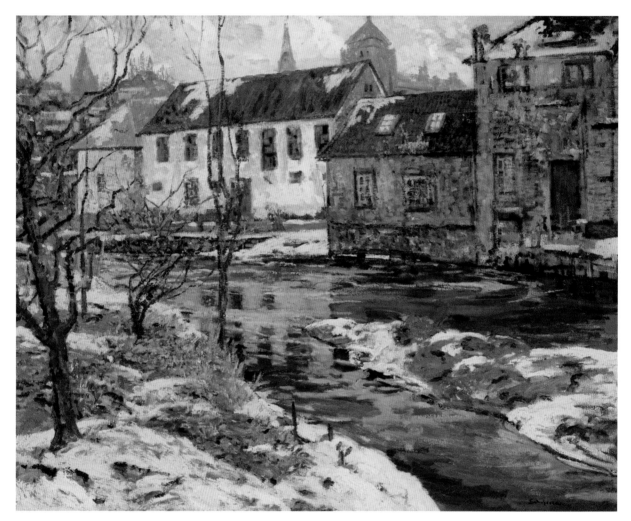

The Old Mills on the Somme, c. 1907, by Walter Elmer Schofield (Indianapolis Museum of Art: Julius Pratt Fund, 09.362) Photograph courtesy of Indianapolis Museum of Art

VALERIO: I have a big question, Peg, that has to do with your great-uncle's subject matter. What was his attitude, as an artist, toward modernity? He lived in a time of great change. Some of his early paintings have modern subjects, like *The Old Mills on the Somme* (c. 1907), which depicts what was then a working river, and *Covered Bridge over the Schuylkill at Norristown (The Red Bridge)* (by 1911; ill.

p. 16), which shows the Norristown Bridge. But later his subjects are more "eternal," including scenes of nature. Did he become nostalgic for a world before industrialization?

PHILLIPS: I think specifically in the painting *Phillack Bridge* (c. 1923) there is a nostalgic sentiment, a dreaminess as suggested in the reflections of the older buildings in the water.

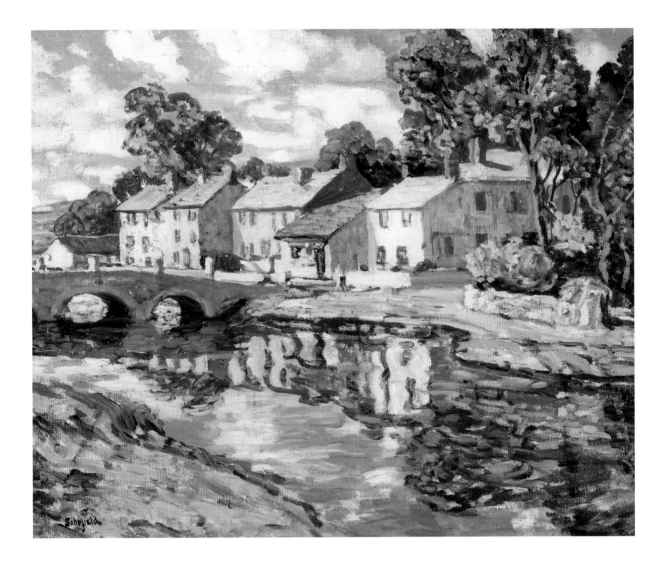

Phillack Bridge, c. 1923, by Walter Elmer Schofield
(Collection of Margaret E. Phillips)

The Cottages, c. 1925, by Walter Elmer Schofield (Chrysler Museum of Art, Norfolk, VA: Museum purchase, 43.27.1) Photograph courtesy of Chrysler Museum of Art, Norfolk, VA

VALERIO: Did he think the world was changing for the worse?

CHURCH: He was very keen on the preservation of historic buildings; his wife, my great-grandmother Muriel, was involved in the founding of the Suffolk Preservation Society and its subsequent development. Elmer's son Sydney, my grandfather, specialized in the repair of historic houses, including Elmer's home Otley High House. He had trained in architecture at Christ's College, Cambridge. Elmer often wrote in his letters about lovely old churches and historic houses all going to ruin, or, once, the sculptures of Amiens Cathedral.

So I think that he was very keen on the beauty of history, and aware that some things should be kept rather than discarded. This was an aspect of modernity that disturbed him—the lack of respect for the art and architecture of the past.

VALERIO: Is his art a vision of the things in the world that will hopefully last forever: the cliffs of Cornwall, the sea, and historic stone structures, like the Tintagel Old Post Office seen in *The Cottages* (c. 1925)?

CHURCH: I think he *was* trying to go somewhere timeless. There are differences between his work before and after the war. It was a good observation

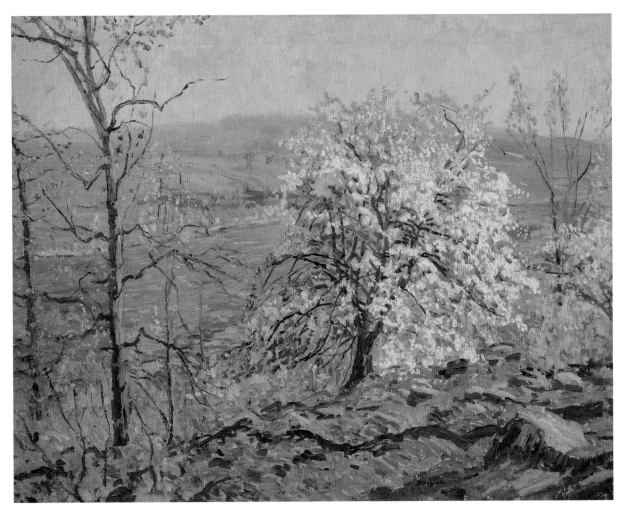

Wild Cherry Blossoms, 1919–20, by Walter Elmer Schofield (Collection of Margaret E. Phillips) Photograph by Paul Rocheleau

you made about his turn away from the industrial scenes that he painted in the first decade of the century. They have an atmosphere of industry and action, like his landscapes of the time, but his postwar pictures are very different. They are serene. However, he was also a pragmatist and had a dim view of progress for the sake of progress. This comes across in his letters, too. For example, in a letter that my grandmother gave to the Smithsonian Archives of American Art,

he describes the news of Robert Falcon Scott's expedition to the South Pole. Scott's team got stuck in a blizzard, just a few miles from the supply dump—and only a few miles beyond that from the base camp. Elmer's letter reads, "The papers are full of the tragedy of Captain Scott's party. What a pity such a fine man and the men with him should be lost in such a useless errand. It does no real good to anyone by their suffering and travails."

MCCAY: It's interesting that that event would have caught his attention.

CHURCH: There was a considerable amount of national pride at that time, so I think it would have been widely discussed.

VALERIO: Can I ask you, Peg, to describe your great-uncle's relationship with Edith Emerson, Woodmere's former director?

PHILLIPS: When Uncle Elmer died, Edith, who was a friend, began to organize a retrospective at Woodmere. I remember she described conversations with his colleague and one-time friend Edward Willis Redfield. She mentioned having to scold him, saying, "You're going to come see the show, Reddy," or something like that. She could be commanding, but he said no, he didn't think so. And she said, "Reddy, don't you think it's time you get over this? It's perfectly ridiculous—you're just having a snit for nothing." She was referring to Redfield holding a grudge about an award my uncle had won in 1904! Can you believe after that long he still had strong feelings about it?

VALERIO: That exhibition was in 1945, so we're talking forty-one years! Did your great-uncle have a friendship with Violet Oakley, who was Edith's life partner?

PHILLIPS: Well, they knew each other, but Uncle Elmer's friendship was with Edith. She was always the link between Violet and Elmer. And Uncle Elmer undoubtedly would have gone to visit them, because he visited everybody. I recall that they lived on St. Georges Road, not far from the West Moreland house.

VALERIO: Was he friendly with William Glackens?

CHURCH: They were close in some ways, but they didn't spend much time together. My sense is that they met up from time to time when Elmer was in New York. I think they got on well.

PHILLIPS: Yes, Uncle Elmer got along well with most people. They also wrote letters to each other; Uncle Elmer received letters from Glackens in Philadelphia.

VALERIO: Interesting. Are there any other artists that you would bring up, James or Peg, who were important to Schofield?

PHILLIPS: He adored Walter Baum, and vice versa. Baum came to our rescue when Uncle Elmer died because he was the one who advocated for getting the paintings out into public collections and important private collections. He was the connection between my parents and Philip and Muriel Berman, who bought a great deal of the work that's now in the collection of the Berman Museum of Art at Ursinus College. Did you know that Baum's second son's middle name is Schofield? I have a nice painting by Baum on the wall, and I go past and bless it every day.

CHURCH: To add to the list of artists he was very good friends with, the ones I think he was closest to in terms of art were the Americans George Gardner Symons, William Wendt, and George Oberteuffer, and the Australian Hayley Lever, who later immigrated to the United States. He became friends with most of them while living in St. Ives, which was very much an international artist community.

PHILLIPS: Hayley Lever borrowed some money from Uncle Elmer and couldn't pay it back, so Lever gave him three paintings instead! Uncle Elmer also had two paintings purchased by the Uruguayan government, and they never paid the bill.

VALERIO: Did he send the paintings?

PHILLIPS: Oh, yes. Uncle Elmer was bad about money. One of his paintings was also in Iran. It was in the American Embassy at the time it was stormed in 1979.

VALERIO: Do we know what happened to that painting?

PHILLIPS and **CHURCH:** No!

PHILLIPS: I recall that Alice Kent Stoddard was another of my uncle's artist friends.

VALERIO: There's a terrific portrait of Schofield by Stoddard.

PHILLIPS: Yes, I recall he had occasion to ask her to make it. She was a great portraitist.

VALERIO: What was your great-uncle like as a parent? You previously told us that he and his wife, Muriel, became somewhat estranged in the 1920s and '30s, and that this accounts to some extent for his extended periods of time living with your family in Chestnut Hill. There must have been a sadness that resulted. Is that so?

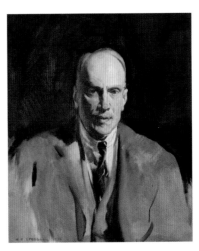

Portrait of Walter Elmer Schofield, 1934, by Alice Kent Stoddard (David David Gallery, Philadelphia)

PHILLIPS: There was tragedy in his life and that had to do with World War I, which was of course a horrendous, life-changing experience for him. He saw the worst that mankind had ever done to itself at the Battle of the Somme. He could never reconcile his basic faith in the world with the destruction and violence he experienced there. He also had family complexities. His wife, Muriel, was a real beauty when she was young. She was British, and she really disliked living in the United States. I recall how she disliked Americans! The family moved to England in 1899, and Muriel remained there for the rest of her life. She and Uncle Elmer had very different relationships with their two sons, Seymour and Sydney. I think it's fair to say that the oldest, Seymour, struggled in some ways, with divorce and professional difficulties—failed ventures in Malaysia and the like. Muriel always seemed to favor Seymour, and this caused friction between the brothers. Uncle Elmer tried to stay out of it—he needed to stay out of it—but I think that the degree of difficulty just made him stay away. I remember my distinct surprise at the age of about ten when I was told that Uncle Elmer had a family in England. I had no idea that Muriel, Sydney, or Seymour existed up until that time. I remember later, when we visited Godolphin, the large estate that Sydney owned, that Seymour had left Cornwall and moved to Sussex. We weren't allowed to mention his name or talk about him.

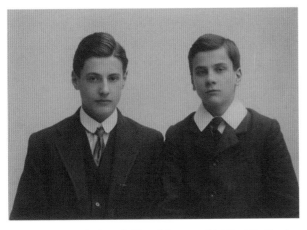

Schofield's sons, Sydney (left) and Seymour (right), at Bedford School, Bedford, United Kingdom, c. 1914. Photograph courtesy of the Schofield Family. Photograph by J. Thomson

VALERIO: Can you see this feeling of estrangement in any way in your great-uncle's paintings? I'm thinking of *The Path to the Sea* (c. 1927), depicting a road to the sea, devoid of human presence. In many paintings of harbors the boats are empty vessels that are missing the human presence that would make them functional. *The Little Harbor* (by 1925), for example, is a quiet painting with a great monumentality. The poetic sadness of the empty shells of boats had to *mean* something to Schofield; he returned to the subject so many times, it must have been a metaphor he meant us to ponder.

PHILLIPS: Well, by the time he was living at Godolphin in the late 1930s with Sydney, Uncle Elmer was older and terribly homesick for Philadelphia. I believe that was why he put snow in the paintings he made at Godolphin. It didn't snow there often, but painting the snow reminded him of the Wissahickon and the Bucks County winter landscapes he loved. He found a real serenity in landscape, and this is why in the paintings he made after the war, there are almost no people. The untouched nature of Cornwall, California, and the Wissahickon in the changing seasons represented serenity and eternity for him. But remember, to the world, Uncle Elmer was a supreme extrovert, and he would mask his deeper feelings by having witty remarks ready at any time.

MCCAY: What were his friendships like?

CHURCH: Elmer had many close friends, including Robert Henri and John Sloan. In general, painting was a social activity. Having true camaraderie, as he had with his own brother, was important. There's a wonderful quote in which he talks about the sadness he experienced when William Wendt was leaving St. Ives. He said that he would miss having a convivial companion who was silent at the proper times so he could concentrate on painting.

The Path to the Sea, c. 1927, by Walter Elmer Schofield (Private Collection)

PHILLIPS: I think life was a social thing for him, just life in general. To return briefly to the topic of his family, he was not home with his wife and sons for a large part of the year. He was in America, painting. And I think that at times he neglected his family. He was fond of the kids, but his job as an artist was in America.

MCCAY: And did they travel to America, the family?

PHILLIPS: Like I said, Muriel hated Americans. She married one and that was enough! When the younger of her sons was six years old, she allowed the two of them to come over and go to school for a year in America. It was one year and that was the end of it! Uncle Elmer had hoped the family would move here permanently, but it didn't happen. Muriel was a difficult person. She always seemed to be eating lunch with her sisters and cousins with hats and gloves on. She was very formal.

VALERIO: Very old-fashioned?

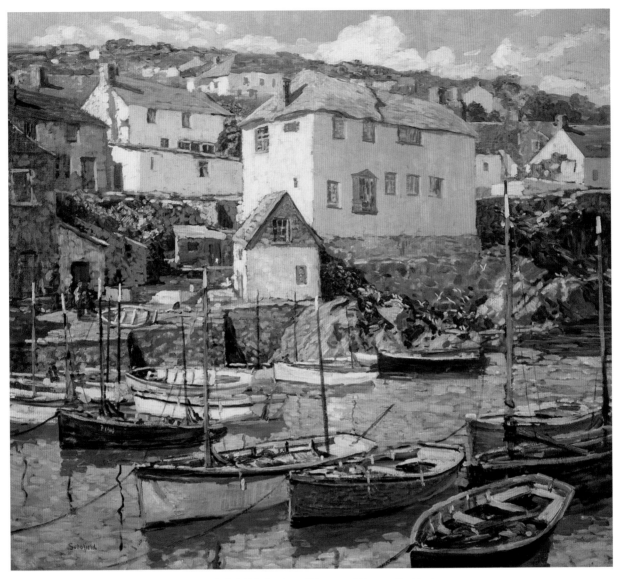

The Little Harbor, by 1925, by Walter Elmer Schofield (Collection of Karen and Thomas Buckley)

PHILLIPS: She was a difficult person to have around. She came over in 1947 to stay with us, and Mother was always trying to help her across the road because everything came from the opposite direction. She would flap her arms and Mother would say, "Stop flapping your arms! I'm going to hang on to you because I don't trust you to cross the road by yourself!"

CHURCH: It's funny, because I have another family story that's been passed down. It's that Elmer's sisters didn't really like Muriel very much. They had wanted Elmer to marry one of their Philadelphia

friends, so there was animosity from the start.

PHILLIPS: Yes, but it goes way back and she persisted. Muriel didn't like them first! During the year she and Elmer lived in Philadelphia, she would say things like, "Oh, they are going to kill me!"

MCCAY: What was Elmer's father, Benjamin, like?

PHILLIPS: Benjamin was a businessman through and through: down-to-earth and hardworking, but not cultured, not sophisticated. He was dedicated to his company and the people who worked

there. Albert, Benjamin's older son, took after his father. Uncle Elmer did not in any way. He took after his mother, Mallie, a distant cousin of Mary Wollstonecraft Shelley, and the Wollstonecraft side of the family, who were more creative.

VALERIO: Did Benjamin approve of his son being an artist?

PHILLIPS: Benjamin didn't understand Uncle Elmer, but Albert would go to bat for him and tell Benjamin, "Elmer needs this . . . " and "Elmer needs that. . . ." Benjamin would take care of the situation because Albert told him to. Benjamin would have a fit because he built Elmer a studio at Wyndhurst, next door to where they lived, but Elmer wouldn't go there and paint from 9:00 a.m. to 5:00 p.m., as they do in business. Albert would have to come and explain that that's not the way artists work. Albert, for all that he was exactly like his father, understood his brother much better than Benjamin understood either one of them.

Wyndhurst house in the Ogontz section of Philadelphia, home of Schofield's parents, Benjamin and Mallie Schofield. Photograph courtesy of the Schofield Family

VALERIO: What about your great-uncle's tuition at the Pennsylvania Academy of the Fine Arts (PAFA)? Did his father pay for that?

PHILLIPS: Yes, he did. Again, it was my grandfather who pressed Benjamin into it. He said, "You can't expect him to be a successful artist without the proper

training, right?" Benjamin could understand that through schooling and training you could become good at your profession, and that's how Uncle Elmer's education at PAFA was paid for. Benjamin also paid for Uncle Elmer to go to Europe—Paris, it was—and get training there, too. Later still, Albert was very protective of his brother and would try to help him with his career. Albert gave Uncle Elmer advice about how to take steps forward and be strategic, as we might say today.

VALERIO: So was it okay for Benjamin to have one son who was an artist, since he had another who was a successful businessman?

PHILLIPS: Benjamin tolerated the fact that Elmer was an artist. At the same time, it was very important to Benjamin that Albert was a good businessman and would be able to take care of the family business. Remember, this was only the last in a chain of companies Benjamin set up.

VALERIO: What were your great-uncle's thoughts about the changing role of women in society? For example, Edith Emerson was a very strong, progressive woman. She was independent. She lived with another woman. Violet and Edith, as a female couple, were ahead of their time. And Elmer was a friend. What does that tell us about him?

PHILLIPS: He embraced people. He wasn't judgmental about anybody.

VALERIO: That's important for us to know.

MCCAY: What I love about the way you talk about your great-uncle, Peg, is that your face lights up and you smile.

PHILLIPS: And the funny part about it was that all my friends from Springside School called him

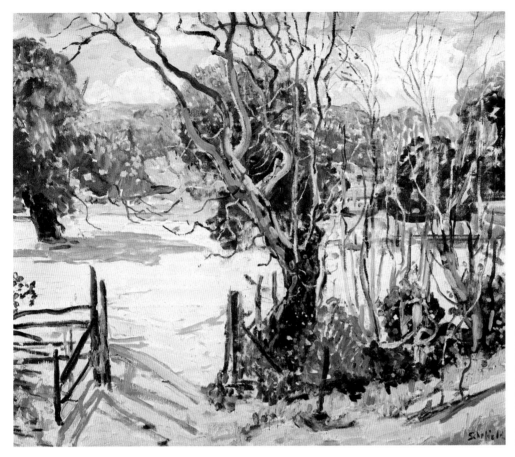

In Arizona, 1934, by Walter Elmer Schofield (Gift of Muriel and Philip Berman, Permanent Collection of the Philip and Muriel Berman Museum of Art at Ursinus College)

"Uncle Elmer" too. He was a warm character who everyone cared about. He wasn't someone you just ignored.

VALERIO: And how did your great-uncle interact with your friends? I mean, you were children. Did he make jokes and spend time with you?

PHILLIPS: He would tell a good story or something like that.

VALERIO: Did he wake up early and set out on the road to paint, or was he a late riser?

PHILLIPS: He would pop down cheerfully to have breakfast with everyone and then disappear, or else go off with my father.

MCCAY: I was thinking about the fact that some people have artists in their family but don't really know anything about them, or they keep their

paintings in the attic. Both you and James are clearly aware and have worked to preserve the legacy of Elmer's artistic achievements and his life. and I wanted to know where that intense respect and love for his work and life came from.

CHURCH: For my part, the appreciation of Elmer's work was passed to me from my grandmother Mary, who was Sydney Schofield's wife. My grandfather died before I was born, but it was Mary's enthusiasm for Elmer and his paintings that nurtured my interest in art. I would say that it was you as well, Peg. You and my grandmother have been primarily responsible for keeping Elmer's memory alive through the last thirty years.

PHILLIPS: For me, the love of Uncle Elmer came from my mother, Sarah Phillips. She cared deeply about her uncle and his reputation as an artist. My grandfather Albert did too.

MCCAY: And do you remember your mother telling you that you had to take care of Elmer's paintings because they were important?

PHILLIPS: She would tell me the paintings were Uncle Elmer's, and they were always hung in prominent places throughout our home. She always cared about the paintings. This is important: when Uncle Elmer died, Sydney asked us to take care of the paintings.

VALERIO: Can you tell us more about that?

PHILLIPS: In the 1940s, Uncle Elmer was living on the Godolphin estate and making some of his most freely painted pictures, taking as his subjects the pond, the streams, and the woods there, as well as the farm structures and cowsheds. He died in England at Godolphin at the end of World War II. Sydney and Seymour couldn't afford the expense of shipping the many paintings that were in Philadelphia over to England, so they asked my mother to find good homes for them. I remember that she sold paintings to her Mitchell relatives, and gave others to some of Uncle Elmer's friends. She was also happy to give paintings to Woodmere, especially because Edith Emerson was organizing the memorial exhibition. This was a time when paintings by Schofield and Redfield were not much esteemed, so it was a big job to find good places for so many artworks. I remember there were paintings leaning against walls all over the house and piled on the larger pieces of furniture.

VALERIO: Among the works that came to Woodmere are *Hill Country* (c. 1913; ill. p. 58), *Morning Tide—Coast of Cornwall* (c. 1920; ill. p. 70), and *March Snow* (1906; ill. p. 49), three of his frequently exhibited paintings. Do you know how those particular works may have been selected for Woodmere?

Untitled, c. 1922, by Walter Elmer Schofield
(Collection of Marguerite and Gerry Lenfest)

PHILLIPS: I don't know, but I would suppose that Edith was the person with that level of knowledge. She was smart. I'm not sure my mother would have known about the history of the individual paintings.

CHURCH: My grandfather Sydney probably had a say in which were donated, or possibly Walter Baum.

VALERIO: Peg, do you remember the memorial exhibition at Woodmere?

PHILLIPS: It was beautiful. It was all the most wonderful paintings by Uncle Elmer, and it would have made him happy. They were all paintings I could have lived with. The exhibition was Edith's doing.

VALERIO: Did Violet Oakley having anything to do with the exhibition, or did she attend the opening?

PHILLIPS: If I recall correctly, Violet was in Europe, perhaps in Sweden on an art-related project that concerned her crusade for world peace. You realize, it was right after World War II. However, when Violet came back to Philadelphia, my parents and I were invited to Violet and Edith's house for tea. Of course we all talked about Uncle Elmer and the exhibition. Woodmere's continued dedication to Uncle Elmer and his legacy makes me very happy. Now, seventy years later, we will celebrate a reunion of his paintings on those walls he really cared about.

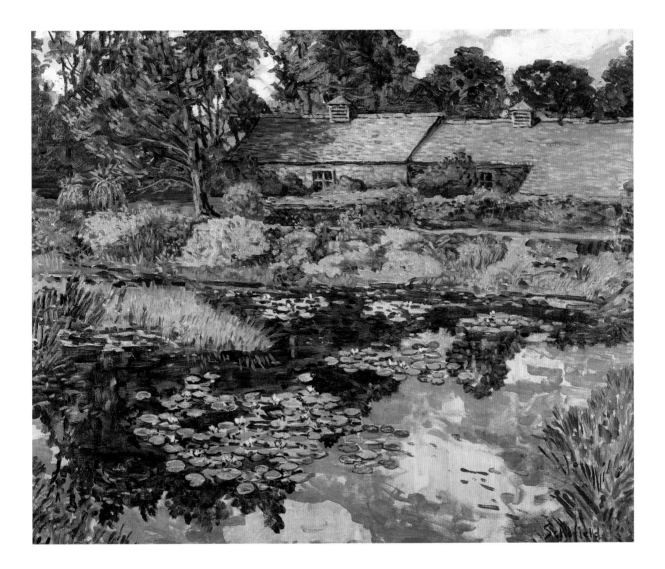

The Ponds, Godolphin, c. 1939, by Walter Elmer Schofield
(Collection of Lucille and Walter Rubin)

On Sunday, March 16, 2014, William R. Valerio, Woodmere's Patricia Van Burgh Allison Director and CEO, hosted a discussion about artist Walter Elmer Schofield in anticipation of the exhibition *Schofield: International Impressionist*.

In attendance were James D. W. Church, great-grandson of Schofield; Therese Dolan, professor of art history at Tyler School of Art, Temple University; Thomas Folk, faculty at New York School of Interior Design and the Appraisal Studies Program, New York University, and author of *Walter Elmer Schofield: Bold Impressionist* (Brandywine River Museum of Art, 1983); Kathleen A. Foster, The Robert L. McNeil, Jr., Senior Curator of American Art and Director of the Center for American Art at the Philadelphia Museum of Art; Valerie Livingston, professor emerita at Susquehanna University, historian of American art and architecture, founding director of the Lore Degenstein Gallery at Susquehanna University, and author of *W. Elmer Schofield: Proud Painter of Modest Lands* (Moravian College, 1988); Brian Peterson, Gerry and Marguerite Lenfest Chief Curator at the James A. Michener Art Museum (retired); and Rachel McCay, Assistant Curator at Woodmere Art Museum.

WILLIAM R. VALERIO: Thank you, everyone, for coming together today to talk about the art of Walter Elmer Schofield—"Scho" to his friends, and "Elmer" to his family. Woodmere is very pleased to organize the exhibition, which will offer an overview of his accomplished career. When I arrived here as the director four years ago, I found five spectacular paintings by Schofield in Woodmere's collection. With a little bit of digging in the Museum's archives, I realized that Schofield was an artist with a significant connection here. He was a friend and colleague of Edith Emerson, the director of Woodmere for almost forty years; after Schofield's death, in 1944, Emerson organized a memorial show to celebrate his achievements, and she did this with the close participation of his "Chestnut Hill family"— that is, with Sarah and Herbert Louis Phillips, the daughter and son-in-law of Schofield's brother, Albert. Sarah and Herbert lived in a house that they inherited from Albert at 408 West Moreland Avenue—near Springside Chestnut Hill Academy—

and were very generous to Woodmere. In the late 1920s and 1930s, when Schofield was spending fall and winter in the United States, the house on West Moreland was his home base. When I saw the checklist for the memorial show, I thought, "We have to offer a repeat of that exhibition!"

THOMAS FOLK: The first thing I'd like to note is that Schofield wasn't staying in one location for six months—he really wasn't. He moved around all the time. From early on, he would make painting trips to Massachusetts and Connecticut, and sometimes to Maine. He also spent time out West: first in Texas in the 1880s, and then in Arizona and California in the 1930s. Helen Clay Frick, of Pittsburgh, had a terrific New England scene by Schofield. He's not often thought of as a New England painter, but he did paint there enough that it should be mentioned.

VALERIE LIVINGSTON: We need to clarify the chronology of the Schofield family residences in Philadelphia.

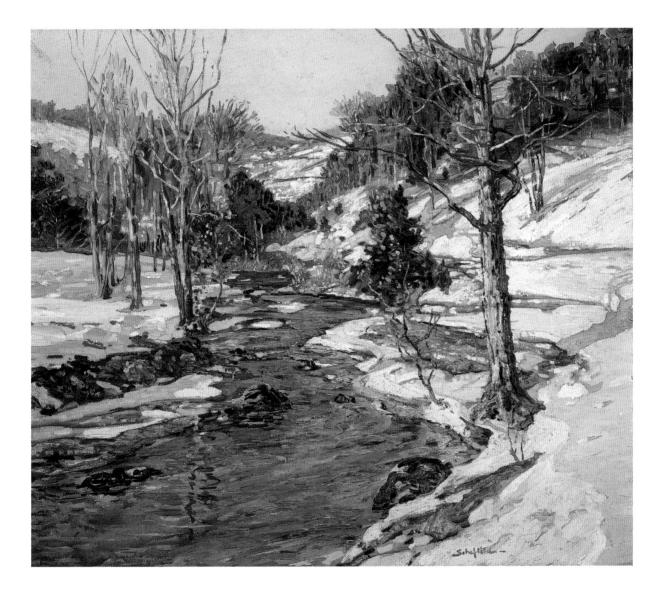

Nearing Spring, c. 1922, by Walter Elmer Schofield
(Private Collection)

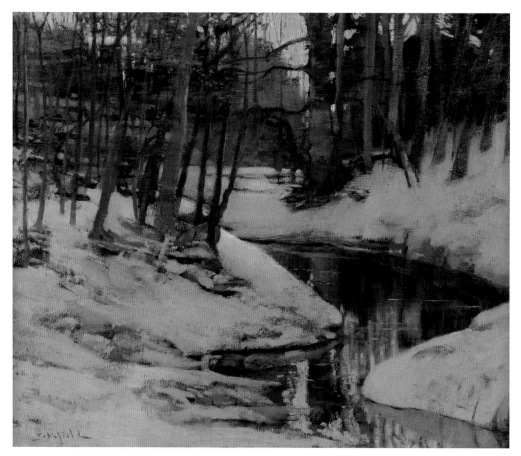

JAMES D. W. CHURCH: In the early days, the family lived in Delaware County, and then moved to Philadelphia. Elmer was born in 1866 in a modest Philadelphia row house at 1529 North Lawrence Street in Kensington. As early as 1896 they lived in a home called Wyndhurst in the city's Ogontz section. In 1901, Elmer and his wife, Muriel, moved to England. On October 28, 1913, Elmer's brother, Albert, and his wife moved to 6816 Quincy Street in the Germantown neighborhood in Philadelphia. Elmer would stay there when he visited the United States, before the family moved to West Moreland Avenue. In the 1920s, Albert and the Phillipses, Albert's daughter and son-in-law, lived at 408 West Moreland.

KATHLEEN A. FOSTER: In connection with the chronology of family residences, I'm noticing that the earliest painting on the checklist is *Winter* (1899) from the Pennsylvania Academy of the

Fine Arts (PAFA). Schofield was a grown-up painter by then; this surely wasn't his earliest work. Thomas Eakins painted *Portrait of Dr. Samuel D. Gross (The Gross Clinic)* in 1875, when he was thirty-one. Schofield was thirty-three when he painted this. Where are the pictures from before 1899 that show his development?

CHURCH: There is limited information about my great-grandfather's work in the early 1890s, and it could be that the early works are among the many he deliberately destroyed. Of his early years, we know that he attended Swarthmore Preparatory School in 1883 and 1884, but he did not enroll in the college. Sometime after graduating from high school he went to Texas, where he worked as a ranch hand at De Vinney Foulke Ranch in San Antonio. He joined a militia group in San Antonio and was discharged in 1888. Back in Philadelphia in

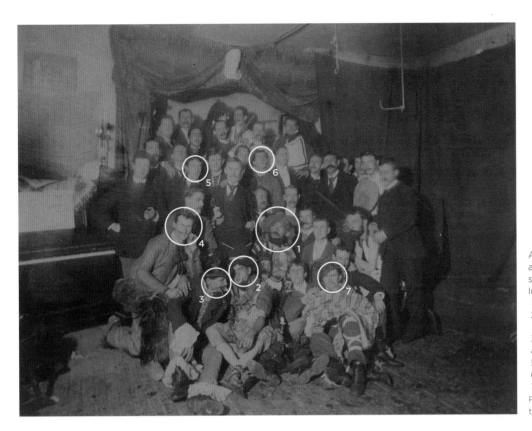

A costume party at Charles Grafly's studio, 1882.
In attendance were:
1 Schofield
2 Edward Willis Redfield
3 Robert Henri
4 Charles Grafly
5 William Glackens
6 John Sloan
7 Hugh Breckenridge
Photograph courtesy of the Schofield Family

1889, he began to take classes at PAFA. Although we have some cartoons he made in the early 1880s, his art career began at PAFA. He was twenty-two or twenty-three by then.

RACHEL MCCAY: I've been through the archives at PAFA and the registration records reveal that Schofield enrolled from January through April 1889 in the Antique Class, in which he was taught drawing from plaster casts. He enrolled for another month of the Antique Class in December 1889. In October of the following year, he enrolled in the Antique Class once again, and in November he was promoted to the Life Class—drawing from the nude model.[1] His only enrollment as a "seasonal" or full-time student took place from December 1891 through May 1892, after which he no longer took classes at PAFA. The pattern of starting and stopping could have been indicative of financial strain, or maybe just that he

was working part-time elsewhere—perhaps at his father's business, the Delph Spinning Company. He worked there later, in the mid-1890s. His classmates at PAFA included William Glackens and Hugh Henry Breckenridge. His teachers would have included Thomas Anshutz, who supervised both the Antique and Life Classes in this decade, assisted from 1891 to 1896 by Robert Vonnoh.

CHURCH: Yes, he developed some strong friendships at PAFA. There's a fantastic photograph of a party in Charles Grafly's studio that includes so many familiar faces.[2] Elmer may be the figure in the center with the silly hat. Upon completing his time at PAFA, in 1892, he went to Europe and attended the Académie Julian, in Paris, where his teachers were William-Adolphe Bouguereau, Gabriel Ferrier, Edmond Aman-Jean, and Lucien Doucet. There are letters between Breckenridge and Robert Henri that

A Midwinter Thaw, c. 1901, by Walter Elmer Schofield (Gift of Muriel and Philip Berman, Permanent Collection of the Philip and Muriel Berman Museum of Art at Ursinus College)

describe Elmer's visit to Edward Willis Redfield, who was living in France at the time.[3] After Elmer returned to Philadelphia, around 1894, we know that he spent time working at the Delph Spinning Company. It's entirely plausible that he could have worked there earlier, as Rachel suggested, and later too.

At that time Elmer was also attending meetings at Henri's studio, where he and other artists would discuss their work and their ideas about how the artist functioned in society (he appears in a few of the group photographs). He then returned to Europe in 1895 on a trip with Henri, Glackens, and Grafly, among others. Aside from a few early sketches and a painting titled *The Alamo* (1890), which was in England and was sold at auction, I don't know much about his paintings prior to the very last years of the century.

VALERIO: I can't speak to the work that came before, but I think of *Winter* (1899; ill. p. 32) as part of a group

of emotive, atmospheric paintings that span the turn of the century. *Winter* has morning light. It's a flashy painting where Schofield shows off what he can do: the dramatic effect of light coming through the trees and reflecting on the water. *A Midwinter Thaw* (c. 1901) is painted with gestural, horizontal sweeps of the brush. The bright yellow light in the window, reflecting in the river, is a beacon in the darkness. *January Woods* (1900) is a wonderful nighttime painting, too, that I would add to this group, together with *January Day* (c. 1906; ill. p. 36), with its early morning or possibly twilight atmosphere.

BRIAN PETERSON: Bill, you're right to draw the connection between these works. It's interesting to keep in mind that when painters such as Schofield, Redfield, and William Langson Lathrop came of age at the turn of the twentieth century, the dominant voice in American painting was probably George Inness. Inness was revered as a great master of landscape

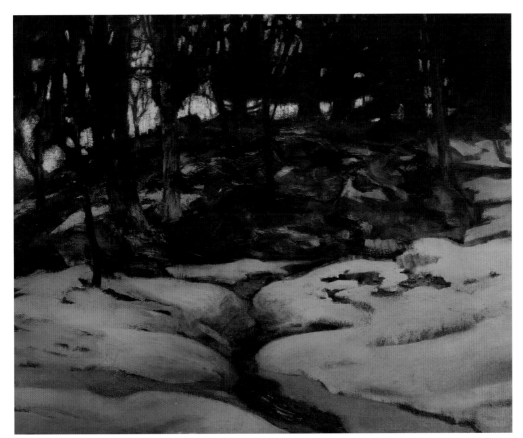

January Woods, 1900, by Walter Elmer Schofield (Private Collection)

painting. He, by the way, utterly despised French Impressionism, probably because of the movement's underlying materialism—its at-times maniacal insistence on, as Redfield put it, painting something as it looked on a certain day at a certain time—combined with its pervasive nostalgia, which to Inness was a cheap substitute for true depth of feeling.

Given the unstoppable tsunami that American Impressionism became later on, it's easy to forget that Inness was so influential in this period. It's especially hard to think about Lathrop apart from him, and to my mind, Schofield's dramatic paintings of light and atmosphere that you just mentioned also have at least a faint aroma of Inness, who was the best-known exponent of the tonalist aesthetic—the master, really. At the time of his death, in 1894, his body practically lay in state at the National Academy of Design in New York; people were paying their respects like he was a US president! Both the Old

Lyme, Connecticut, and New Hope, Pennsylvania, art colonies were more or less founded in the late 1890s by followers of Inness—Henry Ward Ranger in Old Lyme, and Lathrop in New Hope. Ironically, both colonies evolved rather quickly toward the Impressionist spirit, with its emphasis on spontaneity, freshness, light, and direct contact with the subject through plein air painting. It's interesting to note the Inness-like qualities of Schofield's early work. Memory, nostalgia, and the direct communication of the nuances of emotion were what motivated artists like Lathrop to unscrew the lids from the paint tubes and limber up the brushes.

VALERIO: Schofield was a great admirer of Lathrop and would have known his work by the 1890s.

PETERSON: Yes. The point of all this—building on Inness, Lathrop, and all that they represented— is that the prevailing ethos among American landscape painters in the last years of the

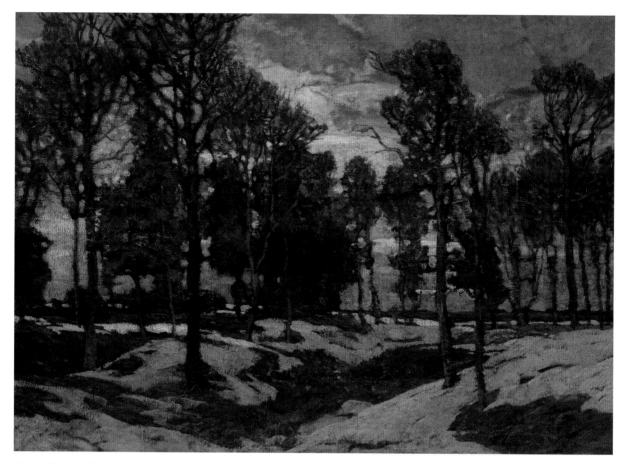

January Day, c. 1906, by Walter Elmer Schofield (Collection of Renny Reynolds and Jack Staub)

nineteenth century was more in the direction of James McNeill Whistler than Winslow Homer— that is, a moody poeticism as opposed to a more narrative realism. Inness, in his last fifteen years or so, made what are arguably the greatest American landscapes. If you wrestled me to the ground and on pain of death asked me to say which American landscape painter I'd stack up against the European masters, I'd have to say that those late paintings by Inness, with their confident, otherworldly transcendentalism, would be the prizewinners. The early Schofield canvases we are talking about, as well as those moody, early Redfields, might be better understood in this context.

FOLK: I think John Henry Twachtman was an influence on these artists, too. His works from the late 1890s are very painterly, intimate, and atmospheric. Twachtman was a regular in annual exhibitions at PAFA and, in 1894, he won PAFA's Temple Gold Medal. It seems likely that Schofield would have been aware of this work; he had just returned from a two-year period of study in France in 1894. Although I've never seen any correspondence between the two, it seems likely that Schofield would have been very familiar with Twachtman's personal interpretation of Impressionism. Like Twachtman's art, canvases such as Schofield's *Winter* (1899; ill. p. 32) have softened contours and a deliberate blurriness.

FOSTER: Yes, Tom, I think you're right about Twachtman. The thing that's spinning in my mind right now, following up on your comment about Inness, is that this is also the trajectory of Henri. He goes to France from 1888 to 1891, studies

Boulevard in Wet Weather, Paris, 1899, by Robert Henri
(Philadelphia Museum of Art: Gift of Meyer P. Potamkin and
Vivian O. Potamkin, 1964-116-6) Photograph courtesy of Philadelphia
Museum of Art/Art Resource, NY

(like Vonnoh, Redfield, and eventually Schofield) at the Académie Julian, and falls in love with Impressionism. Henri is painting bright—he's painting white and high-keyed—and then, in the mid-1890s, when he makes several trips to France from Philadelphia, he falls in love with Édouard Manet and Spain, and his entire palette goes into darkness. So Henri in 1899 is painting night scenes. His painting that we have at the Philadelphia Museum of Art, *Boulevard in Wet Weather, Paris* (1899), contains just one gleam of light that reflects on the wet pavement. This is not late tonalism, and it's not just a response to Inness; there's also this Spanish atmosphere taking over. And Henri, being Henri, takes everybody with him. They all go into darkness at this time. That's why I was interested in seeing what Schofield's work looked like when he was in Philadelphia, in the Henri circle in the mid-1890s, five years earlier than *Winter* (1899; ill. p. 32)—to see if he painted in a higher-keyed style at first and then followed this curve from light into dark.

FOLK: Henri was really dark. He was darker than the other people.

FOSTER: Yes, when I say dark, I really mean black.

THERESE DOLAN: Camille Pissarro was doing nighttime city scenes, too. He did several at this time, working in Paris.

VALERIO: Are there any letters between Henri and Schofield at this early point? Are there any documents that describe their travels together?

CHURCH: There are about four letters from later, with two from around the period of World War I.

LIVINGSTON: We know that in the summer of 1895 Schofield, Glackens, and Henri traveled on bicycles around the Northern European countryside. Henri continued his relationship with Schofield throughout his career, even through the difficulties of World War I and Schofield's commission as second lieutenant in the Cornwall Royal Garrison Artillery at age forty-nine. One letter from Schofield to Henri dated November 18, 1915, discusses his feelings about having to take leave of his painting while he was training in the Royal Fusiliers. I have it here with me; he stated:

> But whatever the outcome, old Henri, I am sending you a friend's good wishes and the hope that some day later on when this tragedy has been played to a finish I can come and smoke a pipe with you and talk things over.[4]

On December 10, 1916—a year later—Schofield wrote to Henri reminiscing about the joy he felt when he was with his friends:

> The memories of old friends, thank Heaven, always manage to creep in somehow. Sloan,

Glack[ens], and you, my boy, always bring up the good old past. . . . When this is over I want to hold out both my hands to the painting tools—I'm hungry for them. . . . All the old life calls to me now and letters from the old clan especially fill me with real joy. My love to you all! . . . Thanks for the pipe![5]

VALERIO: One of the surprises, to me, about Schofield is that he maintained such strong friendships and ongoing conversations about art with Henri, Glackens, and Sloan. They are the three artists who seemed to be his closest friends in New York, though we think of them as being more in the realist camp than in the Impressionist camp, with which Schofield is traditionally associated. Brian, I'm very glad that you pointed me to the 1994 exhibition *American Impressionism and Realism: The Painting of Modern Life, 1885–1915* at the Metropolitan Museum of Art, which began to open up the dialogue between artists we traditionally think of as realists and artists we think of as Impressionists. Schofield could have been included in that exhibition!

FOSTER: Although it must be noted that Schofield, like Sloan and Henri, was a Philadelphia guy who left for England and never lived full-time in New York— and that exhibition focused on New York artists. By the time Schofield finished with PAFA, in his mid-twenties, he was a fully shaped adult, and his closest friends were Philadelphians such as Sloan and Henri. It's just that they moved to New York.

PETERSON: Except for Redfield.

FOSTER: We keep returning to Sloan and Henri and Redfield, who were all members of this group. That's why I was looking for more of Schofield's early work, to see what he was doing in that bohemian crowd in the 1890s, before he went to Europe.

A caricature by Robert Henri of himself, Schofield, and William Glackens.

VALERIO: Although Schofield was a talented cartoonist—as we see in the clever caricatures of himself and others in some of his letters— he didn't work in newspaper illustration, as his friends Sloan and Glackens did. Sloan's and Glackens's artistic approaches were shaped by their experiences as commercial illustrators for newspapers such as the *Philadelphia Press* and the *Philadelphia Inquirer*, and later for mass-market magazines, which they pursued to a greater or lesser extent even after they turned their focus to painting.

FOLK: No, Schofield didn't work as an illustrator at all.

FOSTER: Did he have an income? Why didn't he work as an illustrator? How did he pay for his trips to France in 1892 and 1895?

CHURCH: This is the family's history and financial situation as best I can describe it: We know that Elmer's parents, Benjamin and Mallie Schofield, had two sons, Elmer and Albert, and five daughters. Benjamin had emigrated from England to Philadelphia in about 1845, and

Mallie was British, too—a distant cousin of Mary Wollstonecraft Shelley. The Delph Spinning Company was only the latest in a series of Benjamin's companies and ventures, some of which are recorded in the Hexamer General Surveys. You can also see the book *Proprietary Capitalism*, by Philip Scranton, about Benjamin's life. When Benjamin died, in 1900, his cash and possessions were seemingly divided between his surviving children; however, he left the company shares in three equal parts to Elmer, Albert, and one of the daughters, Alice.

VALERIO: The letterhead for the company dated May 6, 1897, lists Albert's name, "W. E. Schofield," and the names of Alice and her husband, and a man named G. F. Ranger. Is it possible that Benjamin had given his sons and daughter the company prior to his death? Did Schofield have a deeper relationship with the company than is generally described?

CHURCH: It's significant, as you previously pointed out, Kathy, that when Elmer was born, in 1866, the family lived in a modest Philadelphia row house in Kensington—not a wealthy man's house, but a worker's house. By the 1890s, they were living in a more impressive abode, a house called Wyndhurst in the Ogontz section of Philadelphia.

From family history, we understand that after Benjamin's death, the management of the company was left in the hands of Albert. Not that this was necessarily an easy life for him. The company was struggling with debt in the first decade of the century, and it was only with the help of in-laws—Alice's husband's family, the Mitchells (who became shareholders in 1904)—that Albert was able to turn the business around. It wasn't until 1912 that it became profitable enough again for a dividend. The business was eventually sold in 1922.

Elmer's financial position at the turn of the century seems to have been precarious, with a wife and, by 1901, two sons of his own, Sydney and Seymour. My great-grandmother Muriel—as we were told in the family, and as seems clear in letters—was forced to save at every turn and live in poor accommodations in St. Ives, only surviving with the financial support of her parents. She even suffered a breakdown in 1911 after Sydney and Seymour had been very ill, Sydney with asthma and Seymour perhaps with polio. I have some letters. In a letter to Elmer dated March 29, 1911, his mother-in-law, Charlotta Taubman Redmayne, wrote:

> Dear Elmer, I was not much surprised to hear of Muriel's breakdown. The last two years have been terribly hard upon her—so many anxieties with the boys, want of rest is sure to tell in the end . . . she gave me no idea in her last letter that she was not well, she'd written so cheerfully.[6]

I believe that the storyline here is that there was some family support, but it wasn't "easy street," as you say in America; it was, rather, staving off hardship and despair. My great-grandfather Elmer worked hard to build a financially successful career as an artist, using the big national and international exhibitions of the great modern American cities to win prizes and make a name and reputation. He wrote excitedly back to England after his first big success, in 1898. On November 22, Elmer received a letter from L. W. Miller on Art Club of Philadelphia letterhead saying, "Dear Sir, I have the honor to inform you that an award of Honorable Mention was made to your picture."[7] His first big honor was to have *Winter* (1899; ill. p. 32) purchased by PAFA for $200.[8] That was a great deal of money back then, but these windfalls were few and far between to begin with.

FOSTER: So, what is our picture now? Did he pay for Paris through a combination of family support and his own earnings at the family company? It's important to recognize the pressure that he probably felt to show his work, win a reputation, and sell paintings in this period—to compete, as James notes, in these big American salons, and find patronage. Eakins, by contrast, lived in his family home, and could always count on his father's support—in a sense, he had the luxury to be independent and contrary in his artistic choices. In France, you might similarly compare the career of Claude Monet, who was very poor, with that of Manet, Edgar Degas, or Gustave Caillebotte, who came from more affluent backgrounds. It sounds like Schofield had to hustle and keep his eye on the market during these early years.

CHURCH: Your characterization is absolutely correct, Kathy. Let me add, however, in answer to your earlier question, that Margaret Phillips, Elmer's great-niece, explained that Albert persuaded their father of the need for a formal arts education, and in turn their father paid for Elmer to attend PAFA, and for several trips to Europe.

MCCAY: He did, however, work for the family business, so perhaps it was a combination of family support supplemented by his own income.

CHURCH: It is also important to reflect on the culture of the Schofield family. Benjamin was an industrialist who was *proud* to own a spinning mill—a factory. He considered himself part of the "food chain," so to speak, of Philadelphia's thriving garment industry and the national economy. The Schofields understood mechanization and modernity as a positive force and there is no question that Elmer did too at least in the years prior to World War I. He conceived of himself as an artist whose job it was to make paintings that showed the beauty of the world around him in a straightforward and relevant manner. He identified with the process of work and working, and this is reflected in his early depictions of modern industrial scenes. *The Steam Trawlers, Boulogne* (1909), which has just resurfaced at auction as if by miracle for this exhibition, is a prime example. A trawler is among the hardest-working of all vessels: it hauls, dredges, and pulls. I should also mention that the members of the Woodward family of Chestnut Hill were important friends and supporters, and they owned the Pennsylvania Railroad. One of their great paintings, *Winter in Picardy* (1907; ill. p. 44) is also an industrial scene and I find it significant that Gertrude and George Woodward gave it to the Philadelphia Museum of Art during its first decade in its magnificent new home in Fairmount. As the artist's great-grandson, I'm proud to think of the painting as one of the "founding" works of the reconfigured museum.

FOSTER: The honor is ours!

VALERIO: I'd like to talk about Schofield and the European artists of this time—those associated with Impressionism and Postimpressionism. This is the work he would have seen and embraced as vanguard practice when he was in Europe in the 1890s and the first decade of the twentieth century. Can we talk about Schofield in relation to these movements more broadly?

DOLAN: Well, one of the things that I've noticed about Impressionism is that when we talk about it in a general way, we're typically describing works that are painterly or very atmospheric. The term "Pennsylvania Impressionism" was attached to the New Hope painters in 1915 by art critic and painter Guy Pène du Bois, in an article for the periodical *Arts and Decoration*. Du Bois contrasted

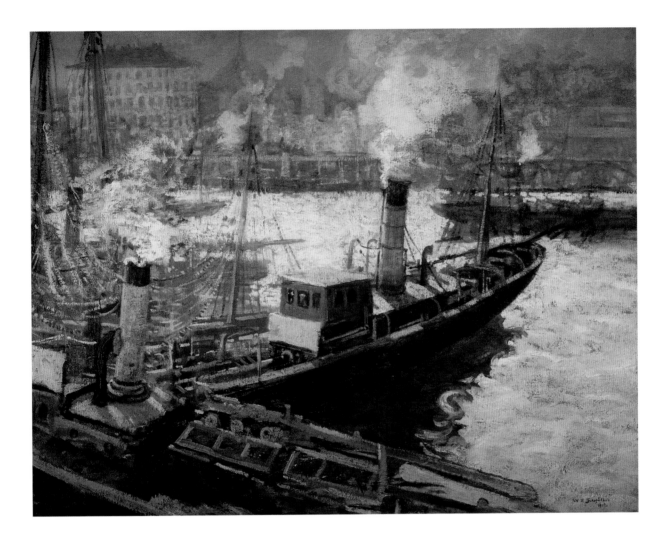

The Steam Trawlers, Boulogne, 1909, by Walter Elmer Schofield
(Collection Jim's of Lambertville)

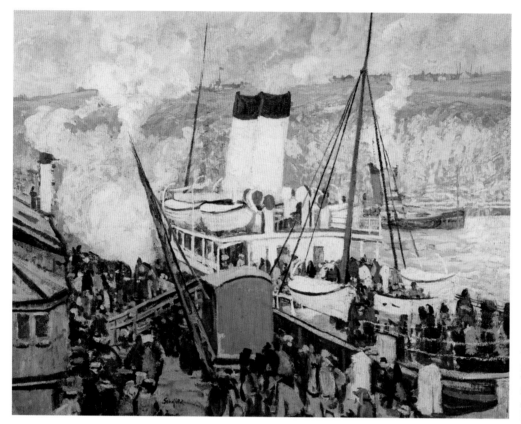

The Packet Boat,
Dieppe, 1910, by
Walter Elmer
Schofield (Collection
of Lucille and Walter
Rubin)

the aristocratic Boston Impressionists, who focused on figure paintings and urban themes, with the Pennsylvania School, whose members demonstrated a vigorous, unsentimental approach to their subject matter. Du Bois characterized the Pennsylvanians as more authentically American in their vernacular of the French Impressionist aesthetic.

It's interesting that after studying with Anshutz at PAFA and then Bouguereau at the Académie Julian, Schofield spent two years in France, staying in the Fontainebleau area where the landscape art of the Barbizon painters had flourished. He also spent time in Brittany. He eventually settled in England, but generally stayed in America between October and April each year. Critics associated him with Pennsylvania Impressionism, but there are many ways to look at his work through the lens of French Impressionism. His painting *The Packet Boat, Dieppe* (1910) has much in common with

Manet's *Folkestone Boat, Boulogne* (1869). Both Schofield and Manet painted with improvisational, summary strokes that express the bustle of a busy harbor whose narrative is anecdotal rather than historical. They both painted a slice of prosaic, contemporary life with no overtones of romanticism or nostalgia. Their boats carry the local populace of the region rather than a fictional Ulysses sailing to Ithaca, and this represents an embrace of modernism, the painting of modern life. Schofield uses multiple directional lines for the girders and billowing smoke to lead the eye along divergent paths that dart around the surface of the canvas, capturing the vibrancy of the activity on the dock. His broken touch here is also very much the kind of thing that Monet used for the smoke and fog in the key work *Impression, Sunrise* (1872), and for his railway station paintings: these are modern subjects that pertain to the link between industry and tourism.

The Packet Boat, Dieppe, 1910, by Walter Elmer Schofield (Private Collection)

The Folkestone Boat, Boulogne, 1869, by Édouard Manet (Philadelphia Museum of Art: The Mr. and Mrs. Carroll S. Tyson, Jr., Collection, 1963-116-10) Photograph courtesy of Philadelphia Museum of Art/Art Resource, NY

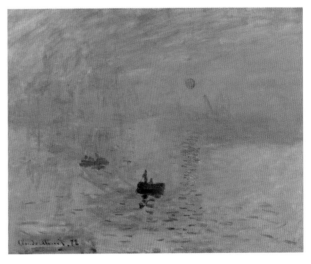

Impression, Sunrise, 1872, by Claude Monet (Musée Marmottan-Claude Monet, Paris) Erich Lessing/Art Resource, NY

Winter in Picardy, 1907, by Walter Elmer Schofield (Philadelphia Museum of Art: Gift of Dr. and Mrs. George Woodward, 1939-7-18)
Photograph courtesy of Philadelphia Museum of Art

Winter in Picardy (1907) reflects Schofield's interest in depicting weather and atmospheric conditions. The mood is somberly poetic with its silvery fog, which penetrates every inch of the canvas. French art critic Jules-Antoine Castagnary explained Impressionism in 1874 by claiming, "They are impressionists in that they do not render a landscape, but the sensation produced by the landscape."[9] This seems especially true here, as Schofield evokes the coldness of the scene by reducing his palette to dulled whites, somber grays, and chilly greens, avoiding any primary colors that might enliven or relieve the deliberate bleakness of the scene.

In preparing for this conversation, I've also been thinking about the Schofield painting called The White Frost (1914), with its great range of subtleties of light and color. We think of the Pennsylvania Impressionists as having a preference for painting snow, but Schofield and the others owe a debt to Monet for this preference. Listen to the parallel thinking: Monet wrote:

> I go out into the country which is so beautiful here that I find the winter perhaps more agreeable than the summer, and naturally I am working all the time, and I believe that this year I am going to do some serious things.[10]

The White Frost, 1914, by Walter Elmer Schofield (The Trout Gallery, Dickinson College) Andrew Bale, Photographer/The Trout Gallery, Dickinson College

Schofield had a similar attitude:

> The landscape painter is of necessity, an outdoors man. . . . For vitality and convincing quality only come to the man who serves, not in the studio, but out in the open where even the things he fights against strengthen him, because you see, nature is always vital, even in her implicit moods, and never denies a vision to the real lover.[11]

Coming back to The White Frost, the high horizon line and the secure geometry of the houses huddled in the landscape anchor the scene against the improvisational brushstrokes and calligraphic energy of the foliage, the frosted terrain, and the leafless tree on the left. Schofield is aligned with the French Impressionists in this sense of structure and counterpoint—geometries poised against seeming spontaneity. Scenes of water, snow, fog, and mist allowed them all to refine their ideas on directly perceived light and color.

VALERIO: There's a Van Gogh–like vigor to The White Frost, but also a lightness of touch that reminds me of the feathery, luminous textures of Pierre-Auguste Renoir. Terry, you also have some observations concerning Schofield in relation to Renoir. Can I ask you to describe them?

DOLAN: Schofield's many great harbor scenes—including *The Inner Harbor, Polperro* (1914) and *A French Harbor* (c. 1927), among others—adopt a viewpoint from above similar to that used by Renoir in *La Grenouillère* (1869), which, even in Schofield's time, was generally acknowledged to be one of the "birthplace" paintings of French Impressionism. Both artists embraced modern life in their views of leisure. Schofield's loose handling of the reflections in the water testifies to his rejection of the subtleties of modeling form and the academic subject matter of his teacher Bouguereau. As early as 1903, with *Docks, Penzance* (1903), the treatment of water is a feature of painterly virtuosity. Then in *A French Harbor*, the dramatic architectural space of the harbor, the bright blue color, and the view from above looking down onto the boats approaches Fauvism and the iconic harbor scenes of André Derain.

La Grenouillère, 1869, by Pierre-Auguste Renoir (Nationalmuseum, Stockholm) Scala/White Images/Art Resource, NY

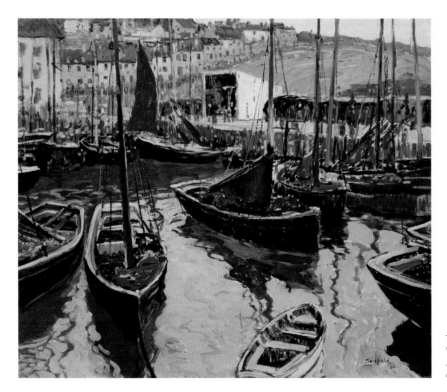

The Inner Harbor, Polperro, 1914, by Walter Elmer Schofield (Collection Jim's of Lambertville) Photograph courtesy of Jim's of Lambertville

Docks, Penzance, 1903, by Walter Elmer Schofield (Collection of Maureen and Gregory Church)

VALERIO: The bright white shed in *The Inner Harbor, Polperro* must be a specific structure. James, do you happen to know what that is?

CHURCH: It seems to be the fisherman's shelter on the wall that closes the inner harbor from outer harbors.

VALERIO: Terry, your observations are very important, not only because the comparisons are so compelling, but also because we tend to think of Schofield and so many of the Pennsylvania Impressionists as provincial artists tucked away in the Pennsylvania countryside. This couldn't be more wrong, and I think you're showing the extent of Schofield's worldliness and sophistication. The paintings you mentioned were cutting-edge in their time. I hope you'll pardon me for asking

A French Harbor, c. 1927, by Walter Elmer Schofield (Collection of Maureen and Gregory Church)

Left: **French Village,** c. 1910, by Walter Elmer Schofield (Private Collection); below: **Red Roofs, a Village Corner, Winter,** 1877, by Camille Pissarro (Musée d'Orsay, Paris: Bequest of Gustave Caillebotte) © Erich Lessing / Art Resource, NY

you to describe another specific comparison you brought to my attention, that of Schofield's *French Village* (c. 1910) and Pissarro's *Red Roofs* (1877). The strategy of ennobling a humble, farm-like country dwelling is similar.

DOLAN: There's no question that *French Village* shares visual characteristics with Pissarro's work of the 1870s and early 1880s. In his humble country scene, Schofield avoids the modern cityscape and urban pleasures preferred by many of the Impressionists. He also sacrifices the somewhat paternalizing "picturesque" view that one might see in an academic's interpretation of the countryside for an unaffected view of a quiet rural site, with its simple planted gardens and unassuming dwellings.

Théodore Duret was among the contemporary critics who took a kindly view of the Impressionists, and he was perhaps the only one who preferred Pissarro to Monet. There's a letter in which he describes the

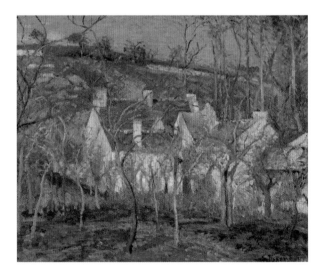

qualities of Pissarro's paintings. I brought it with me because we should think about the statement as it applies to Schofield:

> You have not got Sisley's decorative sense or Monet's amazing eye, but you have something

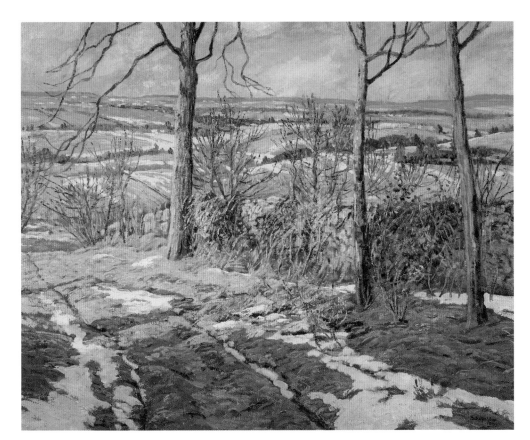

March Snow, 1906, by Walter Elmer Schofield (Woodmere Art Museum: Gift of Sydney E. and Seymour Schofield, 1949)

they do not—a profound, intimate sense of nature and a gift of forceful brushwork, so that every picture of yours rests on absolutely firm foundations. . . Go your own way, go on painting rural nature.[12]

He might have said the same to Schofield, had he seen his art. These early paintings by Schofield, as much as they are structured compositions, feel as uncontrived as the people who we imagine to live in these dwellings.

PETERSON: There's an experimentation and a profound transformation that occurs very quickly in Schofield's work in the early part of the century. Look at PAFA's painting, *Winter* (1899; ill. p. 32), compared to Woodmere's *March Snow* (1906): there's an increase in scale, breadth of space, and complexity of textures, light, color, and touch. There are many ways to address the change. French art and that of Schofield's Philadelphia cohort are

ingredients, but there are also broader cultural pathways, pathways of individual growth on the part of the artist, and social and historical pathways.

VALERIO: One of those pathways concerns Schofield and the New Hope group, not only Lathrop, whom we've discussed, but also Redfield. Tom, was Redfield's style of painting a catalyst for the change that occurred in Schofield's work in the first decade of the twentieth century?

FOLK: Redfield really invented the manner of vigorous painting that became something of a signature for the New Hope School, in my opinion. He was a great influence on Schofield, and vice versa. There is ample documentation in letters to show that, at least up to 1904, they were working closely together; Schofield was spending time in New Hope and painting with Redfield outdoors. It was easy for Schofield to visit Redfield because there was a train at the time

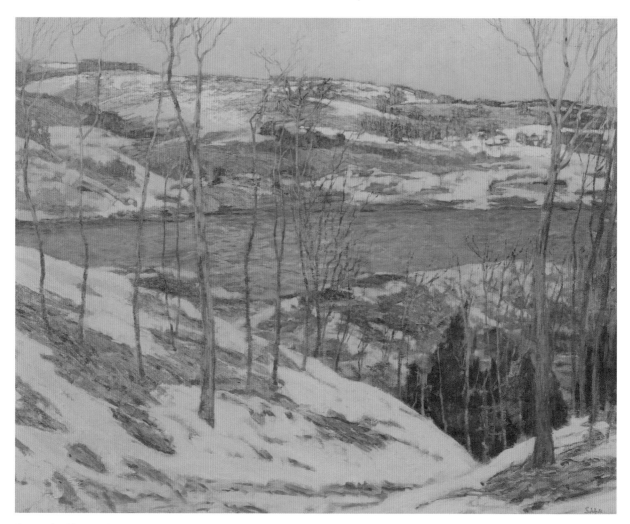

Across the River, c. 1904, by Walter Elmer Schofield (Carnegie Museum of Art, Pittsburgh: Purchase, 05.2) Photograph © 2014 Carnegie Museum of Art, Pittsburgh

from downtown Philadelphia to Bucks County. In a recorded interview, Redfield relates that during one of these visits, he told Schofield about a snow scene depicting the hillside near his home on the Delaware River that he was going to paint for the Carnegie Institute.[13] He was going to do it in one go, en plein air, capturing as much as he could get. Then, in Redfield's mind, Schofield went back to England and painted *Across the River* (c. 1904)

from memory. Schofield could paint from memory! Schofield submitted his painting to the Carnegie annual exhibition in 1904 and won the Gold Medal of the First Class. Redfield, who was on the jury, never forgave Schofield for "stealing" his subject matter. The Carnegie still owns the painting and I'm so glad it will be here for the exhibition! Schofield was really not a big part of the New Hope School after that.

VALERIO: After 1904?

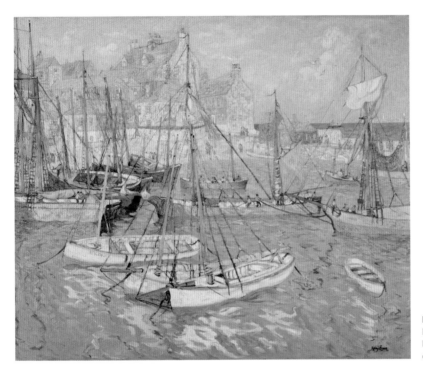

Fisherman's Quarters, c. 1915, by Hayley Lever (Dallas Museum of Art: Gift of the Dallas Fair Association) Photograph courtesy of Dallas Museum of Art

FOLK: There wasn't much of a New Hope School *before* 1904. In addition to Redfield, there was only Lathrop and Charles Rosen. Daniel Garber arrived in 1907, and Robert Spencer, Rae Sloan Bredin, John Fulton Folinsbee, and the rest came later.

CHURCH: One important thing to remember about this information from Redfield: it was recorded sixty years after the event. Perhaps he simply wished to put his own account on the record, but time can distort facts. The contemporary evidence suggests a different story.

FOLK: I'm not saying that Schofield copied Redfield, or anything necessarily bad about Schofield, but it's a parallel development for sure, and for whatever reason, right or wrong, Redfield thought it was his style. But I don't think Pennsylvania Impressionism has to be just New Hope—I think it's artists from Pennsylvania who painted in a certain style.

LIVINGSTON: I agree.

CHURCH: Let's also not underestimate the close relationships between Schofield and the artists who were part of the art colony at St. Ives. Hayley Lever was one of them, and he is an important artist to consider when thinking about the development of Schofield's work. We were just talking about Jim Alterman's *The Inner Harbor, Polperro* (1914; ill. p. 46). There is a strong relationship with Lever's harbor scenes of the same years, just before the outbreak of World War I. They share an interest in subject matter and technique. I'm not trying to take anything away from Redfield as an important innovator. However, to my mind, it appears that critical changes were happening in Elmer's work well before *Across the River* (c. 1904). For example, it was Elmer's first visit to Cornwall (England) in 1903 that appears to have begun the transformation

Breezy Day, Early Autumn, c. 1902, by Walter Elmer Schofield (Reading Public Museum, Reading, PA) Photograph courtesy of Reading Public Museum, Reading, PA

in his painting. This is evident in a comparison of *Breezy Day, Early Autumn* (c. 1902) with *Zennor Cove—Coast of Cornwall* (1903). Both have the same brushwork and treatment of sky, but the color and composition are far more expansive in the latter work.

VALERIO: The relationship with Redfield was complicated for Schofield, but that seems to have been the case with Redfield and other artists, too. I'm wondering if we can put this story of Schofield and Redfield's relationship in a broader context. James, I'll ask you, because it was you who brought this cartoon to our attention: Schofield depicts himself with a flat cap and pipe, the "Pittsburgh" medal on his chest, and Redfield's outsized and outstretched hand reaching over from behind his back to grab the medal away.

Zennor Cove—Coast of Cornwall, 1903, by Walter Elmer Schofield
(Woodward Collection)

Above: Schofield included this caricature in a 1904 letter to John Sloan. Schofield stands, while Edward Willis Redfield's hand reaches out to grab the Carnegie medal from him; right: In the same letter, Schofield is "struck apoplectic" by the great news of having won the medal. (Letter from Schofield to John Sloan, November 18, 1904. John Sloan Manuscript Collection, Delaware Art Museum)

CHURCH: There is an illustration for a little poem that Elmer sent to Sloan after winning the Gold Medal of the First Class from the Carnegie and earning $1,500 for the purchase of *Across the River* (c. 1904; ill. p. 50). The poem describes Schofield's feelings on hearing the news, after he had previously feared his work wouldn't even be hung:

> He didn't suspect it
> And was struck apoplectic
> But prompt medical aid
> Bro't the blood from his "haid"
> And so he was saved
>
> But his mind never cleared
>
> And the vision that he saw
> Was a <u>red</u>, <u>red</u> paw

> That tried to get "oof"
> What the Jury gave forsooth
>
> And that is what he feared
>
> And at night he'd wake with fright
> With his throat clutched good and tight
> By that awful reddish paw
> Which he'd really think he saw
> And his thick mustache he'd gnaw
> Etc. etc. etc.[14]

The emphasis on "red" is clearly suggestive, intimating Redfield, while the "get 'oof'" suggests Redfield's desire to reverse the jury's decision. This would have been a remarkable action for Redfield to have attempted.

VALERIO: Does that make sense to you, Tom?

FOLK: Redfield was on the jury the 1904 Carnegie annual, which means he was ineligible to win a prize that year.

CHURCH: There are two very important points to bear in mind with this. One is that, as Tom just mentioned, Elmer's painting didn't compete with any painting by Redfield, because Redfield served as a juror and was therefore ineligible to win medals. That was the rule of the Carnegie—and most other institutions—so if Redfield was painting to win a medal, he could not have been directly competing with Elmer at that particular exhibition.

Furthermore, there's a letter that Redfield wrote to Henri in 1904 describing the pictures at that year's exhibition, before the announcement of the prizes. He commented, "Schofield had two very good canvases at Pittsburgh."[15] If he objected to the subject matter, it stands to reason that he would have voiced that objection to Henri, as they were very close friends. But he made no objection at the time. Besides, all of those Philadelphia artists would have painted together hundreds of times before. The real objection seems to have been to the fact that Elmer won the medal at all—Redfield perhaps wanted someone else to receive it, or he was simply envious—not the fact that the canvas depicts a place that Redfield also painted or had hoped to paint.

FOLK: But Redfield still remembered it until the 1960s.

FOSTER: It seems Redfield was mad because he may have tried to steer the prize to someone else; he certainly was in a position to have tried to prevent Schofield from winning it. And Schofield knew it! I think there was a lot of horse-trading on those juries.

MCCAY: Peg Phillips remembered that in 1945 Edith Emerson invited Redfield to the memorial exhibition of Schofield's work at Woodmere, and Redfield didn't attend. According to Peg, Edith really tried to convince Redfield to forget his grudge.

VALERIO: The horse-trading comes through in Sloan's diary, too. When he described the 1906 PAFA *Annual Exhibition*, Sloan stated something to the effect that he was glad that Glackens would be there to advocate for him, in a sense.[16]

CHURCH: Sloan—indeed, any of them—might never have succeeded against the prevailing Boston academic style without friends on the juries. In 1905, Elmer and Henri were on the jury at the Carnegie, and Redfield was awarded the Silver Medal of the Second Class and $1,000, while Sloan and Glackens earned the two Honorable Mentions. This was big news for them all. Schofield built a professional relationship with the Carnegie, even scouting out paintings in Europe.[17] The awards built relationships through prestige and built professional and social capital—and the money was significant.

VALERIO: I'd like to talk a little bit about Schofield and Redfield as artists with distinct temperaments, as manifested in their paintings. Yes, they share certain compositional tropes of near and distant bodies of land, as well as scale. But I've always felt that Redfield has a staccato energy and paint application that's very different from the energy that I get from Schofield.

FOLK: They painted very differently. Redfield would take a painting outside in wintertime, tie his easel to a tree so his work (fifty by fifty-six inches was his largest size) wouldn't blow away, and paint for

eight hours in the cold, standing in one place with no bathroom. Oil paint freezes in the winter. Schofield liked that idea, but he wasn't as much wedded to it. Schofield's largest size in oil paintings was fifty by sixty inches. He was more of a studio artist; if he felt he had a winning composition from an outdoor painting session, he would go back to the studio and paint it in a fifty-inch scale, and then he might paint it on a more intimate, twenty-four-by-thirty-six-inch scale. Or he might do a small oil on the spot. A study of his paintings reveals that Schofield often did the same subject in graduated sizes. However, it's not always clear which size came first. He and Redfield were savvy businessmen when it came to their art.

CHURCH: It appears Elmer made decisions for reasons of practicality. Redfield generally worked within a short radius of home, so carrying a day's work on his back was feasible. Elmer traveled huge distances to paint and often stayed at a particular place for weeks. Shipping that many pictures—with any more than a few large canvases amongst them—would have been prohibitively expensive. Most had to be portable, even just to transport them home.

LIVINGSTON: Actually, regardless of scale, Schofield spent much time outside in the open air. His preference for painting outdoors was noted in articles written and published about him during his lifetime. The open-air approach was also the basis of his ability to offer a sense of the tangibility of nature. For example, the Metropolitan Museum of Art's great painting *Sand Dunes near Lelant, Cornwall, England* (1905) conveys a sense of the textures of those unique sand dunes.

CHURCH: I have a copy of a 1905 letter from Elmer's wife, Muriel, which says, "What a shame Mr. Redfield should copy your last frames and pictures to a

great extent—what a mean creature—He seems to stop at nothing and intends to run you very close."[18] This letter really was a surprise to me, suggesting that Redfield had already gained a reputation for ruthlessness toward Elmer—at least in Muriel's eyes—by this time. In the same letter, she encouraged him to keep his work private before exhibition to prevent "Mr. Redfield or other unscrupulous people" from gaining "time to copy" as a sensible precaution. It's surprising to think of Redfield behaving in this manner—toward a friend, too!

FOLK: Really? Are there any letters directly between Schofield and Redfield?

CHURCH: There are mentions and references in Elmer's letters to Muriel, but there are few surviving letters from his friends, and none from Redfield as far as I know.

VALERIO: Well, how was Redfield painting in 1906?

FOLK: Redfield gets brighter and less tonal starting in the middle years of the century's first decade. However, I think some of his best paintings were made in the 1920s. That's late for Impressionism, so to speak, but I think that's when he got really good. Unfortunately, by the time he got to the late 1930s, he had problems with his hands, including arthritis. Redfield was an establishment guy, not a bohemian artist. His goal was to get his paintings into every important museum in the United States, and he was quite successful in the early twentieth century. This is why he felt competitive with Schofield.

PETERSON: Besides, he was a curmudgeon and a very difficult personality to deal with.

LIVINGSTON: Redfield was unlike Schofield, who had a reputation as an affable, social person who helped to promote the careers of his fellow artists.

Left: **Sand Dunes near Lelant, Cornwall, England**, 1905, by Walter Elmer Schofield (Lent by The Metropolitan Museum of Art: George A. Hearn Fund, 1909, 09.26.1) Image © The Metropolitan Museum of Art. Image source: Art Resource, NY; below: **Lelant**, c. 1904, by Walter Elmer Schofield (Private Collection)

FOLK: To discuss the Schofield and Redfield relationship, we have to come back to the relationships both artists had with Sloan. I was friendly with Helen Farr Sloan, the artist's second wife. Reading the letters carefully is important. Schofield and Sloan were great friends; Schofield stayed with the Sloans in New York when he was there, and then helped promote Sloan's career in England. Redfield really despised Sloan, more than he hated anyone else. He may have had problems with Schofield, and felt competitive, but he really hated Sloan. Redfield would say no to anything Sloan did. This turned into a deep resentment, because Sloan's urban subjects seemed to become more resonant with audiences over time, and by the 1930s, Redfield's paintings weren't as thematically relevant. As the New Hope School paintings got put in the basements of museums, the Ashcan School became more prominent and gained its place in the history of American art; Redfield and Schofield, for

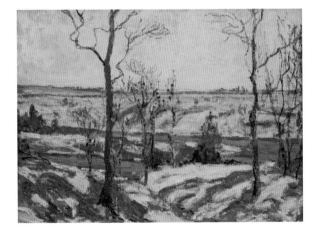

that matter, were in the basements, while Henri and Sloan were on the walls. This was killing Redfield. He hated what happened, and remember how Bennard Perlman titled his book *Painters of the Ashcan School: The Immortal Eight*? Redfield called them "The Immoral Eight." He didn't hold back from expressing his jealousy.

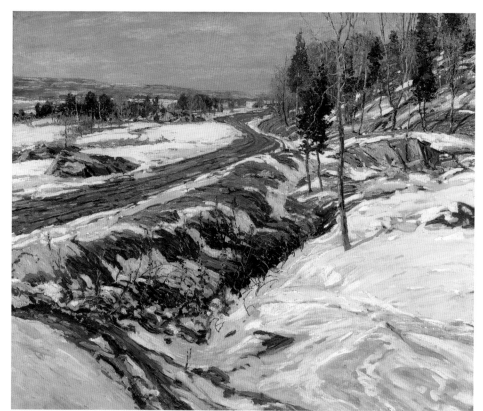

Hill Country, c. 1913, by Walter Elmer Schofield (Woodmere Art Museum: Gift of Sydney E. and Seymour Schofield, 1949)

CHURCH: The rift with Sloan materialized sometime after 1903. Redfield and Sloan were friends until that time. It's only perhaps from 1904, with these letters to Elmer, that any tension becomes evident. It worsened steadily and by November 8, 1906, Sloan declared, "Glackens on it [PAFA jury], which is fine but oh . . . Redfield on the Hanging Committee!! S'Death."[19] Then, by 1908, Sloan declared, "My whole inside nature is revolted by [him]. Others, who haven't found him [Redfield] out, wonder at my attitude."[20] What on earth had happened to generate such animosity? Redfield didn't appreciate Sloan's painting or his choice of wife, Dolly, so there were contentious subjects between them.

MCCAY: Schofield wasn't an avant-garde modernist either. In Sloan's diary entry from February 7, 1908, he recounted how, having visited the famous show of The Eight at the Macbeth Gallery, Schofield disliked the work of Maurice Prendergast and Arthur Davies.[21]

CHURCH: Prendergast and Davies were the odd ones out, though, taking less of the realist, less of the Philadelphia approach advocated by Eakins and Anshutz, than the others. They seem less modern to my eyes, although I know Prendergast's flat picture space was considered innovative by many critics.

PETERSON: The conversation about realism and Impressionism in American art is fascinating because it blurs the lines between the two. To understand the history of American Impressionism and realism, it's crucial to understand what was happening politically in the art world in the era of the Great Depression. All of this informs our perceptions of the period. In the Garber catalogue raisonné, Lance Humphries points out that Garber began injecting more figurative elements and interactions into his paintings around this time, apparently because his gallery was urging him to get more with the program of the 1930s. Garber's paintings, like those of Redfield and Schofield,

Late Afternoon, c. 1925, by Edward Willis Redfield (Woodmere Art Museum: Museum purchase, 1959)

were getting put in the basement. And this is really surprising because not long before, these boys were the gold-medal-winning artists of America. The appreciation of the Pennsylvania Impressionists seriously declined in the 1930s.

FOLK: Redfield lived to be ninety-five years old, and never had the satisfaction of seeing any revival of recognition or appreciation.

VALERIO: He got to see a lot of changes in American art, well beyond the ascendancy of the Ashcan painters. I can't imagine what he thought about Abstract Expressionism.

PETERSON: Well, he stopped painting in the 1940s!

DOLAN: And he destroyed a lot of his work.

FOSTER: Getting back to the paintings: I've been sitting across from *Hill Country* (c. 1913), and because I've seen this painting several times at

Woodmere, I know it's a Schofield. But if I were shown this painting in a slide exam, I'd say it was made by Redfield. I'm interested in this moment of intersection and what's the same about their approach and style, as well as what's different. *Hill Country* and Redfield's *Late Afternoon* (c. 1925) share a tonality, the same creamy application of paint, and a very vigorous, spontaneous touch.

FOLK: The concept and positioning of the viewer, though, is completely different. In Schofield's painting you're at the bottom looking up at the landscape. Redfield places the viewer someplace high, looking down on the scene.

VALERIO: Your remark about positioning, Tom, is very relevant to Schofield. I've looked at *March Snow* (1906; ill. p. 49) quite a bit, and I've thought about Sylvia Yount's proposal that Walt Whitman's outdoorsman—the American outdoorsman who's as sensitive as he is rugged—was a central figure for

The Rapids, c. 1914, by Walter Elmer Schofield (Smithsonian American Art Museum: Bequest of Henry Ward Ranger through the National Academy of Design, 1954.11.1) Photograph courtesy of Smithsonian American Art Museum, Washington, DC/Art Resource, NY

the Bucks County artists.[22] There's a subtle poetry to Schofield's vigorous winter scenes. March snow is the last snow; tracks emerge from below and the warmth of spring is ever so slightly suggested by the warm light. It's also important to acknowledge the large shadow that comes in on a diagonal from the lower right. It's all about the traces of activity in the landscape. Or, I've always felt that in *Hill Country* (c. 1913; ill. p. 58), the artist presents us with a conversation between a road and a ditch. You have to wonder whether the ditch was created when the road was made, or whether the ditch exists because of the vagaries of nature. Nature is wild, like the clump of weeds in the foreground—the man-made road has a power, speed, strength.

CHURCH: Redfield's dynamism derives in part from his brushwork, more broken than Elmer's, while Elmer's dynamic is more compositional, with high horizon lines and scenes tilted up toward the picture plane, often abruptly cropped. Elmer's paintwork is sinuous, with extensive impasto and tapestry-like blocks of color.

FOLK: Redfield spent more money on paint—there's a ton of paint on his canvases.

LIVINGSTON: Schofield, on the other hand, creates an illusion of thick paint, but he usually painted in one layer. By the 1920s, he was leaving large areas of bare canvas.

DOLAN: Did Schofield use a palette knife?

CHURCH: I've often thought that he did. I'm also fairly sure he used the handle of his brush to "sculpt" the paint in the foreground of *Hill Country* (c. 1913; ill. p. 58), especially in the brambles. In *The Rapids* (c. 1914) it looks as if he applied the paint with either a very thin, hard brush, or with a brush handle.

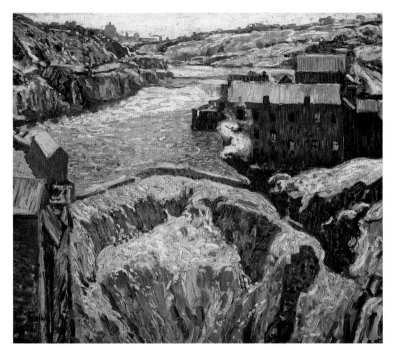

Lower Falls, 1915, by Walter Elmer Schofield
(Memorial Art Gallery of the University of
Rochester: Bequest of Mrs. Ernest R. Willard)
Photograph courtesy of Memorial Art Gallery of the
University of Rochester

PETERSON: Bill, in regard to your comment about *Hill Country* (c. 1913; ill. p. 58) being a conversation between a road and a ditch, I'd take that a little further and say that it's a conversation between a person and a place that has a road and a ditch. It's a very specific kind of conversation between painter and landscape, and it also applies to Redfield's work, but in a different way. I think of them as brothers, in a sense. You know how brothers are related, but they're very different, too? They come from the same genetic background, but they have their own ways of doing things. Schofield's work often has a quality of intimacy, that's how I read it. There's a grandeur to Redfield's paintings, a bigness.

CHURCH: Their filial similarities were noted at the time, with PAFA's Managing Director Harrison S. Morris commenting, "W. Elmer Schofield and Edward W. Redfield, the two 'fields' whose borders march together . . . Robert Henri and John Sloan must be classed with their comrades, both in aims and antecedents."[23] It's interesting that he also notes the "couples": Schofield and Redfield, Henri and Sloan.

VALERIO: Brian, are you talking about the way each artist positions the viewer, such that he or she can "feel" nature's grandeur or intimacy?

PETERSON: That's part of it.

FOLK: Redfield's not going to put you in a ditch!

FOSTER: Yes, you're a long way from the foreground in *Hill Country*.

FOLK: *The Rapids* is another painting with extraordinary drama: the viewer is positioned low, looking up, and the water is rushing forward.

VALERIO: There's a sense of threat there, and I can't help but note that it's made about 1914. *Lower Falls* (1915), with the great dramatic drop in the foreground, even feels dangerous.

PETERSON: It's the paint application, too, and the interplay of color. Not in these works, but in general there's a softness to Schofield's touch with paint. Often with Redfield it's like an aggressive attack on the surface. On the other hand, the word that was sometimes used to describe both of them, which is really fascinating, is "virile."

FOLK: They both presented themselves as virile men, Redfield and Schofield.

DOLAN: That's also how they distinguished themselves from the French—

FOSTER: And from the Bostonians, who are always characterized in this era as being more "genteel" and "refined."

CHURCH: Elmer's friend, the noted critic C. Lewis Hind, described him using those terms—as "an open-air man, wholesome, healthy, hearty . . . His art is virile and outstepping, crisp and candid, and I should not wonder if he with [Willard Leroy] Metcalf and Redfield, to mention but two others, became the founders of an American school of landscape, rooted and grounded in the soil."[24]

PETERSON: What's interesting about that to me is that artists are sometimes masters at marketing themselves, so maybe it was a macho image they were creating to help sell their pictures. But if you talk to Redfield's grandson, he says no, his grandfather actually was that kind of person.

FOLK: Sure he was.

PETERSON: Redfield taught his grandson how to hunt and fish and trap.

FOLK: He had to farm—did his own farming, too— and built furniture.

CHURCH: It's interesting that the myth associated with this circle of realist artists is true to a point: they were tough. Elmer himself was a noted boxer, as recorded by the American painter and illustrator Burt Barnes, who described a round between Elmer and British artist Moffat Lindner. Barnes wrote,

He [Lindner] was fifty or sixty pounds lighter than the American [Schofield], twenty years younger and much quicker and more adept, so at first he was an easy winner on points. Presently, however, he was sailing through space and technically took the count. . . for while the American always disclaimed any talent for fighting, it was well known that on a previous afternoon he had knocked out a lieutenant of the British Navy who held the championship of the Mediterranean Fleet.[25]

On the other hand, Elmer was an aesthete. He taught his son Sydney how to paint in the early 1920s. *Phillack Bridge* (c. 1923; ill. p. 19), for example, has a companion painting by Sydney of the other half of Undercliff hamlet. They also had common interests in art and historic architecture.

PETERSON: It's also hard to imagine Garber out there in the wilds of Bucks County teaching his grandchildren how to lay a trapline! I believe Garber was essentially an Emersonian transcendentalist, but with a dash of Eakins and PAFA realism thrown into his work, and a touch of narrative here and there. But take a look at Garber's gorgeous painting *South Room—Green Street* (1920, Corcoran Gallery of Art), or any number of others where light and space seem to radiate with spiritual energy, and then look at mature Redfields and Schofields, and the differences are profound. Interestingly, Garber, like Inness, also disliked Impressionism, probably for the very reasons that Redfield and Schofield liked it—that plain-speaking, what-you-see-is-what-you-get, down-home-American-pioneer-spirit way of thinking.

FOSTER: Well, Garber wasn't keen on painting outdoors in cold weather, and he didn't show enthusiasm for Redfield's athletic, "all at one go" method. He was a much more contemplative painter,

Left: **Bridge to Village**, c. 1925–35, by Walter Elmer Schofield (Private Collection); below: **The Hanged Man's House**, 1873, by Paul Cézanne (Musée d'Orsay, Paris) © Gianni Dagli Orti/The Art Archive at Art Resource, NY

with smaller, shorter strokes and premeditated compositions. Schofield was somewhere between the two. I see Garber's sensibility, in particular, in the abstraction of Schofield's big salon compositions. They have very self-consciously decorative surfaces, which in those days was understood as admirably progressive. And they both liked these "climbing" compositions that flatten space and bring the distance forward to the surface of the painting—a classic Postimpressionist strategy.

DOLAN: *Bridge to Village* (c. 1925–35), with its curving road that brings the viewer into the picture, is an example of a Cézannesque painting by Schofield. I'd compare it to a painting that Paul Cézanne made in 1873, when he first began to work with Pissarro, called *The Hanged Man's House*. There is a ribbon of road that falls down into flatness. And the high horizon line is something that Pissarro used all the time. Cézanne did more of something like this—where he got up high

and you don't enter into the scene, you overlook it. What we see immediately with Cézanne is this will to construct, not to dissolve everything in the way that Monet did, especially in his later works.

The Bridge Inn, by 1929, by Walter Elmer Schofield
(Fine Arts Collection of The School District of Philadelphia)

MCCAY: As I've come to know Schofield's paintings, I've come to admire his ability to create a strong sense of place, with the distortion of space being only one component of his ability to create a unique atmosphere. The School District of Philadelphia's *Bridge Inn* (by 1929) has a similar vertical component to *Bridge to Village* (c. 1925–35; ill. p. 63) but the sense of place is completely different.

PETERSON: "Sense of place" is a crucial concept to understanding Impressionism's hold in America. It occurs to me that, in a way, the Impressionist movement in America was a bit like the early Renaissance, when, for example, you saw biblical parables depicted on Lake Geneva. Back then it was a matter of civic pride to have Jesus walk on water in Switzerland; here, everybody who was anybody had to get in on the Impressionist action. There's a sense that every community had to have its own claim on Impressionism. But is there a specific, recognizable stylistic identity that characterizes each of these places? Are there stylistic traits specific to Old Lyme or Cos Cob (Connecticut), or to Brown County (Indiana), or to Carmel or Laguna Beach (California)? Is there an "ism," in other words, associated with each of these locales, linked to each of these places? I think that when you look at Schofield, Redfield—all of these painters—you have to ask that question.

Now there's another question, which we've pointed out several times. These guys were members of a club. They often studied in the same places, and they hung out at the Salmagundi Club in New York, and the Sketch Club in Philadelphia. They were buddies. They were also very good at the pure mechanics of being artists. If you look at the checklist of the Panama Pacific International Exposition of 1915—this is about the most ambitious feat of art administration I've ever seen—something like eleven thousand paintings were there, from all over the world. And the participation from Philadelphia was extraordinary. How did they get so good at getting their work out there? On the other hand, we hear about all the gossip between them, and there are all the letters—sometimes they seem like little kids fighting in a sandbox.

The typical path was, first, journey to an urban center such as Philadelphia or New York, study at one of the academies with an American teacher of some renown, and then, to get the necessary "street cred," go to one of the European meccas, usually France. Monet's famous home at Giverny might as well have been an American embassy for a while. Dozens of American painters made pilgrimages there: Theodore Robinson, Metcalf, Frederick Carl Frieseke—one of them, Theodore Butler, even married Monet's stepdaughter. So they go to these places, they absorb certain kinds of values, certain ways of doing things. They come back and spread across the land, and the art colonies are born, but again, to what extent was the work they made specific to the places where they ended up? Or were they—and particularly Schofield, who was constantly on the move—carpetbaggers in a certain sense, bringing with them certain attitudes and mindsets that were essentially superimposed on the local geography? And then they went back to New York, Chicago, Boston, and Philadelphia, and had their shows in the galleries and museums there.

To me there's a dynamism to this story, and these issues can be discussed about pretty much any artist or group of artists: To what extent is an artist an individual voice, operating in a solitary manner, according to his or her own interior imperatives? At the same time, to what extent is an artist a

member of a community? To what extent is an artist influenced, nourished, helped, and supported by a society of like-minded people who all have similar goals—who are trying to pay their bills, as Kathy rightly pointed out? They need each other to do that, but they're also fighting with one another, just as brothers and sisters often squabble. The dynamism occurs between the individual voice and the communal voice.

My sense of what's needed now in terms of the scholarship about Bucks County artists, and maybe beyond that as well, is a kind of maturity. In other words, we need to get at the truth of the individual artists as best we can, based on the actual evidence, evidence in the pictures—evidence, as we're giving here, in the documentation. But we also need to see them as part of a larger movement of cultural history, and really look at the big picture, too. The movement of history is not just what's going on in the art world. There's a long-term, ongoing evolution in the way the Western mind looks at reality, and Schofield is very much a part of that. The challenge for scholars is to cleave to the particular, to really take a hard, disciplined, and unbiased look at the individual as an individual—but also, at the same time, to cast an eye on the general, that is, how the story of the individual is folded into the vast sweep of intellectual, cultural, and psychological history. I feel that the Bucks County story is a model—an archetype, even—of how this dynamism plays itself out in real time, in real people's lives.

LIVINGSTON: The rivalries between them were linked to strongly held ideas about how to construct a painting, and specifically a landscape. William Merritt Chase says, if there's a tree in your way, move it so the design is beautiful and your landscape is where you want it to be. Henri says, if that tree is in the way, paint it. The whole American landscape comes from those two.

VALERIO: And where does Schofield fit into that? I ask because there's a great 1908 diary entry by Sloan in which he describes a painting by Schofield on view at the National Academy. He wrote, "Schofield has a thing that I didn't care for much, all mannerism."[26] I thought that was a very interesting comment that cuts to this question of composing in a seemingly naturalistic way, or with artifice, in a "mannered" way.

FOSTER: I'd love to see that picture.

CHURCH: That would have been *Winter on the Somme* (c. 1907).

VALERIO: It's funny because that painting is constructed with a tight, dynamic, and obviously "mannered" geometric composition, but the earth tones and "realist," textured paint are qualities I would have expected Sloan to like.

LIVINGSTON: For Schofield and the Pennsylvania painters, the Henri approach to realism is always there.

VALERIO: I agree that Schofield's paintings are mostly constructed and composed in space; they don't strike me as entirely "natural." But an aspect of Impressionism is its constructed, mannered quality, as in the dramatic distortions of Degas or the complex spatial relationships of Manet or Monet. Terry, as the expert at the table on French Impressionism, can you comment?

DOLAN: Well, as we've already discussed, it's hard to define one "Impressionism" because it was a very complicated, very short-lived formal movement. It was given its name in 1874. By 1880 the Impressionists had ceased to exist as a group because Monet and Renoir and others went off in their own directions. The only

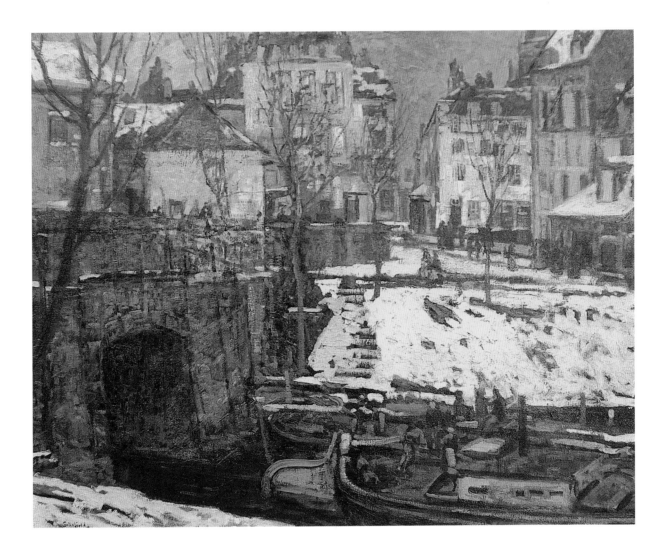

Winter on the Somme, c. 1907, by Walter Elmer Schofield
(Private Collection) Photograph courtesy of Gratz Gallery

one to exhibit at all eight Impressionist exhibitions was Pissarro; Pissarro I think was a very big thing for Schofield. We've already discussed his painting *Red Roofs* (1877; ill. p. 48). Cézanne (who is so tied to Pissarro) and Monet were also important for Schofield. Their "touch" is all so different.

Looking at Schofield's Cornish paintings and his placement of the high horizon, I think of Cézanne's paintings with high horizons, like *Bay of L'Estaque* (1879–83). It "overlooks"; you're not inserted in the landscape. The high horizon line creates a flatness and a two-dimensionality that departs from classic notions of Impressionism. The sensibility of distortion is really Postimpressionist. You can see this in Schofield's painting *Cliff Shadows* (1921).

What really interests me about Schofield is that he studied with Bouguereau. I'd like to see his earlier paintings. I'm with Kathy—I want to see where he was coming from and where he was going, because Bouguereau was the quintessential academic painter that all the modernists turned their backs on. The high-keyed chiaroscuro of Bouguereau may very well be something that Schofield maintained throughout his career. When he was at the Académie Julian, Redfield wrote, "I studied with Bouguereau. But you can't learn painting in art schools. Besides, our gods were painters like Degas and Monet."[27] So Redfield and Schofield turned their backs on academic painting as the French Impressionists did. They also developed in a manner that's similar to Gustave Courbet in its broadness and its thickness and its boldness. Courbet died in 1877, but he was still an influential figure at that time. That's why I asked about the palette knife: he often used one. It's also why I like that Brian is bringing in the different regional configurations of Impressionism in America.

VALERIO: It's interesting to think about the broad sweep from Courbet to Cézanne, with so many artists like Schofield caught in their spell. Kathy and I worked with the wonderful scholar Robert L. Herbert, whose ideas about realism and Impressionism are talked about in the Met's catalogue.[28] Herbert describes that Impressionism's underpinning was the literary concept of naturalism: a naturalist's view of the world that is somewhat detached, but at the same time, convinces of a "natural" subjective impression of some thing or phenomenon that exists in space. It's a very broad, complicated definition that can embrace artists like Eugène Boudin, Courbet, and Cézanne— French realist, Impressionist, and Postimpressionist painters alike. In French paintings, there's a shift in the 1890s with the concept of the "synthetic," or synthetism, which ushered in a willingness to distort and to invent an abstracted view of reality, a new paradigm.

DOLAN: Well, Herbert is also interested in social history and ideas of city painting versus country painting. For the New Hope artists, it was more about country painting, and maybe specifically the work of Pissarro, Monet, and Cézanne. Monet was a true landscape painter after 1882—there are hardly any figures in his canvases thereafter—whereas Renoir, mostly a city painter, became a classicist and a portraitist.

LIVINGSTON: An important moment for the young Schofield has to have been the 1893 World's Columbian Exposition in Chicago. French Impressionism was a sensation in America from that moment.

FOLK: Yes, it was when Impressionism became accepted internationally.

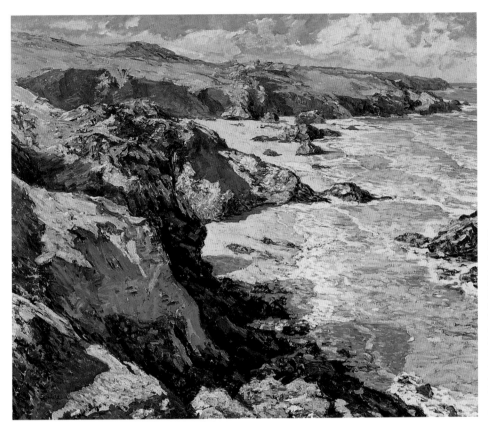

Left: **Cliff Shadows**, 1921, by Walter Elmer Schofield (Corcoran Gallery of Art, Washington, D.C.: Museum Purchase, Gallery Fund) Photograph courtesy of Corcoran Gallery of Art, Washington, D.C.; below: **Bay of L'Estaque**, 1879–83, by Paul Cézanne (Philadelphia Museum of Art: The Mr. and Mrs. Carroll S. Tyson, Jr., Collection, 1963-116-21) Photograph courtesy of Philadelphia Museum of Art/Art Resource, NY

DOLAN: It's also when Paul Durand-Ruel brought Impressionism to New York. His first shows of French painting in New York took place as early as 1886.

VALERIO: Schofield went to Durand-Ruel's gallery in New York. It's in Sloan's diary. He also owned a print of a Monet painting, *Le Dejeuner* (1868; ill. p. 99), he obtained there.

DOLAN: Another aspect of our discussion of Whitman and Schofield's "masculinity" is that Impressionism was "gendered" as feminine in the late 1880s. As Impressionism moved into Symbolism, the art critics of the time pinned the demise of the movement on the Impressionists' dependence on color over line. Téodor de Wyzewa, Camille Mauclair, and Roger Marx—all influential

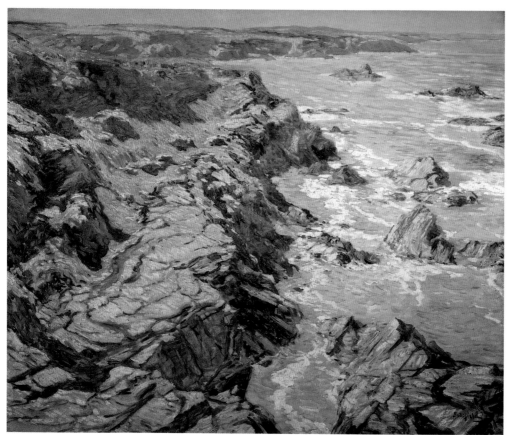

Morning Tide—
Coast of Cornwall,
c. 1920, by Walter
Elmer Schofield
(Woodmere Art
Museum: Gift of the
Estate of the artist
through Mrs. Herbert
Phillips, 1952)

critics writing in France in the early 1890s—pinned Impressionism's decline on what they saw as its "feminine" characteristics of dependence on sensation and superficial appearances, its physicality, and the capriciousness of its flickering brushstrokes.

VALERIO: Of course, these are all antiquated ideas about gender that all too often persist, I'm sorry to say, but they are fascinating. I have to imagine that back in the 1890s and the first decade of the twentieth century, the young Schofield of Philadelphia had to figure out a way to transform the perceived delicacy or even femininity of Impressionism, as you describe it, into something of his own that suited the machismo

of his American, outdoorsman's sensibility. He eventually arrived at a way of making images that are linear and solid, on the one hand, and painterly, mannered, and spontaneous on the other. I feel this especially in his Cornwall paintings of churning oceans and rocky cliffs from the 1920s and 1930s. Here again I can only think of Monet at Étretat, and the constant return to places identified with "primordial" rock and ocean. I think it's no accident that *Morning Tide—Coast of Cornwall* (c. 1920) and *A Rocky Shore* (1924), a Maine landscape, are depictions of magnificent geology with no houses or people. This is just after Schofield's experience of World War I, and he shows us a world with no trace of humankind's interference in nature's

A Rocky Shore, 1924, by
Walter Elmer Schofield
(Private Collection)

order. There are about fifty paintings of the
Cornwall cliffs that we know by him as well as
wonderful depictions of Maine.

DOLAN: These are like the Étretat paintings.

VALERIO: It's the world untouched by modernity.
At a certain point after the war, Schofield turned
away from the interaction between nature and
humanity that seemed central to his earlier work.

DOLAN: Again, I think Cézanne is a relevant voice
here: he had a powerful presence as an artist who
constructed, built, and gave solidity to a mysterious
vision of nature. That's the difference between
Schofield's Cornwall paintings, where he built up a

sculptural entity, and Monet's work, in which he had
a tendency to dissolve the surface. They're both
concerned with the rock, but the treatment is totally
different. They're both poetic, but it's about mood.
This is really about vigor, about the touch and the
solidity.

PETERSON: I'm going to toss in my two cents here
and agree with Terry; yes, Schofield was looking at
the same kind of subject matter as Monet, but the
treatment is very different. The mindset behind it is
different. Cézanne is the interesting touchstone.

VALERIO: The artist Peter Paone, my good
friend, commented on the influence of Cézanne
on Schofield's early painting *Zennor Cove—Coast*

Trenwith—Cornish Farm, by 1932, by Walter Elmer Schofield
(Woodmere Art Museum: Museum Purchase, 1946)

of Cornwall (1903; ill. p. 53). He commented that Schofield embraces Cézanne's visual language, where architecture and nature interact with one another. He also noted the apparent influence of Vincent van Gogh in the striated strokes he used. It appears as if he were drawing with lines of paint.

PETERSON: Yes, but I think the other point about Cézanne is that he was studying, in those locales depicted in his landscapes—there's passionate observation, though he's abstracted them a bit. And they're "geometricized."

DOLAN: Right, I would agree.

PETERSON: I can see Cézanne in *Trenwith—Cornish Farm* (by 1932). It's not obvious, but there's a geometry in the way he's placed the houses, a structuring of reality.

VALERIO: *Trenwith—Cornish Farm* is a strong painting not only because of the constructed way Schofield has "built" the composition, but also because of the complexity of detail: crenelated stone walls, chickens in the yard, fencing and stone elements that are as painterly as they are specific. All the details express nostalgia for a simpler world. There's not a phone line or a sign of electricity.

PETERSON: Well, just think about what was going on in the world at that time, in 1932. That's when Hitler was about to take over Germany. Those were nasty times to be alive, and things were going to get a lot worse. So there's arguably an element of nostalgia in Schofield, but whether or not that's a direct kind of symbolism, I don't know. Either way, this is not a guy who's painting like Raphael Soyer.

VALERIO: Nor does he seem to continue to heed his friend Henri's imperative to paint the subject matter of his age.

PETERSON: Right, and there was significant pressure on artists in that period to create work that was directly political, that related to the suffering of human beings. There was something a little suspicious about you if you were aloof from those kinds of concerns.

FOLK: Don't you think he had fought his war—World War I—and by the 1930s he saw the world passing into new phases of strife, and so he painted anything he felt like at that point?

FOSTER: He was sixty-five years old. He was just going to paint what he wanted to paint.

FOLK: I also think he felt the art world passing him by. Modernism and abstraction weren't his thing, so he painted what made him happy.

PETERSON: Tom, what did Schofield sell a painting for in the 1920s or '30s?

FOLK: In 1921 he had an exhibition at Macbeth Gallery in New York where a painting was priced at $3,000, but most were around $1,800. In 1927 he had an exhibition at the Milch Gallery in New York. The highest-priced painting was $2,000. Most were around $600. So there was quite a range of prices. More importantly, during the Great Depression his prices were even higher. For example, at the 1931 exhibition *Paintings by W. Elmer Schofield* at the Corcoran Gallery of Art in Washington, DC, his highest price, for a painting titled *Freshening Breeze* (date and location unknown), was $5,000. Six other paintings in that exhibition were $4,000, and his lowest price was $800. Of course, sizes are rarely indicated in these checklists.

CHURCH: The prices varied enormously over his career, with *Winter* (1899; ill. p. 32) sold to PAFA for $200 in 1899, *Across the River* (c. 1904; ill. p.

Morning Light,
Tujunga, 1934,
by Walter Elmer
Schofield (Woodmere
Art Museum: Gift
of Leigh and Sally
Marsh, 1992)

50) sold to the Carnegie for $1,500 in 1905, *The White Frost* (1914; ill. p. 45) purchased for $2,500 in 1915 by Dr. and Mrs. Rudolph H. Hofheinz (this is bigger, though—fifty by sixty inches), and then *Cliff Shadows* (1921; ill. p. 69) purchased for $4,000 by the Corcoran in 1921 and *The Rapids in Winter* (c. 1919; ill. p. 5) was purchased by the "head" of a museum in 1923 for $3,500. These were amongst the highest prices he ever achieved. Generally, these prices were exceptional. This is also his very finest work. The $600 pictures in later years were small, twenty-four inches or so.

VALERIO: Those are good amounts of money. Can I ask that we talk about his later California paintings? I've always loved *Morning Light,*

Tujunga (1934). I think one of the exciting parts of the exhibition will be this group of works, including *Purple Mountains* (1934; ill. p. 14) and *The Canyon, Tujunga* (1934). The paint is really alive and spontaneous. He was having some fun with color at the expense of the structure that's so evident in his earlier work. Is there a new "free modernist" phase happening in these California paintings?

FOLK: If he was a modernist, he didn't know it. He wasn't doing this to be a modernist painter.

PETERSON: It's worth keeping in mind that European modernism, and modernism in general, was pretty much rejected by American painters in

The Canyon, Tujunga, 1934, by Walter Elmer Schofield (Gift of Muriel and Philip Berman, Permanent Collection of the Philip and Muriel Berman Museum of Art at Ursinus College)

the 1930s, when Schofield created most of these California paintings. There were a few artists, but it wasn't considered the hip thing to be doing.

FOLK: And the important thing is that by the '30s he wasn't doing as many big paintings. He didn't have to sell to make a living and a reputation.

CHURCH: In Los Angeles, he was selling his work via Stendahl Art Galleries, and in New York, through Grand Central Art Galleries. Although he was still producing canvases at forty by forty-eight inches or larger, his main income was from works at smaller, "over-mantel" sizes, thirty by thirty-six inches or twenty-six by thirty inches, which sold more readily. It was a concession to necessity.

On the subject of modernism, Elmer gave a radio interview in 1934 in which he stated:

> Today, Modernism, which takes many forms of expression, has aroused varied feelings in the artistic circles. Ridicule on the one hand and great enthusiasm on the other. Personally, I feel that modern art, as it is called, is a very vital necessity . . . I am reminded of that new discovery insulin, which is in its action like the Modernist trend in art. Insulin, you know, counteracts too much sugar in the blood.[29]

PETERSON: That is an interesting comparison. There's also a sense of freedom in these paintings.

FOLK: There's a freedom, yes.

Left and below: **Untitled**, 1917–21, by Walter Elmer Schofield (Collection Brandywine River Museum of Art. Gift of Mary Schofield, 1990, in appreciation of the work of the Brandywine Museum) Both photographs courtesy of Brandywine River Museum of Art

DOLAN: There's a playfulness, and I noticed this one is oil on board rather than on canvas—

FOLK: Yes, he did a lot on board at that time.

CHURCH: Some on Masonite, but often unprimed plywood in the 1930s and '40s.

FOSTER: Turning to the drawings from the Brandywine River Museum of Art, you can see the process of Schofield composing, bracketing his scenes of the Cornwall coast. You can see him thinking about them as compositions. There's a premeditated quality to these, and of course, the earlier works are salon paintings, too, for the big exhibitions. Looking at the later *Morning Light, Tujunga* (1934; ill. p. 74) in Woodmere's collection—I think this is him becoming an Impressionist, in the

Ponds in Autumn, Godolphin, c. 1940, by Walter Elmer Schofield (Collection of Martin Stogniew)

most classic fashion: just setting his canvas up and just going at it without premeditation. The earlier pictures are composed and contrived. They're very thoughtful. Monet always said, you're not supposed to plan ahead, you're just supposed to go out and plant your easel, paint what you see, and not think about organizing the composition.

DOLAN: Yes, Monet says, look at the world as if you were a man who was born blind and suddenly were given sight. Here's a patch of blue, here's a patch of yellow—that's what Schofield did here.

FOSTER: It's got spontaneity. It's not as geometrically organized as these others—it's more informal and playful, as you said. He was just exploring it. Tom, I think your point is

the right one. These are not meant for major exhibitions. He was doing it for his own pleasure and adventure. They have a completely different feel than his big salon pictures.

PETERSON: I think that's a cool point that by the 1930s and '40s he became an Impressionist. [laughs]

DOLAN: Yes, isn't that funny?

FOSTER: That's what it looks like to me!

VALERIO: The newly dubbed "Impressionist" phase continued through the end of Schofield's career, with wonderful paintings like *The Ponds, Godolphin* (c. 1939; ill. p. 29) and *Ponds in Autumn, Godolphin* (c. 1940). His son Sydney bought a great manor house called Godolphin, in Cornwall, in 1937.

Schofield moved there, lived there, and painted there, creating works such as *Gwedna Woods* (1940) and *The Hayricks* (c. 1940). The Godolphin paintings have a freedom. They've got the immediacy that Kathy described. With Woodmere's dedication to Philadelphia's artists, I can't think of the late Schofield paintings without thinking of subsequent landscape painters such as Neil Welliver or John Laub, the Fischbach Gallery artists.

CHURCH: The family story is that Elmer and Sydney discovered the house together on a painting expedition in Cornwall, and by chance heard of it being up for sale. Sydney had to hire a train to bring the contents of the High House, his Red Poll cattle, and his Suffolk Punch draft horses down from Suffolk.

FOSTER: They're smaller pictures, too—easier to finish quickly, though some of these later ones, like *The Hayricks*, recover that sense of Postimpressionist order underlying the composition.

PETERSON: Tom, do you think Schofield would be associated with Bucks County without that statement by Du Bois? He said Schofield and Redfield were the pillars of the New Hope School, but in the same breath he said that George Gardner Symons was an archetypal New Hope painter, and as far as we know, Symons never set foot in Bucks County.

CHURCH: Symons was a friend of Elmer's from his St. Ives days. He painted extensively in Massachusetts and California, but not in Pennsylvania as far as I know. They maintained their friendship until Symons died, in 1930. I doubt Elmer would have ventured to California without knowing Symons and William Wendt.

Gwedna Woods, 1940, by Walter Elmer Schofield (Gift of Muriel and Philip Berman, Permanent Collection of the Philip and Muriel Berman Museum of Art at Ursinus College)

FOLK: But I think Schofield was closer with Symons. I've seen correspondence between them, and two works by Symons were in the collection of Peg Phillips, which indicates an exchange of paintings. They exhibited together in California, at the Stendahl Art Galleries. Schofield did a lot of socializing there, and he even held painting classes at the marina. Although Schofield and Symons were friends, I don't think Symons was in Bucks County at all, really. As James has said, both were also acquainted with Hayley Lever, another landscape painter who was exhibiting at the Stendahl Art Galleries in the 1930s.

PETERSON: And Schofield was only marginally connected to Bucks County.

VALERIO: Did Schofield ever participate in any of the Phillips Mill or New Hope exhibitions?

PETERSON: I don't think so.

FOLK: No, Phillips Mill began in 1929.

VALERIO: Is there a Bucks County subject after 1910 in Schofield's work? Many of the later forest scenes from Pennsylvania are of the Wissahickon, which he painted from his brother's house here in Chestnut Hill. Peg Phillips describes how

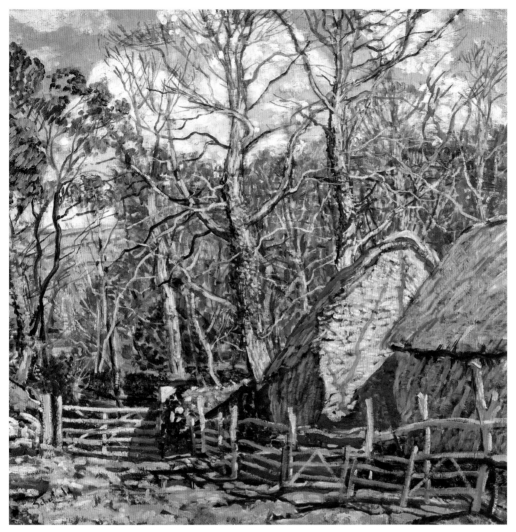

The Hayricks, c. 1940, by Walter Elmer Schofield (Gift of Muriel and Philip Berman, Permanent Collection of the Philip and Muriel Berman Museum of Art at Ursinus College)

Wissahickon in Winter (c. 1920; ill. p. 17) always hung in their home on West Moreland, something of a centerpiece of the house.

FOLK: There's a story: Sometime in the 1920s, Schofield went to Bucks County to borrow paintings from Lathrop for an exhibition, but Lathrop wasn't home and he just took the paintings he wanted anyway. As far as Pennsylvania artistic friendships developed, Walter Baum had great respect for Schofield, and often visited him when Schofield returned from Europe. In fact, Baum named one of his sons Elmer Schofield Baum.

CHURCH: Even when he was in England he described himself as a Philadelphian. He painted around

Pennsylvania, but his identity was wrapped up with the city of Philadelphia, the city of his birth. This, at least, is the way members of his family knew him.

PETERSON: I wanted to add one comment. We talked about the Pennsylvania Impressionists and what's needed in their study, and I think we're at a crucial moment. Here's another angle on that. If you go back almost twenty years, Tom had just written his pioneering book, *The Pennsylvania Impressionists* (1997); this got the word out. If you look at the careers of these painters in their lifetimes, they were absolutely stellar, amazing, for American painters—world-class careers. In the eyes of their peers, they were top-drawer artists. That proves my point. Then, for whatever reasons, their work went in

the basement. We talked already about the cultural climate and context of the 1930s. Jump ahead sixty years and there was a situation in the late 1990s and early 2000s where there was a need for the kind of boosterism that sometimes happens in the process of assessing artists. There was a feeling that these were artists of substance, that many of them may have been overlooked by history, and that they needed a boost. I think we've reached the point now where that boosterism is unnecessary.

VALERIO: Galleries such as Jim's of Lambertville played a role in this new evaluation, as did private collectors like Marguerite and Gerry Lenfest. The Lenfests' extraordinary gift of their collection to the James A. Michener Art Museum in 1999 essentially created a "place" for these artists.

PETERSON: On a related subject, you asked about the term "Pennsylvania Impressionists." I'd like to see the term "New Hope School" used again.

VALERIO: Instead of the term "Pennsylvania Impressionism"?

PETERSON: Correct. Because historically, when was it first used, Tom?

FOLK: I started using it to refer to the artists in my exhibition, *The Pennsylvania School of Landscape Painting: An Original American Impressionism* (Allentown Art Museum, 1984). A couple of other writers referred to some of the major painters, like Redfield, Schofield, and Garber, as Impressionists before me: Richard Boyle in 1974 and William H. Gerdts in 1980.[30] But I was the first to call the group Impressionists.

PETERSON: Right, and I understand that, because it was necessary. We've popularized the term as well by using "Pennsylvania Impressionism" at the Michener.

FOLK: Yes.

PETERSON: My point is that now there's an opportunity to step back from "rooting for the home team" and ask hard questions—as is happening here with Schofield—and to simply try and get at the truth. I think it's important to look at Schofield as his own voice, and to consider not only how he is connected to the Bucks County group, but also how he is just as much a creature of Cornwall, France, and New York, and the broader spectrum of twentieth-century art.

VALERIO: I think Schofield is such an interesting test case because he's so much associated with Pennsylvania Impressionism—or rather the New Hope School—and yet after 1904, it seems like he had little to do with the art community with its roots there.

FOLK: You know, why not call them the "Pennsylvania School of landscape painting," as Du Bois did in 1915?[31]

PETERSON: That's true. "Pennsylvania Impressionism" was perhaps necessary nomenclature early on in the scholarly process, but it may not be necessary anymore.

FOLK: You might be right.

CHURCH: The artists were mostly Philadelphia-educated PAFA students, but really individuals, each with a unique way of translating that outlook. In my great-grandfather's career, his allegiances were truly international. One of the achievements that made Elmer most proud was that the French government purchased one of his paintings, *Morning Light* (1922). It was transferred to the Musée d'Orsay in the late 1980s and is now in the Château de Blérancourt. I'm sorry it's not going to be here for the exhibition, but I'm glad we will have its close "cousin," *Morning* (c. 1923).

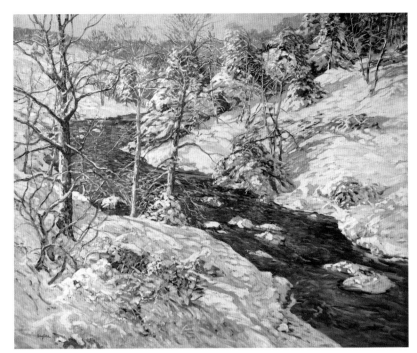

Left: **Morning**, c. 1923, by Walter Elmer Schofield (The Collections of Hobart and William Smith Colleges) Photograph courtesy of the Collections of Hobart and William Smith Colleges; below: **Morning Light**, 1922, by Walter Elmer Schofield (Château de Blérancourt, France, on deposit from the Musée d'Orsay) © RMN-Grand Palais/Art Resource, NY

FOLK: Some early significant artists from this group had studied in New York, including Rosen, Spencer, Martha Walter, and Bredin, in particular.

PETERSON: All these artists can stand on their own and look fine in any museum.

FOSTER: I would vote for freeing Schofield from Pennsylvania Impressionism.

FOLK: It's hard to disassociate Schofield from Pennsylvania Impressionism because, throughout his life, he shared a continuing dedication to large-scale Impressionist landscapes. As we've discussed, it's possible to mistake a Schofield painting for a Redfield.

FOSTER: But in a way, part of his obscurity is the result of our wish to put people in categories, either regional or national. Many American artists painted between two countries and also fell into a kind of crevasse because they're, say, neither completely British nor fully American—I would cite Benjamin West and Edwin Austin Abbey, for example. So, in a way, we just need to lift the artists above all these categories and labels, which are driven by a kind of marketing and local boosterism—which isn't necessarily a bad thing, but it does tend to pigeonhole artists, at the expense of a fuller picture.

VALERIO: Well, this has been a very complex, rich conversation. I would venture that our collective observations construct a fuller picture of Schofield than we've ever had before. Let me thank everyone for their contributions to the flow of ideas around the table!

NOTES

1 Students had to take the Antique Class first; then they "graduated" to the Life Class "upon recommendation of the Instructors, and upon the approval by the Committee of a drawing or drawings executed by them in the Academy, and representing the entire human figure." *Circular of the Committee on Instruction 1891–92* (Philadelphia: Pennsylvania Academy of the Fine Arts, 1891).

2 This photograph has been dated to the autumn of 1892. See Bennard B. Perlman, *Painters of the Ashcan School: The Immortal Eight* (New York: Dover Publications, 1988), 40.

3 "Was quite delighted a few days ago to see Reddy walk in looking like some railroad millionaire. He and Schofield went down to Brolles last Tuesday for two months." Hugh Henry Breckenridge, Paris, to Robert Henri, December 2, 1892. Robert Henri papers, Beinecke Rare Book and Manuscript Library, Yale University.

4 Schofield to Robert Henri, November 18, 1915. Robert Henri papers, Beinecke Rare Book and Manuscript Library, Yale University.

5 Schofield to Robert Henri, December 10, 1916. Robert Henri papers, Beinecke Rare Book and Manuscript Library, Yale University.

6 Charlotta Taubman Redmayne to Schofield, March 29, 1911. Schofield Family Archive (formerly Godolphin House, Cornwall, United Kingdom).

7 L. W. Miller to Schofield, November 22, 1898. 1897–1901 Scrapbook, Schofield Family Archive (formerly Godolphin House, Cornwall, United Kingdom).

8 "Will you accept two hundred from academy for *Winter* Please Answer, H. S. Morris." Harrison S. Morris to Schofield. Schofield Family Archive (formerly Godolphin House, Cornwall, United Kingdom).

9 Jules-Antoine Castagnary, "L'Exposition du boulevard des Capucines: Les Impressionistes," *Le Siècle*, April 29, 1874.

10 Claude Monet, as cited in Katherine Rothkopf, *Impressionists in Winter: Effets de Neige* (London: Philip Wilson Publishers, 1998), 84.

11 As cited in Thomas Folk, *The Pennsylvania Impressionists* (Madison, NJ: Fairleigh Dickinson University Press, 1997), 56.

12 Théodore Duret to Camille Pissarro, December 6, 1873, as cited in *Pissarro, ed.* Françoise Cachin (London: Arts Council of Great Britain, 1980), 43.

13 Edward Willis Redfield, interviewed by Robert H. Lippincott, *Bucks County Realtor Magazine*, March 4, 1963. http://soleburyhistory.org/edward-w-redfield-1/. The Carnegie Institute is now the Carnegie Museum of Art.

14 Schofield to John Sloan, November 18, 1904. John Sloan Manuscript Collection, Delaware Art Museum.

15 Edward Willis Redfield to Robert Henri, October 25, 1904. Robert Henri papers, Beinecke Rare Book and Manuscript Library, Yale University.

16 John Sloan, *John Sloan's New York Scene: From the Diaries, Notes, and Correspondence, 1906–1913*, ed. Bruce St. John (New York: Harper and Row, 1965), 77.

17 "Schofield is the private agent (confidential) of the Carnegie Institute, Pittsburgh, in England, France and Germany this year. He is to watch out for good paintings in the foreign exhibitions and let [John] Beatty [director of the Carnegie Institute] know of them." Sloan, *John Sloan's New York Scene*, 307. David Tovey suggested that Schofield might have fulfilled such a role in *Pioneers of St Ives Art at Home and Abroad (1889–1914)* (Tewkesbury, UK: Wilson Books, 2008), 312.

18 Muriel Schofield to Schofield, October 17, 1905. Reel 5043, Walter Elmer Schofield Papers, Archives of American Art, Smithsonian Institution. See also Tovey, *Pioneers of St Ives Art at Home and Abroad*.

19 Sloan, *John Sloan's New York Scene*, 77.

20 Ibid., 203.

21 "Schofield came in on his way back to England. I took him up to the show [*The Eight*] which he said was fine, though he was not enthusiastic over Prendergast's or Davies's work. We came back, Dolly came in, and we waited for Henri to go to dinner with Scho." Ibid., 193–94.

22 Sylvia Yount, "'In Education, Comradeship, and Common Aims': The Bucks County Painters and the Pennsylvania Academy of the Fine Arts," in *Pennsylvania Impressionism*, ed. Brian H. Peterson (Philadelphia: James A. Michener Art Museum and University of Pennsylvania Press, 2002), 57–70.

23 Harrison S. Morris, "Philadelphia's Contribution to American Art," *Century Magazine* (March 1905): 726.

24 C. Lewis Hind, "An American Landscape Painter: W. Elmer Schofield," *International Studio* 48, no. 192 (February 1913): 284.

25 Burt Barnes papers, 1909–1977, Archives of American Art, Smithsonian Institution.

26 Sloan, *John Sloan's New York Scene*, 271.

27 Folk, *The Pennsylvania Impressionists*, 42.

28 H. Barbara Weinberg, Doreen Bolger, and David Park Curry, *American Impressionism and Realism: The Painting of Modern Life, 1885–1915* (New York: Metropolitan Museum of Art, distributed by Harry N. Abrams, 1994).

29 Schofield Radio Transcript A, October 1934. Schofield Family Archive (formerly Godolphin House, Cornwall, United Kingdom).

30 Richard J. Boyle, *American Impressionism* (Boston: New York Graphic Society, 1974); William H. Gerdts, *American Impressionism* (Seattle: Henry Art Gallery, University of Washington, 1980).

31 Guy Pène du Bois, "The Pennsylvania Group of Landscape Painters," *Arts and Decoration* 5, no. 9 (July 1915): 351–54.

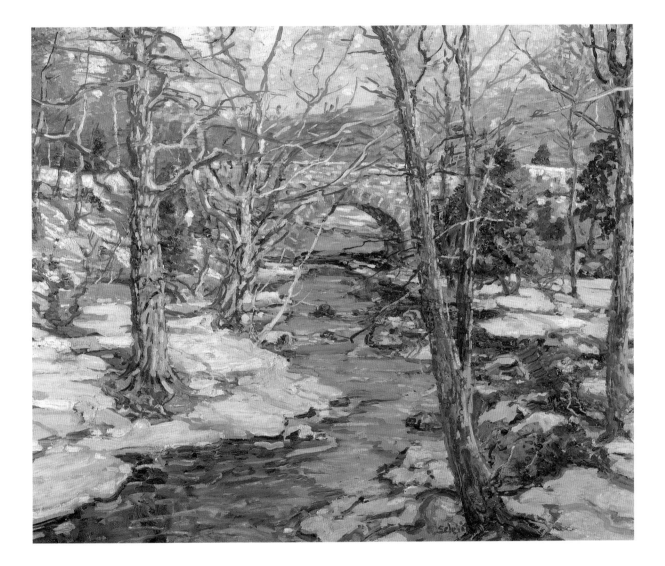

Snow Stream, c. 1930, by Walter Elmer Schofield
(Collection of Marguerite and Gerry Lenfest)

On Monday, April 7, 2014, Sally Larson, Woodmere's Deputy Director for Collections and Registrar, visited the studio of paintings conservator Steven B. Erisoty to talk about the art and science of conservation and his particular approach to cleaning *Morning Tide—Coast of Cornwall* (c. 1920), one of several works by Walter Elmer Schofield in the Museum's collection.

SALLY LARSON: Steven, you and I have known each other for years, and you've worked with Woodmere on many conservation projects. I have to say, every time we work together I learn something new.

STEVEN B. ERISOTY: That's so nice to hear.

LARSON: We're here in your studio and in front of us is *Morning Tide—Coast of Cornwall*, a very large painting that you've just finished conserving. Over the last several months we've had ongoing conversations about Schofield's paintings. We talked a lot about linings and wax layers, paint loss, crackle, grime—a lot about grime. [laughs] But we kept coming back to the subject of respecting the original intent of the artist. Before you begin work on a painting, how do you go about deciphering what that might have been? Is it a question of art history, or science, or both?

ERISOTY: It's both, because they intersect all the time. But the best place to start thinking about Schofield and his intentions is probably in the art historical sense. Artists like Claude Monet and Pierre-Auguste Renoir, who were the vanguard artists of Schofield's time and his likely inspirations, were about light, brightness, color, and direct application of paint. Like Schofield, they worked in oil paint, and they rejected the centuries-old tradition in Western

art of constructing an image with subtle, transparent layers and glazes, and using saturated darks to heighten the contrast—and then using varnish to heighten it even more. Instead, the goal was color and directness, immediacy; seeing the artist's hand at work in front of you: the bold brushstrokes! The range of subtlety and expression in the stroke was the important element.

Like the French artists of his time, Schofield painted in a direct way. He used bright colors and subtle gradients of mid-tones. In this particular painting, you can see his bold, beautiful brushwork; the paint is rich, thick, textured. When he was finished with a painting, that's what he wanted it to look like. He was done. He didn't want to add saturation or subtleties, or to manipulate the surface further with layers of varnishes and glazes. How do we know this? Well, it's

Morning Tide—Coast of Cornwall, c. 1920, by Walter Elmer Schofield (Woodmere Art Museum: Gift of the Estate of the artist through Mrs. Herbert Phillips, 1952)

Detail of **Morning Tide—Coast of Cornwall**, showing the painting before cleaning and treatment (left side) and after cleaning and treatment (right side). Photographs courtesy of Steven B. Erisoty

because we've looked at a lot of other paintings that he did, which have fortunately remained untouched for years and years—they're basically just dirty—and we can clearly see that he left them unvarnished. It was common practice for many American Impressionists. Daniel Garber, Edward Willis Redfield, and other artists working in the New Hope School very commonly left their paintings unvarnished. That doesn't mean everyone in that era had the same goals. Many other artists working at the same time as Schofield continued to varnish their paintings and to emphasize contrast. As a conservator you need to be aware that that was their goal, and not treat that painting as you would a Schofield, for example. You're looking at the painting and you're letting it tell you what it's supposed to look like. Art is communication, and the artist is communicating with us all the time, and my job is to be like a conductor. I'm not the one who is creating the work of art, but my proper interpretation of the piece helps the

audience connect with it again. It clarifies the artist's message.

LARSON: Aside from the visual effect, varnish also protects the surface, doesn't it?

ERISOTY: Yes, it keeps paint from absorbing grime.

LARSON: And grime's the enemy.

ERISOTY: Yes. [laughs]

LARSON: Schofield was classically trained at the Pennsylvania Academy of the Fine Arts, here in Philadelphia, and at the Académie Julian, in Paris, so he had to have been aware that varnishing protects the surface. But he chose not to varnish because he absolutely didn't want to give his paintings the glossy, high-contrast appearance of an old master?

ERISOTY: It's hard for me to gauge his level of awareness of the fact that without varnishing, dirt would be a bigger problem, but natural resin

varnishes turn brown over time. Artists knew that, and they knew that if you were applying a varnish, at some point it would oxidize and turn brown. It would no longer saturate the surface and would have to be removed or reduced, and then replaced, to reachieve the saturation and protective quality.

LARSON: Do you think there was a general awareness then that someone in the future would be entrusted to alter the work somehow in the course of trying to conserve it, to protect it?

ERISOTY: Yes, and you know, different artists have different levels of comfort with that. Some artists were very afraid, because conservators who are careless will use overly harsh solvents or cleaning agents that strip off the surface of paint. Paintings can be ruined if you're not careful when you're cleaning them. But the fact is, if you don't varnish it, you have to clean off dirt; if you do varnish it, you have to clean off discolored varnish. Things age, things change; they don't stay the same. As much as we'd like them to stay exactly as they were when the artist's brush left the canvas, that isn't going to happen. Schofield chose *not* to varnish, but once a work left his hands, it was out of his control.

LARSON: Let's talk more about *Morning Tide—Coast of Cornwall*. I know it was incredibly dirty when you first examined it.

ERISOTY: Yes, it appears that a grime layer had settled on it for a number of years, and then somebody may have come along and rubbed oil into the surface.

LARSON: Schofield lived and worked in an industrial age, when houses were heated with coal, and people smoked cigarettes and cigars indoors. Schofield himself smoked a pipe. Are these some of the sources of the accumulated grime we're talking about?

ERISOTY: Yes, exactly.

LARSON: Who would have applied the oil? A conservator? And why?

ERISOTY: It could have been the owner—it could have been anybody. Probably not a conservator, because a modern-day conservator would never do that. Oil turns brown, it attracts dust, and it becomes difficult or impossible to remove, especially in the highly textured areas. It was likely a linseed-based oil, so they probably thought it would saturate the color. Instead it became another, major element of the grime. But that's not all. Someone else apparently tried to clean the oil, and after that failed, they put a dull varnish over the whole thing. So you had a grime layer, a discolored oil layer, and a dull varnish that also turned brown. It just looked terrible! Fortunately, there is a very sturdy paint layer, so I was able to remove the varnish layer, and remove and reduce the oil layer with appropriate cleaning agents. Most of the dirt came up with the oil layer, pretty much at the same time. Then I applied a very thin layer of a non-yellowing, low-saturating varnish that will deter further absorption of grime by the paint layer.

LARSON: You varnished it?

ERISOTY: I know I just said that Schofield didn't varnish his paintings, but it is a conservation-quality varnish that protects the surface but retains the appearance of an unvarnished painting. And of course, this and all other applications are easily removed and everything's reversible—except the dirt. You can't put that back on, or at least not the same dirt. [laughs]

Detail of **Morning Tide—Coast of Cornwall**, showing the painting before cleaning and treatment (left side) and after cleaning and treatment (right side). Photographs courtesy of Steven B. Erisoty

It's standard practice to document every step of the process so that, if necessary, you can work backwards and undo everything.

LARSON: All of the wonderful mid-tones are back. We can also appreciate the complexity of Schofield's color sense. The palette is generally cool with warm yellows, greens, and brilliant blues, conveying a sense of sunlight.

ERISOTY: As you can see in the photograph (above), the left side of the image is how the painting looked before cleaning and treatment. The dark horizontal lines are very exaggerated,

just like the dark shadows and the cliffs. And after cleaning and treatment, on the right side of the image, the mid-tone blues and grays unite the composition across the canvas. The whole painting pulls together. Where there's a bright white, as in the crests of the waves, or a dark gray or black, as in the textures of rock, there's a smaller degree of contrast, which is what the artist wanted.

LARSON: I agree. It's more dimensional now, almost sculptural. And there's a sense of fluidity between forms.

The White Frost, 1914, by Walter Elmer Schofield (The Trout Gallery, Dickinson College) before cleaning and treatment (right side) and after cleaning and treatment (left side). Photographs courtesy of B. R. Howard and Associates, Carlisle, Pennsylvania

One of the great things about the exhibition is that Schofield's paintings are getting the attention they deserve; several have been conserved specifically for the show. Dickinson College's painting *The White Frost* (1914; ill. p. 45), for example, had a layer of grime and old yellowed varnish, but fortunately not as thick and troublesome as that of *Morning Tide*. The right side of the image (above) shows the painting as it was prior to cleaning and treatment. The left side shows how it looks now. You can see how the colors and contrast look balanced, much more natural.

Biggs Museum of American Art's *Spring Thaw* (by 1913; ill. p. 102) was in excellent condition overall, but it too had a dense layer of surface grime and discolored varnish. Grime was deeply embedded in the thickly painted areas, especially in the snow highlights. *Lower Falls* (1915; ill. p. 61), lent by the Memorial Art Gallery of the University of Rochester, was in similar condition.

All four of these paintings have what you refer to as a sturdy paint layer. What does that mean?

ERISOTY: Well, direct painters don't always achieve their goals right out of the gate. Sometimes an artist will paint something, and every stroke is perfect and he doesn't have to change it. Other times the same artist will have to work through something, he's not achieving his goal, or he changes his mind. So he paints in something else on top. Now, Schofield's application of paint is still thick and direct: he's not building up thin, semitransparent layers to form depth and glazing. For him, the brushstroke is the brushstroke. He's not trying to build up a subtle layer of transparency to make a beautiful flesh tone. It's direct, thick paint. Or direct thin paint. The paint overlaps, of course, but it's a sturdy layer, not a build-up of delicate glazes.

LARSON: You said that *Morning Tide* has a wax lining on it, and that problems occurred because of heat during the lining process.

ERISOTY: Yes, somebody put a wax lining on it, which I think they did by hand. I don't do wax linings too often anymore, and when we do a lining nowadays, we generally do it on a hot table. The whole table heats to an even temperature that you're monitoring; you get it to the melting point of the adhesive—whether it be wax or a synthetic, nonpenetrating adhesive—and then you cool it down. It's under vacuum pressure, which you can adjust. The painting is face up, so you don't crush the textures of the paint surface. But with the earlier techniques, conservators would use irons, just like the ones you use to iron your clothes with; they'd use an iron on the back of the painting to attach the new layer of canvas to the existing one. With this particular work, it looks like they went over a couple of areas too many times, and the heat caused the paint on the other side to blister a little. There were two very odd areas where there were tiny, blister-like bubbles, very likely caused by overheating in the ironing process.

LARSON: What did you do?

ERISOTY: We're talking about subtlety; very few people are going to notice it. It's a highly textured painting and the bubbles were only really visible because there were small losses where those little blisters broke. I filled them with a reversible filling material, and with a tiny brush, painted them out.

LARSON: You really can't see them at all. Can you talk about relining in general and how that changes the original?

ERISOTY: Well, again, you only reline when you have to. It's a matter of doing the least possible intervention, and we're talking about paintings on canvas when we're talking about linings. Canvas has a lifespan—it's going to degrade with time. A seventeenth-century painting is most likely going to be relined. Everybody expects it. If it's a case of a twenty-year-old painting that's lined versus a twenty-year-old painting by the same artist that's unlined, usually a collector or a museum will prefer the unlined one because it's closer to the way it was when it left the artist's hands. And the lining does change something. Unlined paintings can have a sort of flexibility to them, a subtle surface modulation that disappears with lining. A painting with a lining becomes flatter, and it isn't going to sag naturally; it's a subtle thing, but it does change the look of it, and it's also why we don't recommend doing it unless absolutely necessary.

LARSON: Any final thoughts on Schofield and conservation?

ERISOTY: I hope we've made it clear that we're very much trying to clarify Schofield's voice and respect his intentions. That's the ultimate goal, and we hope that by clarifying his voice, we can help the public, the audience, connect with him as much as they should be able to and really appreciate the beauty of his work. Looking at this beautiful direct painting, *Morning Tide*, you can imagine standing there and hearing those waves crash against the shore—it's just beautiful.

LARSON: Steven, this has been wonderful. Thank you.

ERISOTY: It was fun.

SELECTED CHRONOLOGY

This chronology represents the distillation of an enormous amount of information. Valerie Livingston provided a valuable foundation, which we merged with research and a framework provided by Dr. Dorothy J. del Bueno. James D. W. Church supplied a veritable mountain of family documents, anecdotes, and photographs, and was a part of every endeavor to decipher meanings and clouded references. Rachel McCay drove the chronology forward, checking and double-checking sources, organizing the effort, and coordinating the submission of content.

Schofield's work appeared in numerous group and solo exhibitions, both during and after the artist's lifetime. Formal exhibition titles have been included if they were documented. In cases where the only known record of an exhibition is contemporaneous newspaper or other media coverage, we provide as much information as possible from those sources.

Schofield's extensive travels were not always documented, but information about his transatlantic crossings is included where ship manifests could be found.

We generally do not note the titles of paintings displayed in the exhibitions listed in the chronology. However, exhibition histories associated with each work featured in *Schofield: International Impressionist* can be found in the Works in the Exhibition section of this catalogue.

WILLIAM R. VALERIO, PHD
The Patricia Van Burgh Allison Director and CEO

1845

Walter Elmer Schofield's father, Benjamin Schofield (April 21, 1820–August 28, 1900), emigrates from Liverpool, United Kingdom, to Philadelphia.

BY 1848

Benjamin's wife, Mallie (October 27, 1822–December 16, 1899), joins him in the US. Mallie is a distant cousin of Mary Wollstonecraft Shelley. The couple lives in Delaware County, Pennsylvania. They will have five daughters and four sons; two sons, Albert Edward Schofield and Walter Elmer Schofield, reach maturity.

BY 1859

The Schofield family buys a three-story row house at 1529 North Lawrence Street, in Kensington, Philadelphia.

The Schofield family home at 1529 North Lawrence Street in Philadelphia. Photograph by Renee Giannobile

Breaking "Texas,"
1886–88, by Walter
Elmer Schofield
(Collection
Brandywine River
Museum of Art.
Gift of Sydney E.
Schofield, 1983)
*Photograph courtesy
of Brandywine River
Museum of Art*

1866

Schofield is born on September 9. (Several ship manifests and Schofield's passport list his birthdate as 1866, though it is listed as 1867 in several obituaries.)

Schofield's United States passport, issued May 5, 1928. His birthdate is listed as 1866. *Photograph courtesy of the Schofield Family Archive (formerly Godolphin House, Cornwall, United Kingdom)*

1883–84

Attends Swarthmore Preparatory School, a high school associated with Swarthmore College.

1886

Graduates from Central High School, Philadelphia.

1886–88

Lives at De Vinney Foulke Ranch in San Antonio for eighteen months.

1889

Enrolls at the Pennsylvania Academy of the Fine Arts (PAFA). At the urging of his brother, Schofield's education is paid for by their father. Schofield's classmates include Hugh Henry Breckenridge and William Glackens; his teachers include Thomas Anshutz and Robert Vonnoh.

Enrolls in the month-long PAFA Antique Class every month from January through April and in December.

Enrolls in the month-long PAFA Night Life Class in May.

1890

Enrolls in the month-long PAFA Antique Class in October.

Enrolls in the month-long PAFA Life Class in November and December.

1891

Enrolls in the month-long PAFA Life Class every month from February through May.

Participates in the PAFA *Annual Exhibition*.

1891–92

Enrolls in the PAFA Life Class for the season, December 1891–May 1892.

1892

Meets fellow Philadelphia artist Robert Henri, who holds Tuesday evening meetings in his studio at 806 Walnut Street. Schofield attends these meetings with his friends Glackens and Breckenridge. Other artists who regularly attend include John Sloan, Edward Willis Redfield, and Charles Grafly.

Participates in the PAFA *Annual Exhibition*.

1892–94

Leaves for France and enrolls at the Académie Julian, Paris, where his instructors include William-Adolphe Bouguereau, Gabriel Ferrier, Edmond Aman-Jean, and Lucien Doucet. Lives in France for this period and travels to Fontainebleau and Brittany.

Stays with Redfield in Brolles, France, from November 1892 through January 1893.

1894

Returns to Philadelphia.

1895

Travels to France and the Low Countries with Henri and Glackens.

1895–96

Works for his father's company, the Delph Spinning Company, at Rosehill, Clearfield, and C Streets in the Kensington section of Philadelphia.

The Schofield family at Wyndhurst, their home in the Ogontz neighborhood of Philadelphia. Schofield is not pictured. Photograph courtesy of the Schofield Family

Letter from Albert Schofield to Walter Elmer Schofield on Delph Spinning Company stationery, July 11, 1907. Photograph courtesy of the Schofield Family Archive (formerly Godolphin House, Cornwall, United Kingdom)

1896

Marries Muriel Charlotta Redmayne at West End Congregational Chapel, Ormskirk, near Liverpool in the United Kingdom, on October 7. Schofield's occupation is listed as "cotton spinner" on the marriage certificate, in reference to his employment at the Delph Spinning Company.

Muriel Schofield. Photograph courtesy of the Schofield Family. Photograph by E. F. Foley, New York, NY

Schofield's father purchases Wyndhurst, a large home in the Ogontz neighborhood of Philadelphia. At Albert's urging, Benjamin builds a studio for Schofield.

Travels to Concarneau, France.

1898–99

Schofield and Muriel purchase a home at 7 Asbury Terrace in the Oak Lane section of Philadelphia.

1898–1915

Participates in each PAFA *Annual Exhibition*.

1899

PAFA acquires *Winter* (1899; ill. p. 32) from its *68th Annual Exhibition*.

Schofield and Muriel relocate to the United Kingdom and live in Muriel's parents' home in Lancashire. From this point on, Muriel lives in the United Kingdom, while Schofield travels regularly from the United Kingdom to the United States, spending months at a time in either country.

Schofield's son Benjamin Seymour Redmayne Schofield (known as Seymour) is born on October 1 in the United Kingdom.

Schofield's mother, Mallie, dies.

1900

Group exhibition: *Exposition universelle de Paris, exposition des beaux-arts, États-Unis d'Amérique. January Night* (date and location unknown) wins Honorable Mention. Other artists represented include Cecilia Beaux, William Merritt Chase, Thomas Eakins, Redfield, John Singer Sargent, Winslow Homer, James McNeill Whistler, and Henry Ossawa Tanner. Jury for the painting selection includes Beaux, Chase, John La Farge, and Vonnoh.

Discussing the United States pavilion, art critic Charles H. Caffin writes,

> In referring now to the landscapes and marines I reach a department which, I believe, more than any other, makes our exhibit noteworthy. In the sections of the other countries I have been surprised at the paucity of landscapes. Scattered through the great French exhibit there are many, but they do not make as considerable a mark as was to be expected. . . The showing made by our men is so strong in landscape, and the amount of it is proportionately so large, that it forms the distinctive feature.[1]

Group exhibition: *22nd Annual Exhibition*, Society of American Artists, March 24–April 28. *Autumn in Brittany* (date and location unknown) wins the Webb Prize, awarded to the "best landscape or marine picture in the [Annual] Exhibition painted by an American artist who has not already received the prize."[2]

Schofield's father, Benjamin, dies.

Travels to Cologne, Germany.

1900–1901

Group exhibition: *5th Annual Exhibition*, Carnegie Institute (now the Carnegie Museum of Art), Pittsburgh, November 1, 1900–January 1, 1901. *Twilight* (date and location unknown) wins Honorable Mention.

1901

Group exhibition: *76th Annual Exhibition*, National Academy of Design, New York, January 5–February 3. *Winter Evening* (date and location unknown) wins the Hallgarten Prize.

Group exhibition: Pan-American Exhibition, Exhibition of Fine Arts, Buffalo, May 1–November 1. *Winter* (1899; ill. p. 32) wins the Silver Medal. Other artists represented include Eakins, Whistler, Beaux, Redfield, Sargent, William Langson Lathrop, Homer, and Breckenridge.

Portrait photograph of Muriel, Seymour, and Sydney Schofield. Photograph courtesy of the Schofield Family. Photograph by W. Halliwell of Southport, Lancashire, United Kingdom

Schofield's son Sydney Elmer Schofield is born on October 19 in the United Kingdom.

Schofield and Muriel rent a home at 99 Cambridge Road, Southport, United Kingdom.

1902

Schofield and Muriel rent a home at Hesketh Park, Southport, United Kingdom.

A Midwinter Thaw (c. 1901; ill. p. 34) is purchased by the Cincinnati Art Museum.

1903

Travels to Penzance and Newlyn, Cornwall, United Kingdom.

Visits St. Ives, Cornwall, for the first time.

Schofield and Muriel rent a home at 16 Tregenna Terrace, St. Ives. Schofield becomes a member of the town's active artist community.

Group exhibition: *72nd Annual Exhibition*, PAFA, January 19–February 28. *Breezy Day, Early Autumn* (c. 1902; ill. p. 52) wins the Jennie Sesnan Gold Medal for best landscape.

Elected an associate member of the National Academy of Design, New York.

Letter from Schofield to Muriel during his first visit to St. Ives before their move to the area, April 30, 1903. He writes, "St. Ives is a very nice place indeed and quite up to my expectations..." Photograph courtesy of the Schofield Family Archive (formerly Godolphin House, Cornwall, United Kingdom)

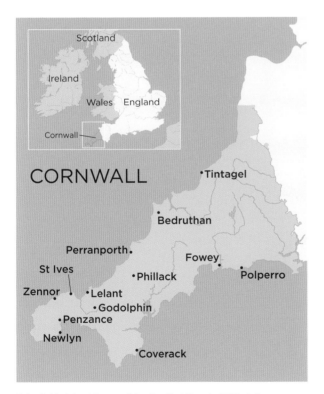

Schofield visited Cornwall for the first time in 1903 at the age of thirty-seven. Thereafter, he explored its towns, harbors, and dramatic coastline in search of the specific views he would capture in his paintings. Sites that are depicted in the paintings in this exhibition are indicated on this map.

Walter Elmer Schofield, date unknown, by Robert Henri (ANA diploma presentation, December 7, 1903, National Academy Museum, New York, 558-P). Henri, Schofield's friend and fellow artist, painted this portrait on the occasion of Schofield's election to the National Academy of Design. New members of the Academy were required to submit portraits. Photograph courtesy of the National Academy Museum

Left: In a letter to John Sloan, Schofield shows himself painting around a group of small children, "not his own." He also makes light of recent changes to his physical appearance, suggesting that he has gained weight. (Letter from Schofield to John Sloan, 1904. John Sloan Manuscript Collection, Delaware Art Museum); below: In a letter to John Sloan, Schofield drew several vignettes in a tongue-in-cheek manner to describe the likely outcome of the Carnegie International Exhibition. At top Sloan cuts coupons; he will need them because he won't be winning any awards. At center, Schofield's sketch of the imaginary award that E.W.R. (Redfield) will never award to Sloan. At bottom, two of Schofield's paintings are kicked out of the exhibition by the jury. (Letter from Schofield to John Sloan, October 13, 1904. John Sloan Manuscript Collection, Delaware Art Museum)

1904

Group exhibition: *79th Annual Exhibition*, National Academy of Design, New York, January 1–30. *Winter Morning* (date and location unknown) is included. Art critic Harrison N. Howard remarks, "In the opinion of many, the finest landscape in the show is W. Elmer Schofield's 'Winter Morning,' and there is a feeling on the part of a great many competent critics that this magnificent picture should have won the Inness prize."[3] The prize was given to Charles Warren Eaton.

Group exhibition: *100th Anniversary Exhibition*, PAFA, January 23–March 4.

Solo exhibition: *Special Exhibition of Landscapes by W. Elmer Schofield*, Art Club of Philadelphia, February 7–20.

Group exhibition (participant and juror for paintings submitted from Philadelphia): St. Louis World's Fair (The Louisiana Purchase Exposition), April 30–December 1. *Winter Morning* wins the Silver Medal. Fellow jurors include Breckenridge, Eakins, John Lambert, and Redfield.

Becomes a member of the Society of American Artists.

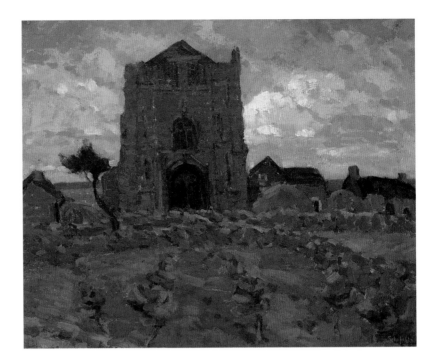

The Old Abbey, c. 1906, by Walter Elmer Schofield (Private Collection)

1904–5

Group exhibition: *9th Annual Exhibition*, Carnegie Institute, Pittsburgh, November 3, 1904–January 1, 1905. *Across the River* (c. 1904; ill. p. 50) wins the Gold Medal of the First Class.

1905

Group exhibition: *Exhibition of the Philadelphia Art Club*.

1905–6

Group exhibition (participant and juror): *10th Annual Exhibition*, Carnegie Institute, Pittsburgh, November 2, 1905–January 1, 1906. Critic M. E. Townsend notes,

> Over thirteen hundred canvases were submitted to a jury, composed of Alfred East, of London; Charles Cottet, of Paris; W. L. Lathrop, Thomas E. Eakins, and W. E. Schofield, of Philadelphia; John W. Alexander, J. Alden Weir, Ben Foster, and Robert Henri, of New York; William H. Howe, of Bronxville.[4]

Carnegie Institute

Pittsburgh, Pa.

JOHN W. BEATTY, M.A.,
DIRECTOR OF FINE ARTS.

December 19, 1904.

Mr. W. Elmer Schofield,

St. Ives, Cornwall,

England.

Dear Sir:

It gives me pleasure to advise you that the Fine Arts Committee has purchased your painting entitled "Across the River." Voucher for the purchase price, fifteen hundred dollars, ($1,500.00) will be presented at the next meeting of the Committee, the middle of January, and a check will be forwarded you directly from the Treasurer's office.

Very truly yours,

DIRECTOR OF FINE ARTS.

(WAM)

Letter from the Carnegie Institute Director of Fine Arts notifying Schofield that the Fine Arts Committee had purchased **Across the River**, c. 1904. *Photograph courtesy of the Schofield Family Archive (formerly Godolphin House, Cornwall, United Kingdom)*

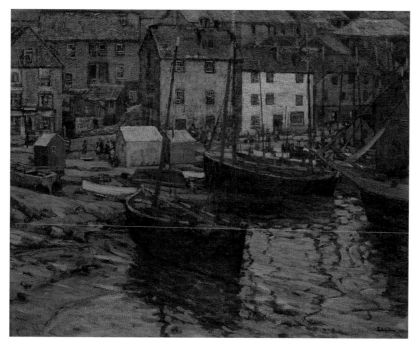

Evening along the Shore, St. Ives, n.d., by Walter Elmer Schofield (NA diploma presentation, February 3, 1908, National Academy Museum, New York 1135-P)
Photograph courtesy of the National Academy Museum

1906

Group exhibition: *28th Annual Exhibition*, Society of American Artists, New York, March 17–April 22. *Sand Dunes near Lelant, Cornwall, England* (1905; ill. p. 57) is purchased for $1,000 by George A. Hearn.

Group exhibition: *19th Annual Exhibition of Oil Paintings and Sculpture by American Artists*, Art Institute of Chicago, October 16–November 29.

Travels to Montreuil-sur-Mer, northern France, in October, with friends including East and Hayley Lever.

1907

Paints at Picquigny, France, in April and May.

Group exhibition: *14th Annual Exhibition*, Cincinnati Art Museum, May 18–July 17. Exhibits *January Day* (c. 1906; ill. p. 36) and *Le Matin* (c. 1903, location unknown). *January Day* is purchased by the Cincinnati Art Museum.

Elected to the Royal Society of British Artists.

Schofield in his studio with **Winter in Picardy** (1907) on the easel in the background, 1907. Photograph courtesy of the Schofield Family. Photograph by W. Herbert Lanyon

Group exhibition: *Winter Exhibition*, Royal Society of British Artists, London.

Schofield and Muriel rent a home in Ingleton, Yorkshire, United Kingdom. Schofield rents a large studio outside of their home.

Becomes a full member of the National Academy of Design.

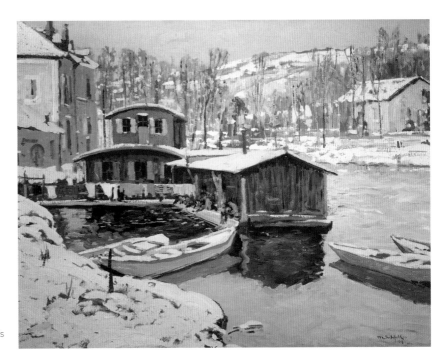

Moret, France, 1909, by Walter Elmer Schofield (Collection of Carol and Louis Della Penna)

1907–11

Participates in each of the three successive occurrences of *Exhibition of Oil Paintings by Contemporary American Artists* at the Corcoran Gallery of Art, Washington, DC.

1908

Visits Sloan. Sloan writes,

> Schofield came in on his way back to England. I took him up to the show [*The Eight*] which he said was fine, though he was not enthusiastic over Prendergast or Davies work. We came back, Dolly came in, and we waited for Henri to go to dinner with Scho.[7]

Group exhibition (participant and juror): *12th Annual Exhibition*, Carnegie Institute, Pittsburgh, April 2– June 30. Exhibits *Winter in Picardy* (1907; ill. p. 44). Jury also includes Lathrop, Chase, and Henri.

Group exhibition: *15th Annual Exhibition of American Art*, Cincinnati Art Museum, May 23– July 20. *Morning* (date and location unknown) is purchased.

Visits Bruges, Belgium, with Lever in June. Writes to Muriel, "Am staying here for a week or ten days anyway—maybe longer. Lever arrived on Saturday. The weather has been hot and sultry so that working out has not been a great pleasure."[5]

Schofield owned a reproduction of a Monet painting, *Le Dejeuner*, from the Durand-Ruel Galleries, Paris. Photograph courtesy of the Schofield Family

Visits Boulogne-sur-Mer, France, in November. Writes to Muriel, "I really don't want to go to the U.S. for a year anyway, just want to get a chance to work hard and continuously outdoors but suppose I had better keep in the 'public eye.' It's necessary and the only way to not be overlooked."[6]

In a letter to John Sloan discussing plans to travel to Pittsburgh. Schofield drew portraits of Robert Henri, Sloan, and himself. He wrote, "When you hit Broad St. you will need this for identification," pointing to his own portrait. (Letter from Schofield to John Sloan, no date. John Sloan Manuscript Collection, Delaware Art Museum)

1908–9

Group exhibition: *Winter Exhibition*, National Academy of Design, New York, December 12, 1908–January 9, 1909.

1909

Travels with Breckenridge to Munich, Venice, Florence, and Paris on behalf of the Carnegie Institute, Pittsburgh, to identify European artists.

Group exhibition: *13th Annual Exhibition*, Carnegie Institute, Pittsburgh, April 29–June 30.

Paints at Moret-sur-Loing, France.

Group exhibition: *5th Annual Exhibition of Selected Paintings by American Artists*, Buffalo Fine Arts Academy, May 11–September 1.

Group exhibition: *Exposición Internacional de Arte del Centenario*, Buenos Aires, July 12–September 1. *First Days of Spring* (date and location unknown) wins the Gold Medal and is "placed in the National Collection, Montevideo [Uruguay]."[8] Other artists

represented include Breckenridge, Davies, Glackens, Grafly, Henri, Violet Oakley, Redfield, and George Gardner Symons. The exhibition travels to Santiago, Chile, as *Exposición Internacional de Bellas Artes*, September 22–December 3.

Group exhibition: *23rd Annual Exhibition of Oil Paintings and Sculpture by American Artists*, Art Institute of Chicago, October 18–November 27.

Group exhibition: *Exhibition of Representative American Pictures*, Royal Academy, Berlin, November.

1910

Serves on the jury of selection and award, as well as the hanging committee, for PAFA's *105th Annual Exhibition*, January 23–March 20. Jury and hanging committee also include Henri and Grafly.

Travels to Dieppe, France, with Julius Olsson and George Oberteuffer in May. Muriel, Seymour, and Sydney join him.

Schofield designed this needlepoint for his niece, Sarah Phillips, who completed it about 1932. It depicts the family's summerhouse near Great Barrington, Massachusetts. (Collection of Margaret E. Phillips)

1911

Buys a home at 5 Oaklands Road, Bedford, United Kingdom.

Spends time at his sisters' summerhouse near Great Barrington, Massachusetts.

Group exhibition: *86th Annual Exhibition*, National Academy of Design, New York, March 11–April 16. *February Morning* (date and location unknown) wins the George Inness Gold Medal.

Group exhibition (participant and juror): *15th Annual Exhibition*, Carnegie Institute, Pittsburgh, April 27–June 30. Jury also includes Chase, Weir, Irving Ramsay Wiles, Edmund Charles Tarbell, Frank Duveneck, Beaux, Charles Harold Davis, Maurice Greiffenhagen, and Anders Zorn.

Leaves Philadelphia for the United Kingdom aboard the SS *Dominion* in August.

Group exhibition: *Appalachian Exposition*, American Federation of Arts and the Nicholson Art League of Knoxville, TN, September 11–October 1.

Group exhibition: Montevideo, Uruguay. A reviewer in *American Art News* writes,

> Late papers from Montevideo give high praise to the exhibition of American pictures recently held there under the auspices of Mr. E. V. Morgan, US minister to Uruguay, and are complimentary to artists represented, and their work. Special mention is made of Ralph Clarkson's portrait of "Loredo Taft," of the landscapes of W. Elmer Schofield. . .[9]

First Days of Spring (date and location unknown) is purchased by the Uruguayan government for the National Gallery of Fine Arts. An article explains,

> Mr. Edwin V. Morgan, American Minister to Uruguay, states in a recent report that the Uruguayan government has bought for the National Gallery of Fine Arts three pictures by American artists, shown at the exposition held in Montevideo. The pictures selected are "First Days of Spring," by Elmer Schofield; "Spirit of Antique Art," by Philip L. Hale, and "Nocturne—the Quinnipiack," by George Albert Thompson. The Art Association recommended the government to purchase these pictures.[10]

1912

Visits Polperro, Cornwall, for the first time.

Reflects on the difficult time Muriel has encountered in the United Kingdom: "We have lived in such a precarious manner that I feel with you it must cease as human nerves cannot stand such a strain without giving way."[11]

Solo exhibition: *Paintings by W. Elmer Schofield*, Corcoran Gallery of Art, Washington, DC, January 20–February 5.

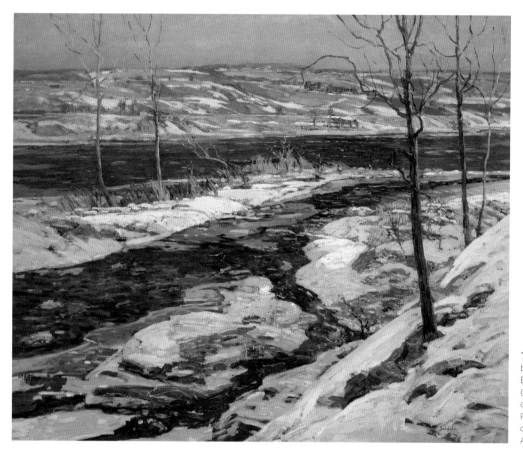

The Spring Thaw, by 1913, by Walter Elmer Schofield (Biggs Museum of American Art) Photograph courtesy of Biggs Museum of American Art

Solo exhibition: Katz Gallery, New York.

Solo exhibition: *An Exhibition of Paintings by W. Elmer Schofield*, Carnegie Institute, Pittsburgh, February 12–25.

Group exhibition: organized by the Minnesota State Art Society, travels to St. Paul, Stillwater, Anoka, and Duluth, April 25–June 16.

Group exhibition (participant and juror): *16th Annual Exhibition*, Carnegie Institute, Pittsburgh, April 25–June 30. Jury also includes John Beatty (president), Alexander, Chase, Foster, Symons, Davis, Tarbell, Lathrop, East, and Henri Le Sidaner.[12]

Solo exhibition: *Exhibition of Paintings by Elmer Schofield*, Buffalo Fine Arts Academy, September 26–October 28.

Leaves the United Kingdom for New York aboard the SS *Cedric* in October.

Solo exhibition: *A Collection of Paintings by Mr. W. Elmer Schofield, N.A.*, City Art Museum of St. Louis (now St. Louis Art Museum), opens November 3.

Group exhibition: *25th Annual Exhibition of American Oil Paintings and Sculpture*, Art Institute of Chicago, November 5–December 8.

Exhibition catalogue for *A Collection of Paintings by Mr. W. Elmer Schofield, N.A.*, City Art Museum of St. Louis, 1912. Photograph courtesy of St. Louis Art Museum

Group exhibition: State Normal School, West Chester, PA. Other artists represented include Chase, Redfield, Henri, Daniel Garber, Sargent, and Bessie Potter Vonnoh.

1912–13

Group exhibition (participant and juror): *4th Biennial Exhibition of Contemporary American Paintings*, Corcoran Gallery of Art, Washington, DC, December 17, 1912–January 26, 1913. Jury for selection and awards also includes Foster, Frank Weston Benson, Richard Norris Brooke, and Gari Melchers.

1913

Group exhibition: *Annual Members' Exhibition of Painters, Sculptors and Architects*, National Arts Club, New York, January 3–28. An article explains, "As is usually the case with 'members' exhibitions, 'extremes meet,' but on the whole the display is above the average. The gold medal, which carries with it the $1,000 prize, was awarded to W. Elmer Schofield for his vital landscape, *Spring Thaw. . .*"[13]

Solo exhibition: *Special Exhibition of Paintings by Mr. W. Elmer Schofield*, Cincinnati Art Museum, February 1–23.

Group exhibition: *88th Annual Exhibition*, National Academy of Design, New York, March 15–April 20.

Group exhibition (participant and juror): *17th Annual International Exhibition of Paintings*, Carnegie Institute, Pittsburgh, April 24–June 30. Jury also includes Beatty (director), Alexander, Chase, Wiles, Davis, Henri, Symons, René François Xavier Prinet, and Henry Caro-Delvaille.[14]

On October 28, Albert and Sarah purchase a home at 6816 Quincy Street in the Germantown section of Philadelphia.

Visits Polperro.

Leaves the United Kingdom for Boston aboard the SS *Devonian* in November.

Visits Falls Village, Connecticut.

1913–14

Group exhibition: *Winter Exhibition*, National Academy of Design, New York, December 20, 1913–January 18, 1914.

1914

Group exhibition: *109th Annual Exhibition*, PAFA, February 8–March 29. *Hill Country* (c. 1913; ill. p. 58) wins the Temple Gold Medal.

Group exhibition: *18th Annual International Exhibition of Paintings*, Carnegie Institute, Pittsburgh, April 30–June 30.

Returns to the United Kingdom from New York aboard the SS *New York* in May.

Visits Polperro and Perranporth, United Kingdom.

Group exhibition: Anglo-American Exposition, American Fine Arts Section, London, May–October.

Group exhibition: *American Paintings and Sculpture 27th Annual*, Art Institute of Chicago, November 3–December 6.

Group exhibition: *8th Annual Exhibition*, Boston Art Club.

1914–15

Group exhibition: *5th Exhibition of Contemporary American Oil Paintings*, Corcoran Gallery of Art, Washington, DC, December 15, 1914–January 24, 1915.

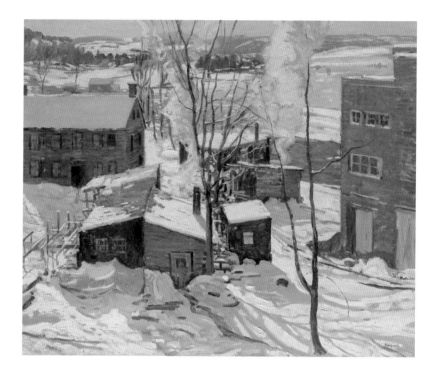

Right: **The Powerhouse, Falls Village, Connecticut**, c. 1914, by Walter Elmer Schofield (Walter H. Schulze Memorial Collection, 1924.915, The Art Institute of Chicago); below: **Building the Cofferdam**, c. 1914, by Walter Elmer Schofield (Friends of American Art Collection, 1914.821, The Art Institute of Chicago). **Building the Cofferdam** was included in the exhibition *American Paintings and Sculpture 27th Annual* at the Art Institute of Chicago. Both photographs © The Art Institute of Chicago

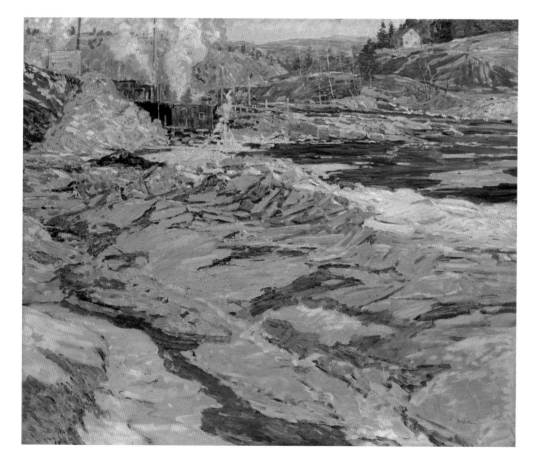

Above: Schofield, Second Lieutenant Cornwall Royal Garrison Artillery, British Army, c. 1915. Photograph courtesy of the Schofield Family; right: Schofield's commission as second lieutenant in the Cornwall Royal Garrison Artillery, 1915. Photograph courtesy of the Schofield Family Archive (formerly Godolphin House, Cornwall, United Kingdom)

1915

Leaves the United Kingdom for New York aboard the SS *Saint Louis* in January.

Group exhibition: *Exhibition of Paintings by W. Elmer Schofield and a Collection of Paintings Representative of the Modern Art Movement in America*, Memorial Art Gallery, Rochester, NY, February 16–March 7.

Group exhibition: Panama Pacific International Exposition, Gallery 68, San Francisco, February 20–December 4. *The Rapids* (c. 1914; ill. p. 60) wins the Medal of Honor. Fellow Americans Alexander, Beaux, Emil Carlsen, Willard Leroy Metcalf, Oakley, Richard Emile Miller, Walter Griffin, and Lawton Silas Parker also win awards.

Returns to the United Kingdom from New York aboard the SS *New York* in April.

Group exhibition: *10th Annual Exhibition of Selected Paintings by American Artists*, Buffalo Fine Arts Academy, May 22–August 30.

Enlists as a private in the Royal Fusiliers, a regiment in the British Army, on July 14. With the assistance and support of Olsson, Schofield is commissioned as an officer in the Cornwall Royal Garrison Artillery on October 24.

Group exhibition: *Paintings by Twelve American Painters*, Grand Rapids Art Association, MI, December 1–31. Other artists represented include Glackens, Paul Dougherty, Symons, Gifford Beal, Henri, Weir, Ernest Lawson, Chase, Childe Hassam, Lever, and George Wesley Bellows.

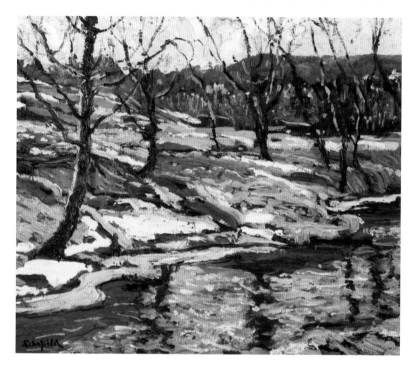

In the Dugway, 1915, by Walter Elmer Schofield (Memorial Art Gallery of the University of Rochester: Gift of the Estate of Emily and James Sibley Watson) Photograph courtesy of Memorial Art Gallery of the University of Rochester

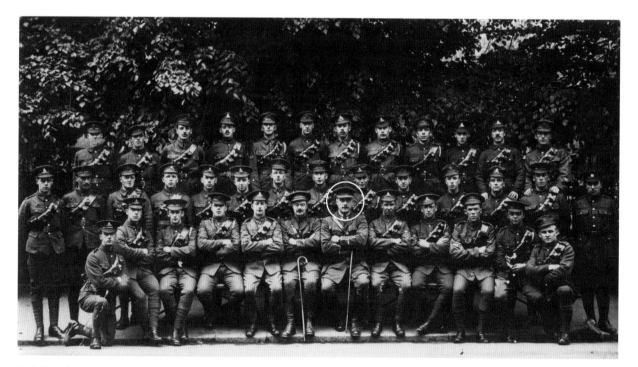

Anti-Aircraft Section, Royal Garrison Artillery (Territorial Force); Schofield is sitting in the front row at the center, c. May 1916. Photograph courtesy of the Schofield Family

1916

Group exhibition: *Exhibition of Paintings by Men Who Paint the Far West, Twelve American Artists and Sandor Landeau*, Detroit Museum of Art, April.

Leaves for the Front in May as (acting) captain of No. 202 Anti-Aircraft Section, Royal Garrison Artillery (Territorial Force). In a letter to W. Herbert Lanyon, Schofield writes, "I am a Captain now and have had the Section ever since I went to Shoreburyness—bringing it out here and am proud of it."[15]

Serves in the Somme campaign.

Group exhibition: *An Exhibition of Paintings by Twelve Contemporary American Artists*, Memorial Art Gallery, Rochester, NY, May.

Group exhibition: *The Exhibition of Works by Foreign-Born Artists, Including Also Those of Foreign Parentage*, Pennsylvania Museum and School of Art and Industry, Philadelphia. His painting *The Powerhouse, Falls Village, Connecticut* (c. 1914; ill. p. 104) wins first prize. (Memorial Hall had been constructed as the grand exhibition gallery for the Centennial Exhibition of 1876. It later became the Pennsylvania Museum and School of Art and Industry. The institution was renamed the Philadelphia Museum of Art after its collection was moved to its current location in 1928.)

1917

Group exhibition: *11th Annual Exhibition of Selected Paintings by American Artists*, Buffalo Fine Arts Academy, May 12–September 17.

Writes to Helen W. Henderson on July 4,

> At present. . . I am now commander of anti-aircraft defenses of this area with a car and lots of running about to do and it's not too

bad. . . I've seen some queer sights out here, dear H., that are unpleasant to recall, so when I get a letter such as yours, which conjures up the sunny years of my life, I am grateful for the look back it gives me.[16]

Participates in the pursuit of the Germans back to the Hindenburg Line.

1918

Fights against the German Spring Offensive in April, acting as battery captain:

> I was with a forward section when it started and went through the first part of it right in the firing port; then the major wanted me to come in as Battery Capt. and I have been very much on the mark since, as I have to visit all sections and look after many things besides— But it is something to feel that one is helping during these times. . . A peaceful man if ever there was one and here I am rushing about in the midst of a terrific battle and rather enjoying things.[17]

Takes part in the Hundred Days Offensive leading to the German surrender.

Serves in the Occupation of the Rhineland.

1919

Demobilized from Dover, United Kingdom, on February 6.

Begins to paint again after a four-year break due to his enlistment in the British Army.

Leaves the United Kingdom for New York aboard the SS *Rotterdam* in March.

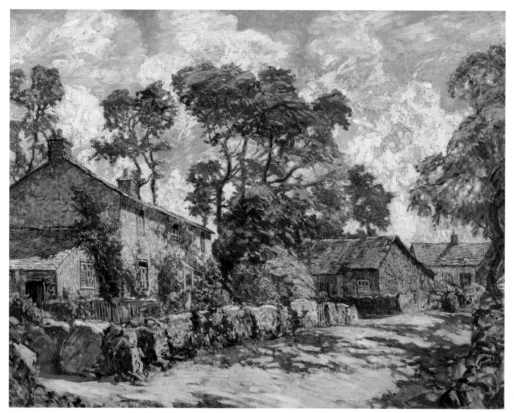

At the Crossroads, c. 1919, by Walter Elmer Schofield (Private Collection, Greenwich, CT) Photograph courtesy of Avery Galleries, Bryn Mawr, PA

Returns to the United Kingdom from New York aboard the SS *Rotterdam* in June.

Acknowledges Muriel's support in a touching letter: "I have freely given you all credit for the great help in making it possible for me to paint at all. . . If I have any success it's due to you, dearest."[18]

Spends the summer in Cornwall.

Leaves the United Kingdom for New York aboard the SS *Baltic* in November.

1919–20

Group exhibition: *7th Exhibition of Contemporary American Oil Paintings*, Corcoran Gallery of Art, Washington, DC, December 21, 1919–January 25, 1920.

1920

Solo exhibition: *Exhibition of Paintings by W. Elmer Schofield, N.A.*, Buffalo Fine Arts Academy, January 10–February 15. *At the Crossroads* (c. 1919) is included.

Solo exhibition: *Exhibition of Paintings by W. Elmer Schofield, N.A.*, Memorial Art Gallery, Rochester, NY, February 16–March 7.

Group exhibition: *95th Annual Exhibition*, National Academy of Design, New York, April 6–May 9. *The Rapids* (c. 1914; ill. p. 60) wins the First Altman Prize and is acquired for the Brooklyn Art Museum (now the Brooklyn Museum).

Group exhibition: *6th Annual Exhibition of Paintings by American Artists*, Detroit Institute of Arts, April 20–May 31.

Group exhibition: *19th International Exhibition of Paintings*, Carnegie Institute, Pittsburgh, April 29–June 30.

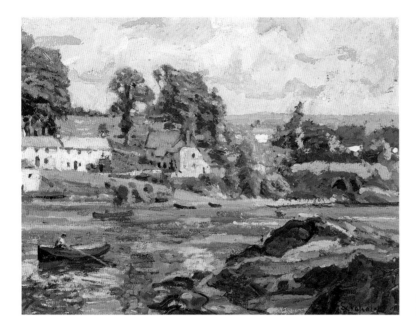

River Exe, 1925–27, by Walter Elmer Schofield (Private Collection)

Returns to the United Kingdom from New York aboard the SS *New York* in May.

Group exhibition: *14th Annual Exhibition of Selected Paintings by American Artists*, Buffalo Fine Arts Academy, May 29–September 7.

Group exhibition: *2nd Annual Exhibition of the New Society of Artists*, E. Gimpel and Wildenstein Galleries, New York, November 8–27.

Leaves the United Kingdom for New York aboard the SS *Baltic* in November.

Group exhibition: *Joint Exhibition of Landscapes by Walter Elmer Schofield and W. A. Lathrop*, Ferargil Galleries, New York.

1920–21

Group exhibition: *Seven Special Exhibitions: Paintings by Guy Wiggins, Charles H. Woodbury, Alfred Juergens, John F. Stacey, Anna Lee Stacey,* *Gifford Beal, Eugene Speicher, and W. Elmer Schofield; Pastels by William P. Henderson; Sculpture by Jo Davidson*, Art Institute of Chicago, December 17, 1920–January 18, 1921.

Solo exhibition: *Paintings by W. Elmer Schofield*, Corcoran Gallery of Art, Washington, DC, December 18, 1920–January 9, 1921.

1920–22

Participates in each PAFA *Annual Exhibition*.

1921

Schofield and Muriel rent Doreen Cottage in Perranporth, where the family will live until 1927.

Solo exhibition: *Paintings of Cornwall and Elsewhere by W. Elmer Schofield*, Macbeth Gallery, New York, March 1–21.

Group exhibition: *Exhibition of Paintings by Gifford Beal, Eugene Speicher and Elmer W. Schofield* [*sic*], Detroit Institute of Arts, April 1–18.

Leaves the United Kingdom for New York aboard the SS *Rotterdam* in November.

Group exhibition: *34th Annual Exhibition of American Paintings and Sculpture*, Art Institute of Chicago, November 3–December 11. Schofield wins the Mrs. Keith Spalding Prize of $1,000 for best landscape.

Group exhibition: *3rd Annual Exhibition of the New Society of Artists*, Wildenstein Galleries, New York, opens November 15. Other artists represented include Henri, Glackens, and Grafly.

Group exhibition: *5th Exhibition of Intimate Paintings*, Macbeth Gallery, New York, November 21–December 12.

1921–22

Group exhibition: *10th Annual Circuit Exhibition of Paintings by American Artists*, Dudley Peter Allen Memorial Art Museum, Oberlin, OH, December 1, 1921–July 1, 1922. Travels to Dayton, Columbus, and Youngstown, OH; Richmond, IN; Springfield, IL; and Syracuse, NY. Other artists represented include Garber, John Fulton Folinsbee, and Lathrop.

Group exhibition: *8th Exhibition of Contemporary American Oil Paintings*, Corcoran Gallery of Art, Washington, DC, December 18, 1921–January 22, 1922. *Cliff Shadows* (1921; ill. p. 69) is purchased by the Corcoran.

1922

The Delph Spinning Company mill is sold.

Group exhibition (participant and juror): *117th Annual Exhibition*, PAFA, February 5–March 6. Jury also includes Colin Campbell Cooper (chairman), Mary Butler, Philip L. Hale, Frederick Hall, John Christen Johansen, Jonas Lie, S. Walter Norris, Elizabeth Okie Paxton, Charles Morris Young, Walter Ufer, Grafly, Frederick George Richard Roth, and Mahonri Mackintosh Young.[19]

Group exhibition: *16th Annual Exhibition of Selected Paintings by American Artists and a Group of Small Bronzes by American Sculptors*, Buffalo Fine Arts Academy, April 9–June 12.

Returns to the United Kingdom from New York aboard the SS *Nieuw Amsterdam* in May.

Leaves the United Kingdom for New York aboard the SS *Zeeland* in November.

Group exhibition: Cleveland Museum of Art. Other artists represented include Garber, Lathrop, and Folinsbee.[20]

1922–23

Group exhibition: *Exhibition of Paintings by Ben Foster, W. Elmer Schofield, Gardner Symons, and Douglas Volk*, Buffalo Fine Arts Academy, December 9, 1922–January 8, 1923.

1923

In January, the French government purchases *Morning Light* (1922; ill. p. 81) for the Musée du Luxembourg, Paris. In 1980, this painting was transferred to the Musée d'Orsay. It is currently on view in the Château de Blérancourt.

Joins Grand Central Art Galleries in New York; sells *The Rapids in Winter* (c. 1919; ill. p. 5) to the "head"

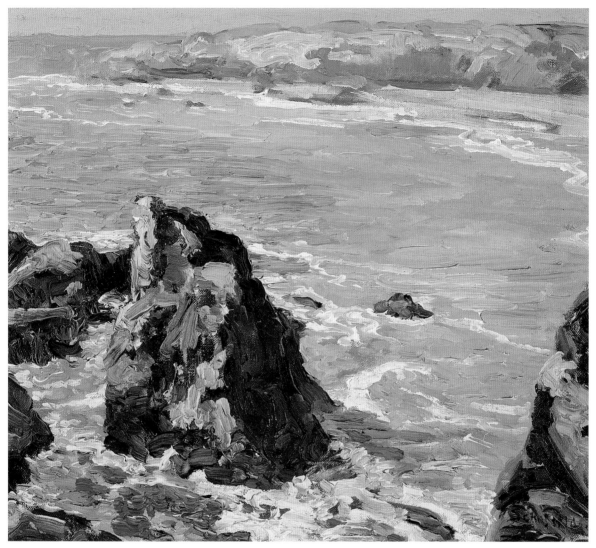

English Coast, c. 1920, by Walter Elmer Schofield (Private Collection)

of an art museum, likely Charles C. Glover at the Corcoran Gallery of Art.

Returns to the United Kingdom from New York aboard the SS *President Harding* in March.

Leaves the United Kingdom for New York aboard the SS *Orbita* in October.

1924

Solo exhibition: *Paintings by Elmer W. Schofield [sic], N.A. Presented by Des Moines Women's Club*, Des Moines Association of Fine Arts, January 16– February 18.

Des Moines Association of Fine Arts purchases *June Morning* (c. 1923; ill. p. 7).

Travels to Chebeague Island, Maine. In a letter to his wife Schofield explains,

> This summer will be quite a contrast to the many I have spent in England and I hope I shall be able to get something out of it. Of course I will always have trouble finding subjects ready-made. The Maine coast I know is not anywhere as fine as Cornwall, but I don't want to do many marines, so that won't matter, but I might find landscape or something in houses that will be paintable.[21]

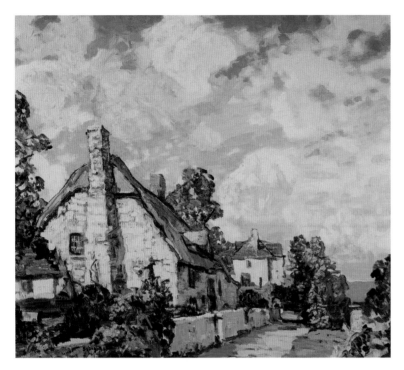

Under Summer Skies, c. 1928, by Walter Elmer Schofield (Collection of Lucille and Walter Rubin)

1924–26

Participates in each PAFA *Annual Exhibition*.

1925

Returns to the United Kingdom from New York aboard the SS *Rijndam* in June.

Leaves the United Kingdom for New York aboard the SS *Caronia* in November.

Solo exhibition: *Recent Paintings by W. Elmer Schofield*, Milch Gallery, New York, November 16–December 5.

Group exhibition: *9th Annual Exhibition*, Concord Art Association, MA.

1926

Group exhibition: *Carnegie International Exhibition*, Grand Central Art Galleries, New York, March 6–April 20.

Group exhibition: *20th Annual Exhibition of Selected Paintings by American Artists*, Buffalo Fine Arts Academy, April 25–June 21.

1927

Solo exhibition: *Paintings of Cornwall and Devonshire by W. Elmer Schofield*, Milch Gallery, New York, January 24–February 12.

Group exhibition: *Exhibition of Paintings and Sculpture by Leading Living American Artists under auspices of Dallas Art Association*, Scottish Rite Cathedral, Dallas, February 5–25 (from Grand Central Art Galleries).

Returns to the United Kingdom from New York aboard the SS *Minnekahda* in March.

Schofield and Muriel purchase Otley High House, Suffolk, United Kingdom. The family will live there for ten years.

Otley High House, Suffolk, United Kingdom, c. 1927–37. Photograph courtesy of the Schofield Family

Albert Schofield's home at 408 West Moreland Avenue in the Chestnut Hill section of Philadelphia. Photograph by April Williams

Schofield's brother, Albert, purchases a house at 408 West Moreland Avenue, Philadelphia, in July. Schofield will visit frequently and stay for periods of time while he is in the US.

Travels in northern France with Lever in July.

Leaves the United Kingdom for New York aboard the SS *Minnekahda* in November.

1928

Group exhibition: *Exhibition of Paintings by Gardner Symons and W. Elmer Schofield*, Montclair Art Museum, NJ, February 2–March 11.

Group exhibition: *Exhibition of Paintings by W. Elmer Schofield, N.A., and Gardner Symons, N.A.*, Stendahl Art Galleries, Los Angeles, March.

Returns to the United Kingdom from New York aboard the SS *Caronia* in May.

Leaves the United Kingdom for New York aboard the SS *Olympic* in October.

Travels to California.

Albert's wife dies. Albert's daughter Sarah with her husband Herbert Phillips and their daughter Margaret E. Phillips relocate from Brooklyn to the home at 408 West Moreland Avenue. They live there with Albert and manage the home.

1929

Group exhibition: *Exhibition of Contemporary American Art by Members of the Grand Central Art Galleries*, Museum of Fine Arts, Houston, January 13–27.

Group exhibition: *January–February Exhibition: Contemporary American Paintings and Sculpture Selected from Recent Exhibitions in American Art Centers*, Memorial Art Gallery, Rochester, NY, January–February.

Returns to the United Kingdom from New York aboard the SS *Minnekahda* in May.

Leaves London for New York aboard the SS *Minnekahda* in November.

Travels to California.

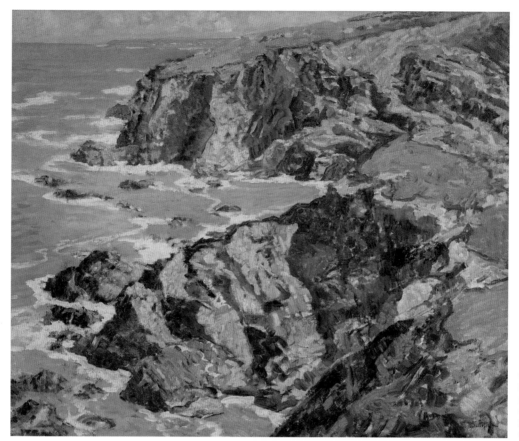

Cliffs at Bedruthan, by 1929, by Walter Elmer Schofield (Private Collection)
Photograph by Christopher Gardner

1930

Returns to the United Kingdom from New York aboard the SS *Lapland* in March.

Leaves the United Kingdom for New York aboard the SS *Majestic* in July.

Returns to the United Kingdom from New York aboard the SS *Homeric* in August.

Leaves the United Kingdom for New York aboard the SS *Berengaria* in October.

1930–33

Participates in each PAFA *Annual Exhibition*.

1931

Returns to the United Kingdom from New York aboard the SS *Ascania* in February.

Leaves the United Kingdom for New York aboard the SS *Berengaria* in August.

Solo exhibition: *Paintings by W. Elmer Schofield*, Corcoran Gallery of Art, Washington, DC, October 24–November 26.

Returns to the United Kingdom from New York aboard the SS *Olympic* in December.

1932

Leaves the United Kingdom for New York aboard the SS *Samaria* in November.

1933

Returns to the United Kingdom from New York aboard the SS *Samaria* in February.

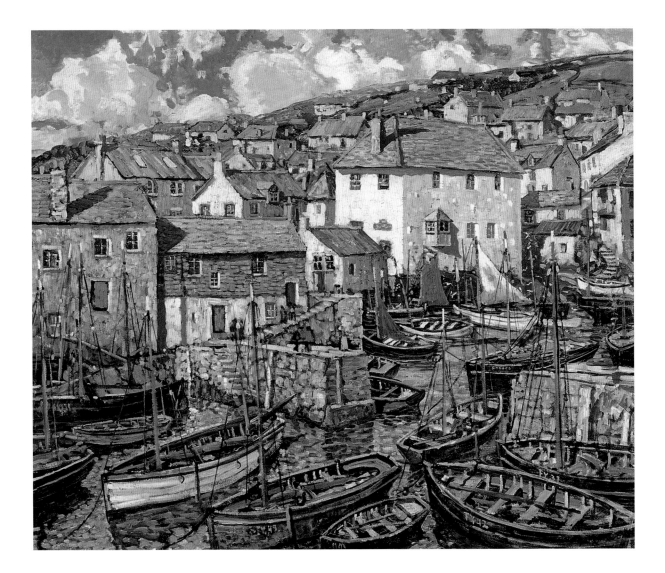

The Harbor, Sunday, by 1929, by Walter Elmer Schofield (Collection
Jim's of Lambertville) Photograph courtesy of Jim's of Lambertville

Old Shaft, Arizona, 1934, by Walter Elmer Schofield (Gift of Muriel and Philip Berman, Permanent Collection of the Philip and Muriel Berman Museum of Art at Ursinus College)

Group exhibition: *31st Annual International Exhibition*, Carnegie Institute, Pittsburgh, October 19–December 10.

Leaves the United Kingdom for New York aboard the SS *Majestic* in November.

1934

Returns to the United Kingdom from New York aboard the SS *Scythia* in May.

Leaves the United Kingdom for New York aboard the SS *Olympic* in August.

Travels and spends time in California. Conducts painting lessons through Stendahl Art Galleries; builds his relationship with the galleries and sells many works.

Solo exhibition: Stendahl Art Galleries, Los Angeles, October.

Schofield in California standing in front of **Old Shaft, Arizona,** 1934. Photograph courtesy of the Schofield Family Archive (formerly Godolphin House, Cornwall, United Kingdom)

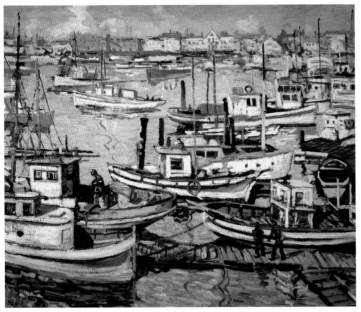

Fishing Fleet, San Pedro, 1934–35, by Walter Elmer Schofield (Private Collection)

1935

Solo exhibition: *Exhibitions: Elmer W. Schofield* [*sic*]*, N.A.*, Faulkner Memorial Art Gallery, Free Public Library, Santa Barbara, CA, March 2–21.

Returns to the United Kingdom from New York aboard the SS *Georgic* in April.

Leaves the United Kingdom for New York aboard the SS *Britannic* in September.

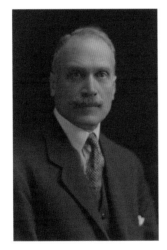

Portrait of Schofield, c. 1935. Photograph courtesy of the Schofield Family. Photograph by Adolphus Tear, Ipswich, Suffolk, United Kingdom

1935–37

Participates in each PAFA *Annual Exhibition*.

1936

Returns to London from New York aboard the SS *Alaunia* in April.

1937

Leaves the United Kingdom for New York aboard the SS *President Roosevelt* in July.

Schofield and Muriel sell Otley House, dividing the proceeds between their two sons. Sydney Schofield uses his share, along with additional savings, to purchase Godolphin, an estate and farm in Cornwall. He operates the farm and begins significant restoration of the manor, in the hope that it will one day become part of the National Trust. Elmer and Muriel move to Godolphin and later to Gwedna, a home within the estate.

Schofield's son Sydney, c. 1930. Photograph courtesy of the Schofield Family

The north front with the portico of Godolphin House, once the home of Queen Anne's Lord High Treasurer, Sidney Godolphin, near Helston, Cornwall. © National Trust Images/Andrew Butler

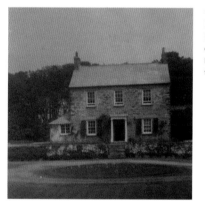

Gwedna, Schofield's home at Godolphin, his son Sydney's estate, c. 1940. Photograph courtesy of the Schofield Family

At the time of the Godolphin purchase, Schofield is visiting California. His family sends him photographs of their new home; he replies, "Those photographs you sent over were much admired—everyone thinks it a grand house and we may have visitors this summer—they are curious to see such a place. Have been out today with the Class."[22]

Returns to the United Kingdom from New York aboard the SS *Aquitania* in September.

Leaves the United Kingdom for New York aboard the SS *Aquitania* in November.

1938

Group exhibition: *First Biennial Exhibition of Contemporary American Paintings*, Virginia Museum of Fine Arts, Richmond, March 12–April 24.

Returns to the United Kingdom from New York aboard the SS *Statendam* in May.

1940

Group exhibition: *Survey of American Painting*, Carnegie Institute, Pittsburgh, October 24–December 15.

1944

Dies at Godolphin. The cause is heart failure. Obituary in the *New York Herald Tribune* states,

> Walter Elmer Schofield, Philadelphia-born landscape painter whose work is in the permanent collections of many galleries, died last night at his home at Godelphin [*sic*] Manor, Cornwall, England. . . . A veteran of the World War, in which he achieved the rank of major, Mr. Schofield lived in England for many years after his marriage to Miss Muriel Redmayne of Southport, Lancashire, England, although retaining his American citizenship.[23]

Buried in the churchyard at St. Uny, Lelant, Cornwall, United Kingdom.

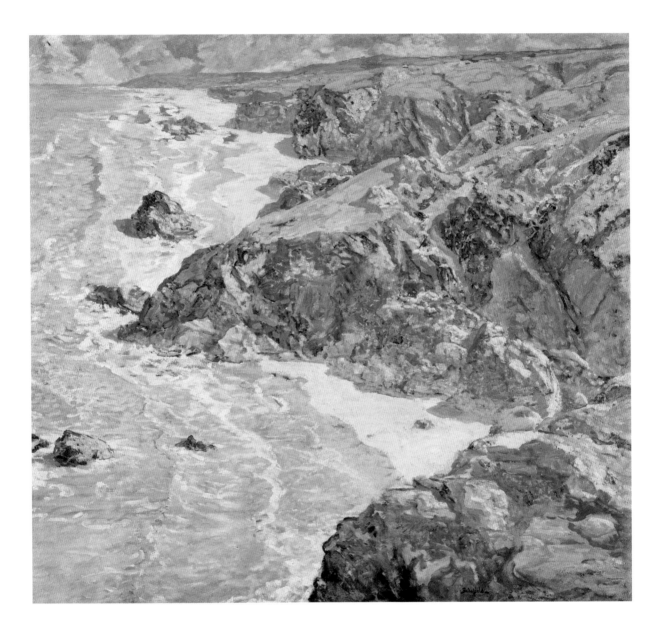

Cornish Coast, c. 1940, by Walter Elmer Schofield (Philadelphia
Museum of Art: Gift of Muriel and Philip Berman, 1989-70-1)
Photograph courtesy of Philadelphia Museum of Art

1945

Solo exhibition: *Memorial Exhibition W. Elmer Schofield, N.A.*, Grand Central Art Galleries, New York, March 27–April 7.

Solo exhibition: *Memorial Exhibition of Oil Paintings by W. Elmer Schofield N.A.*, Woodmere Art Gallery (now Woodmere Art Museum), Philadelphia, November 3–26 (organized by Edith Emerson with the participation of Sarah Phillips, Schofield's niece).

1946

Group exhibition: *Annual Exhibition*, PAFA. Includes *Cornwall Coast* (date and location unknown).

1946–47

Philip and Muriel Berman meet Sarah and Herbert Phillips through Walter Baum. They purchase a number of important paintings, which are now in the Philip and Muriel Berman Museum of Art at Ursinus College, Pennsylvania, and the Philadelphia Museum of Art.

1947

Schofield's remains are moved to the Church of St. James the Less in Philadelphia. Schofield wished to be buried in the United States with his family. His wife is buried beside him. Sydney designed his headstone.

Exhibition catalogue for *Memorial Exhibition of Oil Paintings by W. Elmer Schofield N.A.*, held November 3–26, 1945, at Woodmere Art Gallery

1949

March Snow (1906; ill. p. 49) and *Hill Country* (c. 1913; ill. p. 58) are donated to the Woodmere Art Gallery as a gift of Sydney and Seymour Schofield through Sarah Phillips.

W. Elmer and C. Muriel Schofield's headstone in the cemetery of the Church of St. James the Less on Clearfield Street, adjacent to Laurel Hill Cemetery, in Philadelphia. The stone was designed by the couple's son, Sydney, and it gives Elmer's birth year as 1867. This contradicts the artist's passport and other documents that list 1866 as his year of birth. In the background is the Wanamaker Memorial Bell Tower and Mausoleum, in which are interred the remains of John Wanamaker, founder of the Philadelphia department store. Photograph courtesy of Kimberly Killeri

c. 1950

Baum donates *The Bridge Inn* to the School District of Philadelphia so that students will have direct contact with art.

1952

Sarah and Herbert Phillips donate *Morning Tide—Coast of Cornwall* (c. 1920; ill. p. 70) to the Woodmere Art Gallery.

1976

Group exhibition: *In This Academy: The Pennsylvania Academy of the Fine Arts, 1805–1976*, PAFA, April 22–December 31.

1977–78

Group exhibition: *Turn-of-the-Century America*, Whitney Museum of American Art, New York, June 30–October 2, 1977. *Winter* (1899; ill. p. 32) is included. Travels to the St. Louis Art Museum,

December 1, 1977–January 12, 1978; Seattle Art Museum, February 2–March 12, 1978; and the Oakland Museum of California, April 4–May 28, 1978.

1983

Solo exhibition: *Walter Elmer Schofield: Bold Impressionist*, Brandywine River Museum of Art, Chadds Ford, PA, September 10–November 20 (organized by Thomas Folk).

1984–85

Group exhibition: *The Pennsylvania School of Landscape Painting: An Original American Impressionism*, Allentown Art Museum, PA, September 16–November 25, 1984 (organized by Thomas Folk). Travels to the Corcoran Gallery of Art, Washington, DC, December 14, 1984–February 10, 1985; Westmoreland Museum of American Art, Greensburg, PA, March 2–May 5, 1985; and the Brandywine River Museum of Art, Chadds Ford, PA, June 1–September 2, 1985.

1988

Solo exhibition: *W. Elmer Schofield: Proud Painter of Modest Lands*, Payne Gallery of Moravian College, Bethlehem, PA, November 3–December 11 (organized by Valerie Livingston).

1990

Group exhibition: *The Pennsylvania Impressionists: Painters of the New Hope School*, Taggart and Jorgensen Gallery, Washington, DC, May 4–June 2. Travels to James A. Michener Arts Center (now James A. Michener Art Museum), Doylestown, PA, June 16–August 26.

1991

Solo exhibition: *An American Impressionist: Walter Elmer Schofield*, James A. Michener Art Museum, Doylestown, PA, June 22–November 3.

2002

Group exhibition: *Pennsylvania Impressionism from the Permanent Collection*, Woodmere Art Museum, Philadelphia, September 15–October 20.

2002–3

Group exhibition: *Pennsylvania Impressionism from the Permanent Collection*, Woodmere Art Museum, Philadelphia, November 28, 2002–March 16, 2003.

2004

Group exhibition: *Philadelphia Traditions*, Woodmere Art Museum, Philadelphia, September 18–October 3.

2005–6

Group exhibition: *Objects of Desire*, James A. Michener Art Museum, Doylestown, PA, September 16, 2005–January 15, 2006.

Group exhibition: *Pennsylvania Impressionist Legacy*, Woodmere Art Museum, Philadelphia, September 25, 2005–January 8, 2006.

2006–7

Group exhibition: *Artists of the Commonwealth: Realism and Its Response in Pennsylvania Painting 1900-1950*, Westmoreland Museum of American Art, Greensburg, PA, February 26–May 21, 2006. Travels to Southern Alleghenies Museum of Art, Saint Francis University, Loretto, PA, August 4–November 5, 2006; Erie Art Museum, PA, December 1, 2006–April 8, 2007; James A. Michener Art Museum, Doylestown, PA, May 19–September 2, 2007.

2007

The National Trust, having purchased a portion of Godolphin in 2000, completes the purchase of the estate and makes it accessible to the public.

2011–12

Group exhibition: *The Painterly Voice: Bucks County's Fertile Ground*, James A. Michener Art Museum, Doylestown, PA, October 22, 2011–April 1, 2012 (organized by Brian Peterson).

2014–15

Solo exhibition: *Schofield: International Impressionist*, Woodmere Art Museum, Philadelphia, September 18, 2014–January 25, 2015.

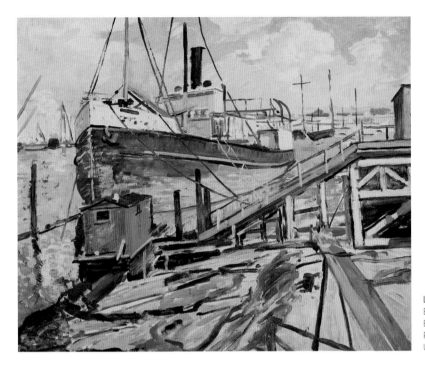

Large Boat at Dock, c. 1934–35, by Walter Elmer Schofield (Gift of Muriel and Philip Berman, Permanent Collection of the Philip and Muriel Berman Museum of Art at Ursinus College)

NOTES

1 Charles H. Caffin, "Our Exhibit at the Paris Exposition," *The Artist: An Illustrated Monthly Record of Arts, Crafts and Industries (American Edition)* 28, no. 246 (July 1900): vii–x.

2 *Catalogue of the Twenty-Eighth Annual Exhibition* (New York: Society of American Artists, 1906), 16.

3 Harrison N. Howard, "Exhibition of the National Academy of Design," *Brush and Pencil* 13, no. 4 (January 1904): 303.

4 M. E. Townsend, "Pittsburgh's Annual Art Exhibition," *Brush and Pencil* 16, no. 6 (December 1905): 199–205.

5 Schofield to Muriel Schofield, June 1908. Schofield Family Archive (formerly Godolphin House, Cornwall, United Kingdom).

6 Schofield to Muriel Schofield, November 18, 1908. Schofield Family Archive (formerly Godolphin House, Cornwall, United Kingdom).

7 John Sloan, *John Sloan's New York Scene: From the Diaries, Notes, and Correspondence, 1906–1913*, ed. Bruce St. John (New York: Harper and Row, 1965), 193–94.

8 John E. D. Trask, *The United States Section, International Fine Arts Expositions at Buenos Aires and at Santiago: Exposición Internacional de Arte del Centenario, Buenos Aires. Exposición Internacional de Bellas Artes, Santiago* (Philadelphia, 1911).

9 "American Oils Abroad," *American Art News* 9, no. 25 (April 1, 1911): 11.

10 "Uruguay Buys Pictures," *American Art News* 9, no. 34 (August 19, 1911): 3.

11 Schofield to Muriel Schofield, January 8, 1912. Schofield Family Archive (formerly Godolphin House, Cornwall, United Kingdom).

12 James B. Townsend, "Annual Carnegie Display," *American Art News* 10, no. 29 (April 27, 1912): 4.

13 "Annual Arts Club Members Display," *American Art News* 11, no. 14 (January 11, 1913): 6.

14 L. Merrick, "Inter'l Carnegie Show," *American Art News* 11, no. 28 (April 26, 1913): 1, 4.

15 Reel 5043, Walter Elmer Schofield Papers, 1885–1974, Archives of American Art, Smithsonian Institution.

16 Schofield to Helen W. Henderson, July 4, 1917. Schofield Family Archive (formerly Godolphin House, Cornwall, United Kingdom).

17 Schofield to Muriel Schofield, March 3, 1918. Schofield Family Archive (formerly Godolphin House, Cornwall, United Kingdom).

18 Schofield to Muriel Schofield, October 29, 1919. Schofield Family Archive (formerly Godolphin House, Cornwall, United Kingdom).

19 Bushnell Dimond, "Philadelphia," *American Art News* 20, no. 10 (December 17, 1921): 8.

20 Jessie C. Glasier, "Cleveland," *American Art News* 20, no. 30 (May 6, 1922): 9.

21 Schofield to Muriel Schofield, May 18, 1924. Letter no. 615, Schofield Family Archive (formerly Godolphin House, Cornwall, United Kingdom).

22 Schofield to Muriel Schofield, February 12, 1937. Letter no. 2.004, Schofield Family Archive (formerly Godolphin House, Cornwall, United Kingdom).

23 "Walter Elmer Schofield; Was Landscape Painter," *New York Herald Tribune*, March 3, 1944, n.p.

The accompanying commentary and descriptive information provided in these catalogue entries draw on the last eight years of my research into my great-grandfather's work. Many miles have been traveled to museum vaults and private homes, which were kindly opened to me, and many of the pictures I've been able to see are included in this list. My dual position as both a researcher and a member of the artist's family has, at times, made for a difficult balancing act. I do not pretend to be objective, but at the same time, I hope to offer unique insights that come from my close relationships with and admiration for family elders who knew and loved Elmer.

It has been an honor to collaborate with Sally Larson, Rachel McCay, Rick Ortwein, and Bill Valerio on the compilation of this checklist. Our goal was to inspire viewers with the beauty and power of my great-grandfather's paintings, and to provide an overview of his achievements. The works selected for the exhibition represent the major directions and developments in his career, as seen in everything from small oil sketches and easel paintings to the large "showpiece" canvases he created for the major salon exhibitions of American art, through which he built his career.

With regard to the histories of the individual paintings that appear in this section of the catalogue, the Woodmere team assisted tirelessly in researching, fact checking, and flagging inconsistencies. Some paintings included here are well documented, with impressive exhibition histories and established provenance. Other paintings have been the subject of extensive new

Newlyn Harbor, Cornwall, c. 1930, by Walter Elmer Schofield (Private Collection)

research. For a few paintings, very little can be deduced at present; the exquisite brushwork and color must speak for themselves.

While we are pleased with and grateful for the many important loans to the exhibition, there are many paintings that we would have liked to include, but which could not be borrowed for a variety of reasons. Nonetheless, I join Woodmere in thanking The Art Institute of Chicago; the Corcoran Gallery of Art, Washington, DC; the Los Angeles County Museum of Art; the Museé d'Orsay, Paris; the National Academy Museum, New York; Godolphin House, National Trust, Cornwall, United Kingdom; The Parthenon Museum, Nashville; and the Penlee House Gallery and Museum, Penzance, United Kingdom for providing the photographs of their paintings that are reproduced in these pages.

JAMES D. W. CHURCH

Alternative titles are given in cases where a painting has been exhibited or published under another title, either during or after the artist's lifetime. Unless otherwise noted, all works are by Walter Elmer Schofield (American, 1866–1944).

1
Winter
Alternate title: **Stream in Winter**
1899
Oil on canvas
29 1/2 x 36 in.
Courtesy of the Pennsylvania Academy of the Fine Arts, Philadelphia, Henry D. Gilpin Fund, 1899.3. Photograph courtesy of Pennsylvania Academy of the Fine Arts

PROVENANCE/OWNERSHIP HISTORY

Purchased by PAFA, 1899

EXHIBITION HISTORY

1899 PAFA: *68th Annual Exhibition*, no. 23, January 16–February 5

1901 Pan-American Exhibition, Exhibition of Fine Arts, Buffalo, no. 530, May 1–November 1 (awarded Silver Medal)

1945 Woodmere Art Gallery (now Woodmere Art Museum), Philadelphia: *Memorial Exhibition of Oil Paintings by W. Elmer Schofield N.A.*, no. 26, November 3–26

1976 PAFA: *In This Academy: The Pennsylvania Academy of the Fine Arts, 1805–1976*, no. 204, April 22–December 31

1977–78 Whitney Museum of American Art, New York: *Turn-of-the-Century America*, June 30–

October 2. Traveled to St. Louis Art Museum, December 1, 1977–January 12, 1978; Seattle Art Museum, February 2–March 12, 1978; and the Oakland Museum of California, April 4–May 28, 1978

1983 Brandywine River Museum of Art, Chadds Ford, PA: *Walter Elmer Schofield: Bold Impressionist*, no. 41, September 10–November 20

1984–85 Allentown Art Museum, PA: *The Pennsylvania School of Landscape Painting: An Original American Impressionism*, September 16–November 25, 1984. Traveled to the Corcoran Gallery of Art, Washington, DC, December 14, 1984–February 10, 1985; Westmoreland Museum of American Art, Greensburg, PA, March 2–May 5, 1985; and the Brandywine River Museum of Art, Chadds Ford, PA, June 1–September 2, 1985

1997–98 PAFA: *Light, Air, and Color: American Impressionist Landscapes*, December 27, 1997–January 9, 1998

2011 Independence Seaport Museum, Philadelphia: *Drawn to the Water: Artists of the Pennsylvania Academy of the Fine Arts Capture Our Region's Waterways, 1830 to Present*, April 15–December 31

PUBLISHED REFERENCES

Boyle, Richard J. *American Impressionism*. Boston: New York Graphic Society, 1974

Danly, Susan. *Light, Air, and Color: American Impressionist Paintings from the Collection of the Pennsylvania Academy of the Fine Arts*. Philadelphia: Pennsylvania Academy of the Fine Arts, 1990

Folk, Thomas. *The Pennsylvania School of Landscape Painting: An Original American Impressionism*. Allentown, PA: Allentown Art Museum, 1984

Folk, Thomas. *Walter Elmer Schofield: Bold Impressionist*. Chadds Ford, PA: Brandywine River Museum of Art, 1983

Henderson, Helen W. *The Pennsylvania Academy of the Fine Arts and Other Collections of Philadelphia*. Boston: L. C. Page and Company, 1911

Pennsylvania Academy of the Fine Arts. *In This Academy: The Pennsylvania Academy of the Fine Arts, 1805–1976*. Philadelphia: Pennsylvania Academy of the Fine Arts, 1976

Poore, Henry Rankin. *Pictorial Composition and the Critical Judgment of Pictures*. New York and London: G. P. Putnam's Sons, 1903 (as *Stream in Winter*)

Ziegler, Francis J. "Sixty-Eighth Annual Exhibition of the Pennsylvania Academy of the Fine Arts." *Brush and Pencil* 3, no. 5 (February 1899): 288–89, 291–96 (as *A January Evening*, perhaps confused with Schofield's other entry, no. 19, at the same exhibition)

COMMENTARY

This important early painting is a prime example of the still winter landscapes with which Schofield initially made a name for himself. *Winter* was his first major breakthrough—his school, the Pennsylvania Academy of the Fine Arts (PAFA), purchased it for $200.[1] Henry Rankin Poore, an instructor at PAFA, included it in his influential 1903 book, *Pictorial Composition and the Critical Judgment of Pictures*.[2] Schofield also selected it as one of the four pictures to represent him at the 1901 Pan-American Exhibition, Buffalo, where it received a Silver Medal.

NOTES

1 Harrison S. Morris to Schofield, date unknown. 1897–1901 Scrapbook, Schofield Family Archive (formerly Godolphin House, Cornwall, United Kingdom).

2 Poore, *Pictorial Composition*, 127.

2
January Woods
1900
Oil on canvas
30 x 36 in.
Private Collection

PROVENANCE/OWNERSHIP HISTORY

Collection of W. G. Hermann

Private Collection

Private Collection

EXHIBITION HISTORY

1900–
1901
Carnegie Institute (now Carnegie Museum of Art), Pittsburgh: *5th Annual Exhibition*, November 1, 1900–January 1, 1901

COMMENTARY

Schofield exhibited two paintings, *January Woods* and *Twilight* (date and location unknown), at the Carnegie Institute *Annual Exhibition* in 1900. He received one of two Honorable Mentions for *Twilight* and was offered $600 for the purchase of both paintings. *Twilight* entered the collection of Willis F. McCook, lawyer to Henry Clay Frick.[1] However, a notice adhered to the back lists a "W. G. Hermann" as the return address in Schofield's handwriting. Hermann was the original owner of *January Woods*.

NOTES

1 John Beatty, Carnegie Institute, Pittsburgh, to Schofield, undated. 1897–1901 Scrapbook, Schofield Family Archive (formerly Godolphin House, Cornwall, United Kingdom).

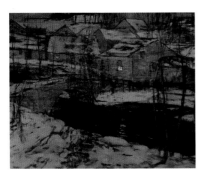

3

A Midwinter Thaw

Alternate title: **Winter Landscape**

c. 1901

Oil on linen

31 7/8 x 39 1/2 in.

Gift of Muriel and Philip Berman, Permanent Collection of the
Philip and Muriel Berman Museum of Art at Ursinus College

PROVENANCE/OWNERSHIP HISTORY

Cincinnati Art Museum purchase, 1902 (deaccessioned)

Collection of Muriel and Philip Berman

Placed on long-term loan at the Philip and Muriel
Berman Museum of Art at Ursinus College, October
1990

Gifted to the Philip and Muriel Berman Museum of Art
at Ursinus College, June 1992

EXHIBITION HISTORY

1902 PAFA: *71st Annual Exhibition*, no. 44, January
 20–March 1

1988 Payne Gallery of Moravian College,
 Bethlehem, PA: *W. Elmer Schofield: Proud
 Painter of Modest Lands*, no. 1 (as *Winter
 Landscape*), November 3–December 11

1990 Philip and Muriel Berman Museum of Art,
 Collegeville, PA (as *Winter Landscape*),
 October 19–November 25

1991 James A. Michener Art Museum, Doylestown,
 PA: *An American Impressionist: Walter Elmer
 Schofield* (as *Winter Landscape*), June 22–
 November 3

1993 Susquehanna University Art Gallery,
 Selinsgrove, PA: *Walter Elmer Schofield:
 Proud Painter of Modest Lands* (as *Winter
 Landscape*), March 19–April 18

1997–98 Westmoreland Museum of American Art,
 Greensburg, PA: *An American Tradition: The
 Pennsylvania Impressionists*, April 13–July 13,
 1997. Traveled to Florence Griswold Museum,
 Old Lyme, CT, October 5–November 30,
 1997; Dixon Gallery and Gardens, Memphis,
 December 14, 1997–February 22, 1998;
 Gibbes Museum of Art, Charleston, SC,
 March 28–May 10, 1998; and Woodmere Art
 Museum, Philadelphia, June 6–August 5,
 1998

2002–4 James A. Michener Art Museum, Doylestown,
 PA: *Earth, River and Light: Masterworks of
 Pennsylvania Impressionism*, September
 21–December 29, 2002. Traveled to
 Florence Griswold Museum, Old Lyme, CT,
 June 28–September 28, 2003; Greenville
 County Museum of Art, SC, November 19,
 2003–January 18, 2004; and Leigh Yawkey
 Woodson Art Museum, Wausau, WI,
 February 7–April 10, 2004

2007 Cantor Fitzgerald Gallery, Haverford College,
 PA: *The Pennsylvania Landscape Colonial to
 Contemporary* (as *Winter Landscape*), March
 2–April 1

PUBLISHED REFERENCE

Livingston, Valerie. *W. Elmer Schofield: Proud Painter
of Modest Lands*. Bethlehem, PA: Moravian College,
1988

COMMENTARY

Schofield exhibited this painting as *A Midwinter Thaw*
at PAFA in 1902. It was purchased the same year by
the Cincinnati Art Museum with accession number
1902.9, as recorded in red paint on the stretcher. It
was later deaccessioned by the museum, possibly
in the late 1940s, although records remain unclear.
It was around this time that the artist Walter Baum
introduced his friends and patrons Muriel and Philip
Berman to Schofield's art. The Bermans acquired the
painting and later gave it to the museum at Ursinus
College that carries their name. *Winter Landscape* is a
descriptive title that the Bermans gave the painting; it
is likely that they were unaware of the artist's original
title, *A Midwinter Thaw*.

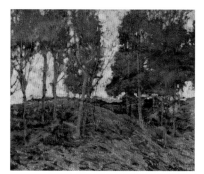

4
Breezy Day, Early Autumn
c. 1902
Oil on canvas
30 x 36 in.

Reading Public Museum, Reading, PA. Photograph courtesy of
Reading Public Museum, Reading, PA

PROVENANCE/OWNERSHIP HISTORY

Dr. Alexander C. Humphreys, by 1914

Mr. W. E. Dickey

Purchased by the Reading Public Museum, 1928

EXHIBITION HISTORY

1903 PAFA: *72nd Annual Exhibition*, no. 107,
 January 19–February 28 (awarded Jennie
 Sesnan Gold Medal)

1914 Toledo Museum of Art, OH: *An Exhibition
 of Paintings Lent by Dr. A. C. Humphreys, of
 New York City, to the Toledo Museum of Art*,
 no. 136, July–September

2011–14 Reading Public Museum, Reading, PA:
 *American Impressionism: The Lure of the
 Artists' Colony*, September 24, 2011–January
 29, 2012. Traveled to the Museum of the
 Shenandoah Valley, Winchester, VA, June
 1–August 4, 2013; Ella Sharp Museum of Art
 and History, Jackson, MI, October 26, 2013–
 January 11, 2014; and Peninsula Fine Arts
 Center, Newport News, VA, January 25–April
 20, 2014

COMMENTARY

Dr. Alexander C. Humphreys was the second
president of the Stevens Institute of Technology,
Hoboken, New Jersey, and an expert on gas
lighting. He assembled a well-known art collection

that included Winslow Homer's *Perils of the Sea*
(1881, now at the Clark Art Institute) and Thomas
Eakins's *Professionals at Rehearsal* (1883, now at
the Philadelphia Museum of Art). Humphreys sold
this painting, together with a significant portion of
his collection, in 1917. *Breezy Day, Early Autumn* was
eventually purchased by the Reading Public Museum
on March 31, 1928.[1]

NOTES

1 Curatorial file (28.69-1), Reading Public Museum, Reading, PA.

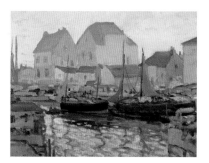

5
Docks, Penzance
Alternate title: **Harbor Scene in Cornwall**
1903
Oil on canvas
20 1/2 x 26 1/2 in.

Collection of Maureen and Gregory Church

PROVENANCE/OWNERSHIP HISTORY

Estate of the artist

By descent in the family to Sarah and Herbert Louis
Phillips

By descent in the family to Margaret E. Phillips

Collection of Maureen and Gregory Church

EXHIBITION HISTORY

1904 Art Club of Philadelphia: *Special Exhibition
 of Landscapes by W. Elmer Schofield*,
 February 7–20

1945 Woodmere Art Gallery, Philadelphia:
 *Memorial Exhibition of Oil Paintings by W.
 Elmer Schofield N.A.*, no. 2 (possibly as
 Harbor Scene in Cornwall), November 3–26

1983 Brandywine River Museum of Art, Chadds Ford, PA: *Walter Elmer Schofield: Bold Impressionist*, September 10–November 20

PUBLISHED REFERENCE

Folk, Thomas. *Walter Elmer Schofield: Bold Impressionist*. Chadds Ford, PA: Brandywine River Museum of Art, 1983.

COMMENTARY

Schofield first visited Cornwall in 1903, traveling to Penzance and Newlyn, on the southern coast of the United Kingdom, before heading north to St. Ives. His first letter from St. Ives, written in April, records how it "beats Penzance/Newlyn to my mind."[1] His palette became lighter at this time. This painting retains what is thought to be its original frame, with wreathed top edges and applied floral cartouches.

NOTES

1 Schofield to Muriel Schofield, April 30, 1903. Letter no. 511, Schofield Family Archive (formerly Godolphin House, Cornwall, United Kingdom).

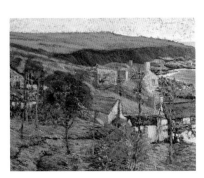

6
Zennor Cove—Coast of Cornwall
Alternate titles: **Coast Cornwall**; **St. Ives**
1903
Oil on canvas
32 1/4 x 39 1/2 in.
Woodward Collection

PROVENANCE/OWNERSHIP HISTORY

Purchased by Mrs. Gertrude and Dr. George Woodward, 1904

Woodward Collection

EXHIBITION HISTORY

1904 PAFA: *73rd Annual Exhibition*, no. 125, January 25–March 5

1910 Buffalo Fine Arts Academy: *5th Annual Exhibition of Selected Paintings by American Artists*, no. 194 (as *Coast Cornwall*), May 11–September 1

1945 Woodmere Art Gallery, Philadelphia: *Memorial Exhibition of Oil Paintings by W. Elmer Schofield N.A.*, no. 3 (as *St. Ives*), November 3–26

COMMENTARY

Zennor Cove—Coast of Cornwall is an important painting from Schofield's first year in Cornwall, following his arrival in April 1903.[1]

In an undated letter written in early 1904, Schofield announced to his wife that he had sold one of his pictures on display at PAFA for $800 to "Dr. Woodward—a very wealthy man" who "seem[ed] quite enthusiastic over it too." This was *Zennor Cove—Coast of Cornwall*. It was subsequently shown in 1910 as *Coast Cornwall* and, although it might seem unusual for Schofield to have exhibited such an early work at that date, we can be reasonably certain that this was the same picture due to the Woodward ownership credit included in the Buffalo Academy catalogue.

Zennor is a small and ancient village in Penwith, a district of rugged hills in the west of St. Ives, and on the north coast of Cornwall. This is the only known work Schofield painted in the area before World War I.

NOTES

1 Schofield to Muriel Schofield, February 1904. Schofield Family Archive (formerly Godolphin House, Cornwall, United Kingdom).

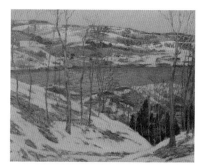

7
Across the River
c. 1904
Oil on canvas
38 x 48 in.

Carnegie Museum of Art, Pittsburgh; Purchase, 05.2. Photograph © 2014 Carnegie Museum of Art, Pittsburgh

PROVENANCE/OWNERSHIP HISTORY

Purchased by the Carnegie Institute (now the Carnegie Museum of Art) from the *9th Annual Exhibition*, 1905

EXHIBITION HISTORY

1904–5 Carnegie Institute, Pittsburgh: *9th Annual Exhibition*, November 3, 1904–January 1, 1905 (purchased by the Carnegie Institute for $1,500) (awarded Gold Medal of the First Class)

1912 Carnegie Institute, Pittsburgh: *An Exhibition of Paintings by W. Elmer Schofield*, no. 30, February 12–25

1983 Brandywine River Museum of Art, Chadds Ford, PA: *Walter Elmer Schofield: Bold Impressionist*, September 10–November 20

PUBLISHED REFERENCES

Folk, Thomas. *The Pennsylvania Impressionists*. Madison, NJ: Fairleigh Dickinson University Press, 1997

Folk, Thomas. *The Pennsylvania School of Landscape Painting: An Original American Impressionism*. Allentown, PA: Allentown Art Museum, 1984

Folk, Thomas. *Walter Elmer Schofield: Bold Impressionist*. Chadds Ford, PA: Brandywine River Museum of Art, 1983, 16, cat. no. 1

Livingston, Valerie. *W. Elmer Schofield: Proud Painter of Modest Lands*. Bethlehem, PA: Moravian College, 1988

"Prize Winning Pictures in Pittsburg Contest." *New York Times*, November 6, 1904 (ill.)

Tovey, David. *Pioneers of St Ives Art at Home and Abroad (1889-1914)*. Tewkesbury, UK: Wilson Books, 2008, 281, 311-12

COMMENTARY

Across the River seems to have been the source of a dispute between Schofield and his colleague Edward Willis Redfield. Redfield believed that Schofield's configuration of land and water was directly "stolen" from a composition he had planned to execute, based on the view near his home along the Delaware River in New Hope, Pennsylvania.[1] As described on pp. 52–58, Schofield's contemporary correspondence with friend and fellow artist John Sloan in 1904 reflects a competitive antagonism between the two, but also suggests a more complex version of events.[2]

Regardless of this drama, *Across the River* is an important painting in Schofield's oeuvre. Schofield was given an honorary dinner at the Art Club of Philadelphia, a social club and organization for the support of the arts near the intersection of Broad and Chancellor Streets (now demolished), in celebration of the award it won at the Carnegie Institute's *9th Annual Exhibition*.[3] The painting was purchased for the Carnegie Institute's permanent collection for $1,500—more than seven times the sum paid for *Winter* (1899; ill. p. 32) a mere five years before.[4]

NOTES

1 First discussed by Thomas Folk based on a recorded interview between Redfield and Robert Lippincott, March 4, 1963. See Folk, *Walter Elmer Schofield*, 18.

2 In one letter, Schofield drew a caricature of Sloan cutting coupons for a "First Prize Pittsburgh" medal with a gift tag that reads "To John Sloan from E.W.R. [Edward Willis Redfield]." Schofield to John Sloan, October 23, 1904. John Sloan Manuscript Collection, Delaware Art Museum.

3 Schofield to Muriel Schofield, 1905. Reel 5043, Walter Elmer Schofield Papers, Archives of American Art, Smithsonian Institution.

4 John Beatty to Schofield, December 16, 1904. Schofield Family Archive (formerly Godolphin House, Cornwall, United Kingdom).

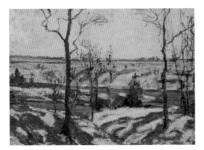

8

Lelant

c. 1904

Oil on canvasboard

9 x 10 1/2 in.

Private Collection

PROVENANCE/OWNERSHIP HISTORY

Estate of the artist

By descent in the family to Mary and Sydney E. Schofield

Private Collection

EXHIBITION HISTORY

2008 Penlee House Gallery and Museum, Penzance, United Kingdom: *Dawn of a Colony: Lyrical Light, St Ives 1889–1914*, June 14–September 13

2011 Falmouth Art Gallery, United Kingdom: *British Impressionists in Cornwall and Cornish Collections*, no. 4, June 25–September 10

PUBLISHED REFERENCE

Tovey, David. *Pioneers of St Ives Art at Home and Abroad (1889–1914)*. Tewkesbury, UK: Wilson Books, 2008, 121–22

COMMENTARY

Canvasboard is a manufactured composite painting board, consisting of a stiff, pressed fiber backing with primed canvas adhered to its front surface. Schofield brought these inexpensive and portable panels on his painting expeditions. *Lelant* is his earliest known study on canvasboard. Another example included in this exhibition is *River Exe* (1925–27; ill. p. 109).

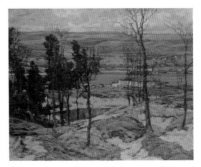

9

Sand Dunes near Lelant, Cornwall, England

Alternate titles: **Sand Dunes, Lelant**; **Sand Dunes near Lelant**

1905

Oil on canvas

38 x 48 in.

Lent by The Metropolitan Museum of Art, George A. Hearn Fund, 1909 (09.26.1). Image © The Metropolitan Museum of Art. Image source: Art Resource, NY

PROVENANCE/OWNERSHIP HISTORY

Collection of George A. Hearn Esq., 1906

The Metropolitan Museum of Art, George A. Hearn Fund, 1909

EXHIBITION HISTORY

1906 PAFA: *101st Annual Exhibition*, no. 27, January 22–March 3

Society of American Artists, New York: *28th Annual Exhibition*, no. 355 (as *Sand Dunes, Lelant*), March 17–April 22 (purchased by George A. Hearn for $1,000)

1983 Brandywine River Museum of Art, Chadds Ford, PA: *Walter Elmer Schofield: Bold Impressionist*, no. 38, September 10–November 20

PUBLISHED REFERENCES

The Collector and Art Critic 4, no. 8 (June 1906): 253 (as *Sand Dunes, Lelant*)

Folk, Thomas. *Walter Elmer Schofield: Bold Impressionist*. Chadds Ford, PA: Brandywine River Museum of Art, 1983, 8, cat. no. 38

Hind, C. Lewis. "An American Landscape Painter: W. Elmer Schofield." *The International Studio* 48, no. 192 (February 1913): 280–89 (ill., as *Sand Dunes near Lelant*)

Hoeber, Arthur. "W. Elmer Schofield: A Painter in the Open." *Arts and Decoration* 1, no. 12 (October 1911): 473-75, 492 (ill., as *Sand Dunes near Lelant*)

Tovey, David. *Pioneers of St Ives Art at Home and Abroad (1889-1914)*. Tewkesbury, UK: Wilson Books, 2008, 281-82

COMMENTARY

Lelant is a large village on the western bank of the Hayle estuary, on the main coast road and branch rail to St. Ives. The Hayle River is bordered by extensive sand dunes, or "towans," as they are known locally. This painting is thought to be a view from Lelant—possibly from somewhere near St. Uny's Church across the river toward the sand dunes above the town of Hayle in the distance.

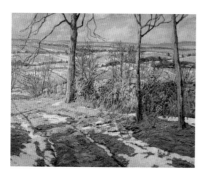

10
March Snow
1906
Oil on canvas
38 x 48 in.
Woodmere Art Museum: Gift of Sydney E. and Seymour Schofield, 1949

PROVENANCE/OWNERSHIP HISTORY

Purchased by Charles C. Glover, president of the Corcoran Gallery of Art, Washington, DC, 1912

Returned to artist, by 1935

Estate of the artist

By descent in the family to Sydney E. and Seymour Schofield

Donated to Woodmere Art Museum, 1949

EXHIBITION HISTORY

1909 Art Club of Philadelphia: *20th Annual Exhibition*, no. 25, October 29-December 5

1912 Corcoran Gallery of Art, Washington, DC: *Paintings by W. Elmer Schofield*, no. 2, January 20-February 5

1983 Brandywine River Museum of Art, Chadds Ford, PA. *Walter Elmer Schofield: Bold Impressionist*, September 10-November 20

1984-85 Allentown Art Museum, PA: *The Pennsylvania School of Landscape Painting: An Original American Impressionism*, September 16-November 25, 1984. Traveled to the Corcoran Gallery of Art, Washington, DC, December 14, 1984-February 10, 1985; Westmoreland Museum of American Art, Greensburg, PA, March 2-May 5, 1985; and the Brandywine River Museum of Art, Chadds Ford, PA, June 1-September 2, 1985

1992 Brandywine River Museum of Art, Chadds Ford, PA: *The Land of the Brandywine*, June 6-September 7

2001-2 Woodmere Art Museum, Philadelphia: *Works from the Permanent Collection*, December-February

2002 Woodmere Art Museum, Philadelphia: *Pennsylvania Impressionism from the Permanent Collection*, September 15-October 20

2002-3 Woodmere Art Museum, Philadelphia: *Pennsylvania Impressionism from the Permanent Collection*, November 28, 2002-March 16, 2003

2004 Woodmere Art Museum, Philadelphia: *Delaware Valley Traditions*, April 18-July 3

2005-6 Woodmere Art Museum, Philadelphia: *Pennsylvania Impressionist Legacy*, September 25, 2005-January 8, 2006

2011-12 James A. Michener Art Museum, Doylestown, PA: *The Painterly Voice: Bucks County's Fertile Ground*, October 22, 2011-April 1, 2012

PUBLISHED REFERENCES

Folk, Thomas. *The Pennsylvania School of Landscape Painting: An Original American Impressionism*. Allentown, PA: Allentown Art Museum, 1984, 49-50

Folk, Thomas. *Walter Elmer Schofield: Bold Impressionist*. Chadds Ford, PA: Brandywine River Museum of Art, 1983, 18, 19, 37

Henderson, Helen W. *The Art Treasures of Washington*. Boston: L. C. Page and Company, 1912

Hind, C. Lewis. "An American Landscape Painter: W. Elmer Schofield." *The International Studio* 48, no. 192 (February 1913): 280–89

Hoeber, Arthur. "W. Elmer Schofield: A Painter in the Open." *Arts and Decoration* 1, no. 12 (October 1911): 473–75, 492 (ill.)

COMMENTARY

The director of the Corcoran Gallery of Art, C. Powell Minnigerode, wrote to Schofield in 1912. He notified the artist that the president of the Corcoran, Charles C. Glover, a prominent Washington banker, philanthropist, and art collector, had offered to purchase *March Snow*, which was then on view in a solo exhibition of the artist's work, for $900. Glover would relinquish his claim to the painting if another purchaser offered the asking price of $1,250.[1] Schofield wrote to his wife, Muriel,

> I am just back from Washington after seeing the Ex. well launched and am glad to tell you dear that there was a picture sold the first day—and I think another as good as sold to Mr. Glover, the Pres. of the gallery and a man of great power and wealth in Washington. . . . I have two galleries and am showing 46 canvases—quite a number I confess but they are good ones and not just padding. . . . This year is going to be a better year for us, my dear—and I do hope our days of almost poverty are over—at all events, precarious living.[2]

Glover's ownership is confirmed in a description of the picture by Helen W. Henderson:

> *March Snow*, in the collection of Mr. Glover, is characteristic of the more personal type of Schofield's work, with its decorative design, its arbitrary greys and broad handling. Schofield is a vigorous, strong and charming personality, and much of himself is reflected in his work.[3]

The circumstance of this important painting's return to the artist is curious. Schofield consigned a number of canvases to Grand Central Art Galleries in New York in 1935, with *March Snow* listed among them. It is possible that it had been part of an exchange with Glover in the 1920s for a more recent work,

The Rapids in Winter (c. 1919; ill. p. 5). As noted in *American Art News* in April 1923, an anonymous "head" of a museum had purchased *The Rapids in Winter* and, with the painting having been shown several times at the Corcoran, we can surmise that this was Glover. The Corcoran Gallery itself had exchanged a previously owned painting of unknown title for the more recent *Cliff Shadows* (1921; ill. p. 69) in 1921.

NOTES

1 C. Powell Minnigerode to Schofield, January 23, 1912. Schofield Family Archive (formerly Godolphin House, Cornwall, United Kingdom).

2 Schofield to Muriel Schofield, March 27, 1912. Letter no. 660, Schofield Family Archive (formerly Godolphin House, Cornwall, United Kingdom).

3 Henderson, *The Art Treasures of Washington*, 146.

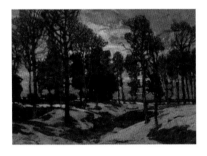

11
January Day
Alternate titles: **Cloud Shadows; A January Day**
c. 1906
Oil on canvas
45 1/2 x 60 1/2 in.
Collection of Renny Reynolds and Jack Staub

PROVENANCE/OWNERSHIP HISTORY

Cincinnati Art Museum, purchased 1907 (1907.192) (deaccessioned 1945)

Coleman Galleries, New York

Babcock Galleries, New York

Collection of Renny Reynolds and Jack Staub

EXHIBITION HISTORY

1906 Art Institute of Chicago: *19th Annual Exhibition of Oil Paintings and Sculpture by American Artists*, no. 272 (as *Cloud Shadows*), October 16–November 29

1907 Royal Society of British Artists, London:
 Winter Exhibition, no. 223

 Cincinnati Art Museum: *14th Annual
 Exhibition*, no. 54, May 18–July 17 (purchased
 by the Cincinnati Art Museum, Annual
 Membership Fund)

PUBLISHED REFERENCES

"Art Notes" (from "The Outlook"). *St. Ives Weekly
Summary*, November 16, 1907, 10 (as *January Day*)

Bryant, Lorinda Munson. *American Pictures and Their
Painters*. New York and London: John Lane Company,
1917 (fig. 149) (as *January Day*)

Jackman, Rilla Evelyn. *American Arts*. New York and
Chicago: Rand McNally and Company, 1928 (pl. 89)

COMMENTARY

January Day is unusual in having been exhibited in
both the United Kingdom and the United States
during Schofield's lifetime. It appears to have been
shown for the first time in 1906 at the Art Institute
of Chicago's *19th Annual Exhibition*. However, it is
identified in the catalogue as *Cloud Shadows*.[1]

Throughout his life, Schofield made a concerted
effort to be recognized and build a career in the
United Kingdom. He made his first successful
submission to the Royal Academy of Arts in 1905; he
was elected to the Chelsea Arts Club in 1907;[2] and he
participated in the Franco-British Exhibition of 1908.
January Day was first shown at the Royal Society of
British Artists in 1907, after Schofield had become a
member. It was well received, with one critic praising:

> A brand-new R.B.A., Mr. W. E. Schofield, should
> ably justify election. His *A January Day* reaches
> below the surface aspect to touch some strong
> suggestion of the dreary cruelty of Nature; it
> cries to us the sombre hopelessness and bitter
> gloom of winter; since Fritz Thaulow, in this
> class, we recall no better picture.[3]

That same year it was included in the Cincinnati
Art Museum's *14th Annual Exhibition*, and was
purchased for the museum's permanent collection.
An extensive description of *January Day* appears in
Lorinda Munson Bryant's *American Pictures and Their
Painters*:

> One would scarcely think of using scenes from
> a snow-covered field, a river of broken ice,
> or shadeless trees scattered over undulating
> ground ornamented with snow-patches for

decorative patterns, yet Mr. Schofield does.
His pictures are like so many patterns for
tapestry work and varied as those taken from
a kaleidoscope. When he painted "A January
Day," Cincinnati Museum, he attained just that
quality of atmospheric illusiveness that leads
us through this open wood into the fields and
then beyond into the unknown. . . . The spirit of
winter is in this open wood. The dancing light
and shade, the blue cloud-flecked sky, the tall
grey trees, and the shorter glossy green ones,
the whistling wind creaking the bare branches
and soughing in the evergreens—Mr. Schofield
has made us conscious of it all.[4]

NOTES

1 A photograph of the east half of the north wall in Gallery 27 at the Art
 Institute of Chicago includes this canvas. The photograph is stamped
 "Frederic C. Remm, Photographer, Art Institute of Chicago." Three
 pictures were exhibited by Schofield that year. Reel 5043, Walter Elmer
 Schofield Papers, Archives of American Art, Smithsonian Institution.

2 Candidate Book, Chelsea Arts Club Archives, Chelsea Old Town Hall,
 United Kingdom. Schofield was nominated by Algernon Talmage and
 Charles Napier Hemy.

3 "Art Notes," *St. Ives Weekly Summary*.

4 Bryant, *American Pictures and Their Painters*, 195–96.

12
The Old Abbey
c. 1906
Oil on canvas
18 1/2 x 23 in.
Private Collection

COMMENTARY

This canvas, known by a descriptive title, *The Old Abbey*, is a plein-air composition painted by Schofield in a fresh, direct manner during one of his many trips to France in the first decade of the twentieth century.

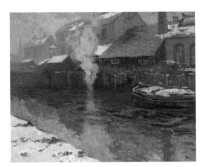

13
Winter in Picardy
1907
Oil on canvas
38 1/2 x 48 in.

Philadelphia Museum of Art: Gift of Dr. and Mrs. George Woodward, 1939-7-18. Photograph courtesy of Philadelphia Museum of Art

PROVENANCE/OWNERSHIP HISTORY

Purchased by Mrs. Gertrude and Dr. George W. Woodward, by 1913

Donated to the Philadelphia Museum of Art by Dr. and Mrs. George Woodward, 1939

EXHIBITION HISTORY

1908 PAFA: *103rd Annual Exhibition*, no. 120, January 20–February 29

National Academy of Design, New York: *83rd Annual Exhibition*, no. 312, March 14–April 18

Carnegie Institute, Pittsburgh: *12th Annual Exhibition*, no. 285, April 30–June 30

PUBLISHED REFERENCES

Harrison, Birge. *Landscape Painting*. New York: Charles Scribner's Sons, 1909, 160 (pl. opp. 154)

Hind, C. Lewis. "An American Landscape Painter: W. Elmer Schofield." *The International Studio* 48, no. 192 (February 1913): 280–89

COMMENTARY

Schofield first exhibited *Winter in Picardy* at PAFA's *Annual Exhibition* in 1908, alongside *The Old Mills on the Somme* (c. 1907). One of the artist's earliest known paintings of an industrial subject, it was included in a rare formal portrait of Schofield in his St. Ives studio, taken by his close friend W. Herbert Lanyon in 1907 (ill. p. 98). Its selection for the photograph suggests that Schofield considered it to be noteworthy, though he appears to have made some slight alterations after the picture was taken.

Winter in Picardy was in the possession of Dr. George W. Woodward by 1913. He later donated it to the Philadelphia Museum of Art. The Woodwards were friends and notable collectors of Schofield's work; at their home in Chestnut Hill, Krisheim, they displayed *Zennor Cove—Coast of Cornwall* (1903; ill. p. 53) and *Winter in Picardy* in their dining room as a pair alongside paintings by Redfield, Edmund Charles Tarbell, Gari Melchers, and Joseph Pearson.

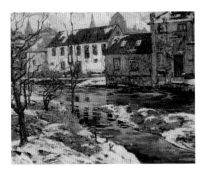

14
The Old Mills on the Somme
c. 1907
Oil on canvas
37 x 47 1/2 in.

Indianapolis Museum of Art, Julius Pratt Fund, 09.362. Photograph courtesy of Indianapolis Museum of Art

PROVENANCE/OWNERSHIP HISTORY

Purchased by the Indianapolis Museum of Art, 1909

EXHIBITION HISTORY

1908 PAFA: *103rd Annual Exhibition*, no. 134, January 20–February 29

National Academy of Design, New York: *83rd Annual Exhibition*, no. 308, March 14–April 18

Buffalo Fine Arts Academy: *3rd Annual Exhibition of Selected Paintings by American Artists*, no. 117, April 30–August 30

1908–9 John Herron Art Institute, Indianapolis: *24th Annual Exhibition*, no. 60, December 6, 1908–January 4, 1909 (purchased by John Herron Art Association)

1909 Art Institute of Chicago: *American Oil Paintings and Sculpture 22nd Annual*, no. 224, October 19–November 28

1983 Brandywine River Museum of Art, Chadds Ford, PA: *Walter Elmer Schofield: Bold Impressionist*, no. 31, September 10–November 20

PUBLISHED REFERENCES

Academy Notes (Buffalo) 4, no. 2 (July 1908): 19

Bryant, Lorinda Munson. *American Pictures and Their Painters*. New York and London: John Lane Company, 1917 (fig. 150)

Folk, Thomas. *Walter Elmer Schofield: Bold Impressionist*. Chadds Ford, PA: Brandywine River Museum of Art, 1983, 22

COMMENTARY

The Old Mills on the Somme was probably painted during the spring of 1907. Schofield did not generally seek out tourist destinations in France, but rather more industrial towns such as Picquigny. His account of Picquigny in a letter to his wife emphasizes the requirements of his intensive painting expeditions:

> I am comfortably settled here and find the place what I want—and very quiet and nice to work [in]—nothing to distract and in winter it would be my ideal—The town itself is quite dead, as all the people here work in the mills thro' the daytime and the streets are deserted—it is larger than I thought, having a population of probably 3 or 4000. But it is a good find for me.[1]

The church in the center of the painting appears to be Saint Saulve of Montreuil-sur-Mer, a town Schofield painted in 1906—perhaps added to enliven the roofline of the mills. The canvas was described by the critic Lorinda Munson Bryant as,

. . . a quiet scene, yet we feel that the whirr of the stones and the hum of the belts fill the air with the music of industry. The open door and the snug well-kept air of the buildings indicates the thrift of labour. The ancient buildings beside the picturesque, ragged old stream, peer anxiously into the deeper pool and smile as they see their own faces. The snow clinging to the stones and water-grass seems to catch up the smile and give it back to us. The shimmer of green and purple-brown that lurks in the shadows and around the bare trees has the tantalising quality of the opal and defies too close scrutiny of its exact tint.[2]

Although Schofield did not win any significant awards between 1904 and 1910, he made a number of important sales of works such as this to museums and individual collectors, ensuring a slightly higher level of financial security. This painting was purchased by the Indianapolis Museum of Art in 1909.

NOTES

1 Schofield to Muriel Schofield, April 12, 1907. Schofield Family Archive (formerly Godolphin House, Cornwall, United Kingdom)

2 Bryant, *American Pictures and Their Painters*, 196-97.

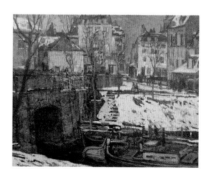

15
Winter on the Somme
c. 1907
Oil on canvas
38 x 48 in.
Private Collection. Photograph courtesy of Gratz Gallery

EXHIBITION HISTORY

1908 Carnegie Institute, Pittsburgh: *12th Annual Exhibition*, no. 284, April 2–June 30

1908–9 National Academy of Design, New York: *Winter Exhibition*, no. 8, December 12, 1908–January 9, 1909

1909 PAFA: *104th Annual Exhibition*, no. 560, January 31–March 14

COMMENTARY

The location of this winter canal scene is not known for certain, but it could be the town of Picquigny, France. Schofield's friend Burt Barnes described painting with him there, along the Somme river:

> While in France with him, I had the opportunity to see him work . . . I have seen him cover one of those canvases with a thing that breathed in something like two hours. The more I saw paint the more I marveled. He did it so rapidly and easily . . . On that trip we were at Picquigny, on the Somme, which is now the British Front. I wonder if he chanced to pass through Picquigny, and if he thought of the days when he painted there.[1]

NOTES

1 Typescript of Burt Barnes, "On Artists I Have Known," 1916: 14. Schofield Family Archive (formerly Godolphin House, Cornwall, United Kingdom).

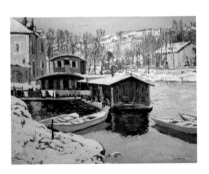

16
Moret, France
Alternate titles: **Winter on the Canal**; **Winter Scene**
1909
Oil on canvas
30 x 38 in.
Collection of Carol and Louis Della Penna

PROVENANCE/OWNERSHIP HISTORY

Newman Galleries, Philadelphia, by 1933

Acquired by the Insurance Company of North America (INA) (now CIGNA), by 1938

CIGNA Museum and Art Collection

Collection of Carol and Louis Della Penna

EXHIBITION HISTORY

1984–85 Fort Lauderdale Museum of Art, FL: *American Impressionism: The New Hope Circle* (as *Winter on the Canal*), December 5, 1984–January 27, 1985

1994 Bianco Gallery, Buckingham, PA: *The Byers' Annual Bucks Fever Art Exhibition: An Exhibition of Bucks County Impressionists from the CIGNA Museum and Art Collection* (as *Winter on the Canal*), April–May

PUBLISHED REFERENCES

Fletcher, J. M. W. "The CIGNA Collection." *Antiques and the Arts Weekly*, May 5, 1995 (ill.)

Hunter, Sam. *American Impressionism: The New Hope Circle*. Fort Lauderdale, FL: Fort Lauderdale Museum of Art, 1984, 62

COMMENTARY

This work depicts the pontoon from which washerwomen (at the center of the canvas) cleaned clothes in the river at Moret, France. Schofield had been to Moret in the late 1890s, so the area would have been known to him when he visited again in 1909. George Oberteuffer may have joined him there—the laundry boat is also visible in several of Oberteuffer's pictures of Moret—as well as the marine painter Paul Dougherty. Schofield wrote to his wife, "Yes dear it's lonely—Dougherty only stayed a few days and I am bored to death—absolutely—cold, cheerless and damp—sums it up—but it is a good cause so no complaints."[1]

NOTES

1 Schofield to Muriel Schofield. Reel 5043, Walter Elmer Schofield Papers, Archives of American Art, Smithsonian Institution.

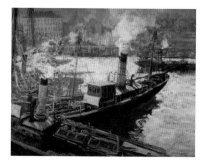

17
The Steam Trawlers, Boulogne
Alternate titles: Boulogne Harbour; Early Morning,
Boulogne; Early Morning, Boulogne Harbor; Steam
Trawlers; Steamers in a Harbor
1909
Oil on canvas
42 3/8 x 54 1/2 in.
Collection Jim's of Lambertville

PROVENANCE/OWNERSHIP HISTORY

Private Collection, 1950s

Acquired by Collection Jim's of Lambertville, 2014

PUBLISHED REFERENCE

Academy Notes (Buffalo), 6, no. 3 (July 1911): 82, 93
(as *Early Morning, Boulogne Harbor*)

EXHIBITION HISTORY

1909　　Royal Society of British Artists, London:
　　　　Winter Exhibition, no. 71 (as *Steam Trawlers,
　　　　Boulogne Harbour*)

　　　　National Academy of Design, New York: *84th
　　　　Annual Exhibition*, no. 173, March 15–April 17

　　　　Carnegie Institute, Pittsburgh: *13th Annual
　　　　Exhibition*, no. 246, April 29–June 30

1910-11　Corcoran Gallery of Art, Washington, DC:
　　　　*3rd Exhibition of Contemporary American
　　　　Oil Paintings*, no. 132 (as *Early Morning,
　　　　Boulogne Harbor*), December 12, 1910–
　　　　January 22, 1911

1911　　PAFA: *106th Annual Exhibition of Oil Painting
　　　　and Sculpture*, no. 304 (as *Early Morning,
　　　　Boulogne Harbor*)

Buffalo Fine Arts Academy: *6th Annual
Exhibition of Selected Paintings by American
Artists*, no. 119 (as *Early Morning, Boulogne
Harbor*), May 12–August 28

City Art Museum of St. Louis (now St. Louis
Art Museum): *The 6th Annual Exhibition of
Selected Paintings by American Artists* (as
Early Morning, Boulogne Harbor), September
17–November 17

1912　　Corcoran Gallery of Art, Washington, DC:
　　　　Paintings by W. Elmer Schofield, possibly no.
　　　　43 (as *Early Morning, Boulogne*), January
　　　　20–February 5

1920　　City Art Museum of St. Louis: *Works by the
　　　　Society of American Painters, Sculptors and
　　　　Gravers*, April 15–May 31

1920-21　Art Institute of Chicago: *Seven Special
　　　　Exhibitions: Paintings by Guy Wiggins,
　　　　Charles H. Woodbury, Alfred Juergens, John
　　　　F. Stacey, Anna Lee Stacey, Gifford Beal,
　　　　Eugene Speicher, and W. Elmer Schofield;
　　　　Pastels by William P. Henderson; Sculpture
　　　　by Jo Davidson*, no. 12, December 17, 1920–
　　　　January 18, 1921

COMMENTARY

This painting is an exceptional example of Schofield's
bustling harbor scenes of the years leading up to
World War I. It depicts Boulogne, where Schofield
visited in late 1908, and was described by an
anonymous critic in glowing terms:

> W. Elmer Schofield's *Early Morning, Boulogne
> Harbor* has added luster to his already brilliant
> reputation as an artist. The painting is true,
> both as a composition and in color scheme,
> and represents the old docks of Boulogne,
> a busy scene of small steamers and tugs
> between the bridges looking across Boulogne
> to Capicura.[1]

Apparently completed, signed, and dated in early
1909, this canvas was exhibited extensively at the
major annual exhibitions in the United States as well
as at the Royal Society of British Artists in London.
The brushwork is energetic, and the foremost trawler
is sketched rather freely, amid plumes of smoke and
swirling water.

From 1909 through 1920, Schofield exhibited the
painting under several different titles, first as *Steam*

Trawlers, Boulogne Harbour, then as *Early Morning, Boulogne Harbor*.[2] Schofield wrote to his wife from Boulogne:

> I have two big ones that I think are good and if I get nothing else here they will pay for the trip—possibly—it's such lonely work here that I think another week will probably wind it up. Of course I won't leave if I think I am getting good stuff out of it dear, but it gets on my nerves to be absolutely alone the whole twenty-four hours.[3]

It is likely that *The Steam Trawlers, Boulogne* is one of the "big ones" mentioned in Schofield's letter, since *The Landing Stage at Boulogne* (c. 1910, Cincinnati Art Museum), which measures 54 1/2 x 66 1/2 inches, is the only other large painting that Schofield is known to have made in Boulogne.

NOTES

1 *Academy Notes*, 82.

2 The painting is reproduced under both alternative titles in two clippings (one perhaps from *The Studio*, a fine and decorative arts magazine published in London) in the artist's file at Albright-Knox Art Gallery, Buffalo.

3 Schofield, Boulogne, to Muriel Schofield, November 1908. Schofield Family Archive (formerly Godolphin House, Cornwall, United Kingdom).

18
Dieppe Harbor
1910
Oil on canvasboard
8 x 10 in.
Collection of Carol and Louis Della Penna

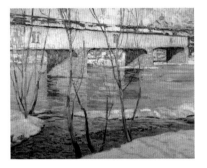

19
The Old Covered Bridge
1910
Oil on canvas
30 x 38 in.
Collection of Rockford Art Museum, IL. Photograph courtesy of Rockford Art Museum, IL

PROVENANCE/OWNERSHIP HISTORY

Purchased by Mr. and Mrs. Ralph Emerson from *Rockford Art Association's 1st Annual Exhibition*, 1913

Donated to the Rockford Art Museum by Mr. and Mrs. Ralph Emerson, 1913

EXHIBITION HISTORY

1912 Corcoran Gallery of Art, Washington, DC: *Paintings by W. Elmer Schofield*, no. 13, January 20–February 5

Carnegie Institute, Pittsburgh: *An Exhibition of Paintings by W. Elmer Schofield*, no. 15, February 12–25

1913 *Rockford Art Association's 1st Annual Exhibition*, IL, February 20–March 1

2011–12 Rockford Art Museum, IL: *River and Vale: American Landscapes*, September 9, 2011–February 12, 2012

2013–14 Rockford Art Museum, IL: *Through the Ages: 100 Years of RAM*, August 23, 2013–January 26, 2014

PUBLISHED REFERENCE

Hind, C. Lewis. "An American Landscape Painter: W. Elmer Schofield." *The International Studio* 48, no. 192 (February 1913): 280–89 (ill.)

COMMENTARY

This painting shows a view of the old covered DeKalb Street Bridge, which ran over the Schuylkill River between Norristown and Bridgeport, Pennsylvania. The dome of the Montgomery County Courthouse is visible in the upper right. It is likely that Schofield visited the area with his friend Charles Morris Young, who lived in Jenkintown and painted the same bridge in 1911 (illustrated below). In a letter to Muriel in 1910, Schofield recorded that he had "been staying out at Young's for a few days and I think I have two or three sketches that are among my good ones."[1] *The Old Covered Bridge* may have been one of the sketches he was referring to. Schofield depicted the structure again after it was repainted in *Covered Bridge over the Schuylkill at Norristown (The Red Bridge)* (by 1911; ill. p. 16). Mr. and Mrs. Ralph Emerson donated this painting to the Rockford Art Museum in 1913. This donation was the second accession into Rockford Art Museum's permanent collection.

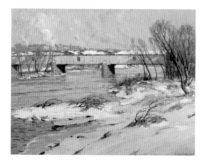

The Old Covered Bridge, 1911, by Charles Morris Young (James M. Cowan Collection of American Art, The Parthenon, Nashville, TN)
Photograph © 1929 by The Parthenon, Nashville, TN

NOTES

1 Schofield to Muriel Schofield, March 7, 1910. Walter Elmer Schofield Papers, Archives of American Art, Smithsonian Institution.

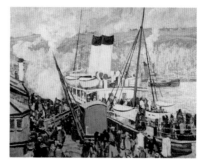

20

The Packet Boat, Dieppe
Alternate titles: **Channel Boat, Dieppe; The Channel Boat, Dieppe; The Channel Boat: Dieppe; The Packet Boat**
1910
Oil on canvas
30 x 38 in.
Collection of Lucille and Walter Rubin

PROVENANCE/OWNERSHIP HISTORY

Owned by A. D. Marks, Esq., by 1913

Collection of the Hon. Roderic Dalzell Henderson, VT, by 1967

Collection of Lucille and Walter Rubin

EXHIBITION HISTORY

1912 Corcoran Gallery of Art, Washington, DC: *Paintings by W. Elmer Schofield*, no. 15 (as *Channel Boat, Dieppe*), January 20–February 5

Carnegie Institute, Pittsburgh: *An Exhibition of Paintings by W. Elmer Schofield*, no. 11 (as *Channel Boat, Dieppe*), February 12–25

Katz Gallery, New York (as *The Channel Boat, Dieppe*)

Art Institute of Chicago: *25th Annual Exhibition of American Oil Paintings and Sculpture*, no. 235, November 5–December 8

1983 Brandywine River Museum of Art, Chadds Ford, PA: *Walter Elmer Schofield: Bold Impressionist*, no. 32, September 10–November 20

PUBLISHED REFERENCES

Folk, Thomas. *Walter Elmer Schofield: Bold Impressionist*. Chadds Ford, PA: Brandywine River Museum of Art, 1983, 22, 42, cat. no. 32

Hind, C. Lewis. "An American Landscape Painter: W. Elmer Schofield." *The International Studio* 48, no. 192 (February 1913): 280–89 (ill., as *The Channel Boat, Dieppe*, and stated as "The property of A. D. Marks, Esq.")

Hoeber, Arthur. "W. Elmer Schofield: A Painter in the Open." *Arts and Decoration* 1, no. 12 (October 1911): 473–75, 492 (ill., as *The Packet Boat*)

Livingston, Valerie. *W. Elmer Schofield: Proud Painter of Modest Lands*. Bethlehem, PA: Moravian College, 1988, 25

"Schofield's Works in Katz Gallery." *New York Times*, April 12, 1912 (as *The Channel Boat: Dieppe*)

COMMENTARY

In 1910 Schofield embarked on a painting expedition to Dieppe, Normandy, where he rented studios with Oberteuffer and British artist Julius Olsson. Schofield described in a letter to his wife, "I have a room to work in with Oberteuffer and Olsson in the adjoining room so we are all together [in a] sort of happy family arrangement. Too much so for my comfort—but everything is harmonious so far."[1]

This trip was a productive expedition from which several major paintings resulted, as well as six studies of the harbor, possibly made from Schofield's studio window. The sketch for *The Packet Boat, Dieppe* is more removed from the subject, and is not as focused on the funnels of the ferry. In the final composition Schofield intensified the scene, immersing the spectator in the hustle and bustle of the quayside. A reviewer for the *New York Times* remarked on this dynamism when the painting was exhibited at the Katz Gallery:

> Compared to *Canal—Bruges* (1908, Private Collection), *The Channel Boat: Dieppe* has a greater complication of interest and a more original composition, but this and all the other pictures in the exhibition speak alike of a direct nature expressing thought by means of the appropriate language.[2]

NOTES

1 Schofield to Muriel Schofield, May 1, 1910. Walter Elmer Schofield Papers, Archives of American Art, Smithsonian Institution.

2 "Schofield's Works in Katz Gallery," *New York Times*.

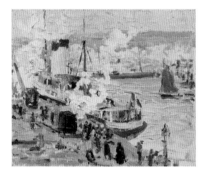

21
The Packet Boat, Dieppe
1910
Oil on canvasboard
9 x 12 in.
Private Collection

COMMENTARY

This is the preparatory study for *The Packet Boat, Dieppe* (1910; ill. p. 42).

22
French Village
c. 1910
Oil on canvas
30 x 38 in.
Private Collection

COMMENTARY

This painting was probably made in 1910, during Schofield's sojourn in Dieppe. The sinuous brushwork that forms the fences and foliage in the foreground is typical of his dynamic prewar style. Though the artist usually traveled without his family, his wife and sons eventually joined him on this trip.

23

Covered Bridge over the Schuylkill at Norristown (The Red Bridge)

Alternate titles: **Covered Bridge; Covered Bridge on the Schuylkill; The Red Bridge**

By 1911

Oil on canvas

38 x 48 in.

Collection Brandywine River Museum of Art. Gift of Margaret E. Phillips, 2003. Photograph courtesy of Brandywine River Museum of Art

PROVENANCE/OWNERSHIP HISTORY

Sarah and Herbert Louis Phillips, by 1922

By descent in the family to Margaret E. Phillips

Donated by Margaret E. Phillips to the Brandywine River Museum of Art, 2003

EXHIBITION HISTORY

1911 Carnegie Institute, Pittsburgh: *15th Annual Exhibition*, April 27–June 30 (as *The Red Bridge*)

1912 PAFA: *107th Annual Exhibition*, no. 457, February 4–March 24 (as *The Red Bridge*)

1945 Woodmere Art Gallery, Philadelphia: *Memorial Exhibition of Oil Paintings by W. Elmer Schofield N.A.*, no. 6, November 3–26 (as *Covered Bridge over the Schuylkill at Norristown [The Red Bridge]*)

1983 Brandywine River Museum of Art, Chadds Ford, PA: *Walter Elmer Schofield: Bold Impressionist* (as *Covered Bridge on the Schuylkill*), September 10–November 20

1984-85 Allentown Art Museum, PA: *The Pennsylvania School of Landscape Painting: An Original American Impressionism* (as *Covered Bridge*), September 16–November 25, 1984. Traveled to the Corcoran Gallery of Art, Washington, DC, December 14, 1984–February 10, 1985; Westmoreland Museum of American Art, Greensburg, PA, March 2–May 5, 1985; and the Brandywine River Museum of Art, Chadds Ford, PA, June 1–September 2, 1985

1991 James A. Michener Art Museum, Doylestown, PA: *An American Impressionist: Walter Elmer Schofield* (as *The Red Bridge*), June 22–November 3

PUBLISHED REFERENCES

Folk, Thomas. *Walter Elmer Schofield: Bold Impressionist*. Chadds Ford, PA: Brandywine River Museum of Art, 1983, 19–20, cat. no. 6

"'The Red Bridge' by W. Elmer Schofield, One of the Prominent Artists Represented at Art Exhibit, 304 North Second Street." *Harrisburg Telegraph*, April 14, 1911, 13 (as *The Red Bridge*)

COMMENTARY

Like *The Old Covered Bridge* (1910; ill. p. 11), this canvas depicts the old bridge between Norristown and Bridgeport. Schofield may have painted both works with Young at Norristown.

Although the artist selected this work for exhibition at the Carnegie Institute and PAFA, it did not sell, and Schofield almost put his palette knife through it. The circumstances were recorded by his daughter-in-law Mary Schofield:

> Then there are two marines which Sarah [Phillips] says that she and Herbert [Phillips] rescued from being "knifed." Elmer was slashing up some old canvases which he did not want [and] which had been at the mill in storage, and when they were properly framed they looked well—especially one of the marines that Elmer gave Sarah, the "Covered Bridge," which is over the stairs. [The] other [was] a frozen stream with Elmer's treatment of snow—a good thing too.[1]

The mill where the paintings had been stored was sold in 1922, suggesting that this picture came into the Phillips's ownership by that date.[2]

NOTES

1 Mary Schofield to Sydney Schofield, 1949. Schofield Family Archive (formerly Godolphin House, Cornwall, United Kingdom).

2 "I have been over here for the last three days and may be here two or three days longer on account of the mill being (I think) sold If I can only sell a few pictures each year we shall be quite comfortably off." Schofield to Muriel Schofield, March 7, 1922. Reel 5043, Walter Elmer Schofield Papers, Archives of American Art, Smithsonian Institution.

24
The Spring Thaw
Alternate title: Delaware River in White
By 1913
Oil on canvas
40 x 48 in.
Biggs Museum of American Art. Photograph courtesy of Biggs Museum of American Art

PROVENANCE/OWNERSHIP HISTORY

Collection of the Hon. Roderic Dalzell Henderson, by 1965

Purchased by Sewell C. Biggs, 1965

Biggs Museum of American Art

EXHIBITION HISTORY

1913 National Arts Club, New York: *Annual Members' Exhibition of Painters, Sculptors and Architects*, January 3–28 (awarded Gold Medal and $1,000)

National Academy of Design, New York: *88th Annual Exhibition*, no. 214, March 15–April 20

1914 Art Institute of Chicago: *American Paintings and Sculpture 27th Annual*, no. 279, November 3–December 6

1920–21 Art Institute of Chicago: *Seven Special Exhibitions: Paintings by Guy Wiggins, Charles H. Woodbury, Alfred Juergens, John F. Stacey, Anna Lee Stacey, Gifford Beal, Eugene Speicher, and W. Elmer Schofield; Pastels by William P. Henderson; Sculpture by Jo Davidson*, no. 20, December 17, 1920–January 18, 1921

1921 Detroit Institute of Arts: *Exhibition of Paintings by Gifford Beal, Eugene Speicher and Elmer W. Schofield* [*sic*], no. 32, April 1–18

1983 Delaware Art Museum, Wilmington: *Selections from the Sewell C. Biggs Collection of Paintings* (as *Delaware River in White*), March 1–April 17

Brandywine River Museum of Art, Chadds Ford, PA: *Walter Elmer Schofield: Bold Impressionist* (as *Delaware River in White*), September 10–November 20

PUBLISHED REFERENCES

Boston Evening Transcript, January 13, 1913, 11

Folk, Thomas. *Walter Elmer Schofield: Bold Impressionist*. Chadds Ford, PA: Brandywine River Museum of Art, 1983, 41, cat. no. 7

The National Arts Club [Membership Book]. New York: Knickerbocker Press, 1914

COMMENTARY

The Spring Thaw has some strong similarities to *Hill Country* (c. 1913; ill. p. 58) in color and paint handling, but it also foreshadows Schofield's panoramic snow-covered landscapes of the postwar years. One critic offered the following description after the canvas was shown at the National Arts Club in 1913:

> *The Spring Thaw*, by W. Elmer Schofield, which was awarded the National Arts Club gold medal, is in every way one of the finest canvases that has come from his brush. The stretch of river cut up by a long, narrow point of land with the offshore beyond covered in parts with patches of melting snow, is executed in a large, masterly manner that notes the essential truths without insisting overmuch upon the literal aspects of the scene depicted.[1]

NOTES

1 *Boston Evening Transcript*, January 13, 1913.

25
Hill Country
c. 1913
Oil on canvas
50 1/4 x 60 in.

Woodmere Art Museum: Gift of Sydney E. and Seymour Schofield, 1949

PROVENANCE/OWNERSHIP HISTORY

Estate of the artist

By descent in the family to Sydney E. and Seymour Schofield

Donated to Woodmere Art Museum by Sydney E. and Seymour Schofield through Sarah Phillips, 1949

EXHIBITION HISTORY

1913–14 National Academy of Design, New York: *Winter Exhibition*, no. 262, December 20, 1913–January 18, 1914

1914 PAFA: *109th Annual Exhibition*, no. 337, February 8–March 29 (awarded Temple Gold Medal)

Carnegie Institute, Pittsburgh: *18th Annual International Exhibition of Paintings*, April 30–June 30

Worcester Art Museum, MA: *Exhibition of Oil Paintings by American and European Artists: A Traveling Collection of Paintings Selected by the American Federation of Arts from the 18th Annual Exhibition at the Carnegie Institute, Pittsburgh*, no. 38, August 16–September 27

Toledo Museum of Art, OH: *International Exhibition: Paintings Selected by the American Federation of Arts from the 18th Annual Exhibition of the Carnegie Institute*, no. 234, November

1915 Buffalo Fine Arts Academy: *An Exhibition of Paintings by American and European Artists*, no. 36, March 6–April 4

City Art Museum of St. Louis: *An Exhibition of Paintings by American and European Artists*, opened May 11

1920 Buffalo Fine Arts Academy: *Exhibition of Paintings by W. Elmer Schofield, N.A.*, no. 27, January 10–February 15

Memorial Art Gallery, Rochester, NY: *Exhibition of Paintings by W. Elmer Schofield, N.A.*, no. 24, February 16–March 7

1923 Art Institute of Chicago: *36th Annual Exhibition of American Painting and Sculpture*, no. 192, November 1–December 9

1925 PAFA: *120th Annual Exhibition*, no. 241, February 8–March 29

City Art Museum of St. Louis: *20th Annual Exhibition of Painting by American Artists*, September 15–October 25

1928 Corcoran Gallery of Art, Washington, DC: *11th Biennial Exhibition of Contemporary American Oil Paintings*, no. 108, October 28–December 9

1929 Memorial Art Gallery, Rochester, NY: *January–February Exhibition: Contemporary American Paintings and Sculpture Selected from Recent Exhibitions in American Art Centers*, no. 44, January–February

1945 Woodmere Art Gallery, Philadelphia: *Memorial Exhibition of Oil Paintings by W. Elmer Schofield N.A.*, no. 11, November 3–26

1983 Brandywine River Museum of Art, Chadds Ford, PA: *Walter Elmer Schofield: Bold Impressionist*, no. 15, September 10–November 20

1984–85 Allentown Art Museum, PA: *The Pennsylvania School of Landscape Painting: An Original American Impressionism*, September 16–November 25, 1984. Traveled to the Corcoran Gallery of Art, Washington, DC, December 14, 1984–February 10, 1985; Westmoreland Museum of American Art, Greensburg, PA,

March 2–May 5, 1985; and the Brandywine River Museum of Art, Chadds Ford, PA, June 1–September 2, 1985

1999 The Miller Gallery, Cumberland County Historical Society, Carlisle, PA: *Pennsylvania Regionalism: The Turn of the Century Impressionism and the Real*, April 16–October 30

2002 Woodmere Art Museum, Philadelphia: *Pennsylvania Impressionism from the Permanent Collection*, September 15–October 20

2002–3 Woodmere Art Museum, Philadelphia: *Pennsylvania Impressionism from the Permanent Collection*, November 28, 2002–March 16, 2003

2004 Woodmere Art Museum, Philadelphia: *Philadelphia Traditions*, September 18–October 3

2005–6 Woodmere Art Museum, Philadelphia: *Pennsylvania Impressionist Legacy*, September 25, 2005–January 8, 2006

2008 Ogunquit Museum of American Art, ME: *The New Hope School: Pennsylvania Impressionists*, August 25–October 31

PUBLISHED REFERENCES

Academy Notes (Buffalo) 10, no. 3 (July 1915): 24

"Academy Opens 109th Exhibition." *Philadelphia Public Ledger*, February 8, 1914, 11

Alterman, Jim. *New Hope for American Art*. Lambertville, NJ: Jim's of Lambertville, 2005

Culver, Michael. *The New Hope School: Pennsylvania Impressionists*. Ogunquit, ME: Ogunquit Museum of American Art, 2008 (ill.)

Folk, Thomas. *The Pennsylvania School of Landscape Painting: An Original American Impressionism*. Allentown, PA: Allentown Art Museum, 1984, 10

Folk, Thomas. *Walter Elmer Schofield: Bold Impressionist*. Chadds Ford, PA: Brandywine River Museum of Art, 1983, 18, cat. no. 15

Nelson, W. H. de B. "Pennsylvania Pre-Eminent." *The International Studio* 52, no. 205 (March 1914): 3–10

Tovey, David. *Pioneers of St Ives Art at Home and Abroad (1889–1914)*. Tewkesbury, UK: Wilson Books, 2008, 318

COMMENTARY

This painting was exhibited alongside *The Rapids* (c. 1914; ill. p. 60) at PAFA in 1914. It can be precisely dated from a reference in a letter to Schofield's wife: "I am just about starting on a 50 x 60 for the Nat. Academy Ex which opens in Dec. And I want especially to be strongly represented. It always means a lot and in other days I was not always seen at my best."[1]

Hill Country is an example of a large-format painting made in the studio from preliminary studies done in plein air, although the original sketches are not known. As the canvas was never sold, it accumulated one of the longest and most distinguished exhibition histories of any of Schofield's major works. He received the Temple Gold Medal for the painting, though contemporary accounts viewed *The Rapids* as the more important of the two works:

> The Temple Gold Medal has fallen into good hands. Elmer Schofield, though young in years, has long held the stage with his big concepts, powerfully brushed in, line and mass well adjusted, colour restrained, but strong. *Hill Country* and *Waterfall* [alternate title for *The Rapids*], both in Gallery F, represent him at his best. We consider the latter the better of the two.[2]

In order to bring *Hill Country* up to date in the early 1920s, Schofield had it reframed in its current Grieve & Co. hand-carved, gilt-wood frame with floral cartouches. Originally it may have been framed identically to *The Rapids*, in an embossed Newcomb-Macklin design.

NOTES

1 Schofield to Muriel Schofield, November 13, 1913. Reel 5043, Walter Elmer Schofield Papers, Archives of American Art, Smithsonian Institution.

2 Nelson, "Pennsylvania Pre-Eminent," 3–4.

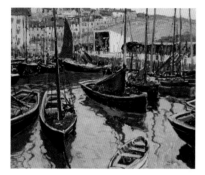

26
The Inner Harbor, Polperro
Alternate titles: A Busy Cornish Harbor; Crowded
Harbor, Cornwall
1914
Oil on canvas
30 x 36 in.
Collection Jim's of Lambertville. Photograph courtesy of Jim's of
Lambertville

PROVENANCE/OWNERSHIP HISTORY

Private Collection, 2009

Acquired by Collection Jim's of Lambertville, 2012

EXHIBITION HISTORY

1915 Memorial Art Gallery, Rochester, NY:
 *Exhibition of Paintings by W. Elmer Schofield
 and a Collection of Paintings Representative
 of the Modern Art Movement in America*, no.
 4, February 16–March 7

1916 Detroit Museum of Art: *Exhibition of
 Paintings by Men Who Paint the Far West,
 Twelve American Artists and Sandor
 Landeau*, no. 62, April

 Memorial Art Gallery, Rochester, NY:
 *An Exhibition of Paintings by Twelve
 Contemporary American Artists*, no. 32, May

COMMENTARY

Polperro is an ancient fishing village in the southeast
of Cornwall—one of the few to have escaped
excessive modernization. This canvas looks east
across the inner harbor from a pier close to the Three
Pilchards Inn. *Polperro Harbor* (illustrated below) is
a smaller related work, looking north from a nearby
vantage point.

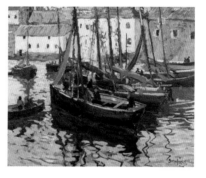

Polperro Harbor, 1914, by Walter Elmer Schofield (Memorial Art
Gallery of the University of Rochester: Gift of Miss Mary O'Brien
in memory of Mr. and Mrs. John J. Sharkey). Photograph courtesy of
Memorial Art Gallery of the University of Rochester

27
On the Road to Perranporth
Alternate titles: Road to Perranporth; The Road to
Pirrinporth
1914
Oil on canvas
26 x 30 in.
Private Collection

PROVENANCE/OWNERSHIP HISTORY

Purchased from the estate of the artist, 1949

Private Collection

EXHIBITION HISTORY

1915 Memorial Art Gallery, Rochester, NY:
 *Exhibition of Paintings by W. Elmer Schofield
 and a Collection of Paintings Representative
 of the Modern Art Movement in America*, no.
 24, February 16–March 7

1917 Buffalo Fine Arts Academy: *11th Annual Exhibition of Selected Paintings by American Artists*, no. 119, May 12–September 17

1919-20 Corcoran Gallery of Art, Washington, DC: *7th Exhibition of Contemporary American Oil Paintings*, no. 68, December 21, 1919–January 25, 1920

1920 Detroit Institute of Arts: *6th Annual Exhibition of Paintings by American Artists*, no. 138, April 20–May 31

1920-21 Art Institute of Chicago: *Seven Special Exhibitions: Paintings by Guy Wiggins, Charles H. Woodbury, Alfred Juergens, John F. Stacy, Anna Lee Stacey, Gifford Beal, Eugene Speicher, and W. Elmer Schofield; Pastels by William P. Henderson; Sculpture by Jo Davidson*, no. 14 (as *Road to Perranporth*), December 17, 1920–January 18, 1921

1921 Detroit Institute of Arts: *Exhibition of Paintings by Gifford Beal, Eugene Speicher and Elmer W. Schofield* [*sic*], no. 23, April 1–18

1922 PAFA: *117th Annual Exhibition*, no. 225, February 5–March 6

1922-23 Buffalo Fine Arts Academy: *Exhibition of Paintings by Ben Foster, W. Elmer Schofield, Gardner Symons, and Douglas Volk*, no. 46, December 9, 1922–January 8, 1923

1923 Memorial Art Gallery, Rochester, NY: *Paintings by Ben Foster, W. Elmer Schofield, Gardner Symons and Douglas Volk*, no. 42, January–February

1929 Stendahl Art Galleries, Los Angeles, no. 43, March

1935 Faulkner Memorial Art Gallery, Free Public Library, Santa Barbara, CA: *Exhibitions: Elmer W. Schofield* [*sic*], *N.A.*, no. 6 (as *The Road to Pirrinporth*), March 2–21

PUBLISHED REFERENCES

A. H. C. "Art Notes and Exhibitions—'Pictures by W. Elmer Schofield on View at Memorial Gallery.'" *Rochester Evening Transcript*, February 17, 1915

"Remarkable Collection of Paintings by W. Elmer Schofield on Exhibition." *Rochester Union and Advertiser*, February 16, 1915

COMMENTARY

The titles of the paintings that resulted from Schofield's 1914 visit to Cornwall trace his journey to Polperro, in the southeast; to Perranporth, on the northern coast; and as far west as St. Agnes. This canvas shows a typical Cornish cottage, cob-walled and thatched, beside a narrow lane. However, the composition is flat, almost abstract, reducing the roof to an oblong form of broad strokes of paint. It was one of two views of the same cottage, but as one reporter observed,

> No two of his pictures show similarity and it is always the effect of the thing on the artist's mind at the time when he painted it and not the thing itself that compels the observer's attention. This is illustrated in a striking way by two pictures of a Cornish Cottage, one on a gray day, the other in sunlight. Though the cottage is the same, the light effect, which is what the artist really painted, is so different that the similarity in subject easily escapes one's notice.[1]

On the Road to Perranporth became one of the most extensively exhibited works of Schofield's career, at both major annual shows and smaller galleries. This was due in part to his never having sold the painting, but perhaps also to the success of this experimental period just before World War I, during which he developed his luminous palette.

NOTES

1 "Remarkable Collection of Paintings," February 16, 1915. *Rochester Union and Advertiser*, n.p. Schofield Family Archive (formerly Godolphin House, Cornwall, United Kingdom)

28
The White Frost
1914
Oil on canvas
50 x 60 in.
The Trout Gallery, Dickinson College. Andrew Bale, Photographer/
The Trout Gallery, Dickinson College

PROVENANCE/OWNERSHIP HISTORY

Presented to the Memorial Art Gallery of the
University of Rochester, gift of Dr. and Mrs. Rudolph
H. Hofheinz in memory of Rudolph Hofheinz, 1915
(1915.2) (deaccessioned 1950)

Private Collection

Mr. and Mrs. James Hornbach Collection

Donated to The Trout Gallery, Dickinson College, by
Mr. and Mrs. James Hornbach, 1975

EXHIBITION HISTORY

1915 Memorial Art Gallery, Rochester, NY:
 *Exhibition of Paintings by W. Elmer Schofield
 and a Collection of Paintings Representative
 of the Modern Art Movement in America*, no.
 32, February 16–March 7

1917 Memorial Art Gallery, Rochester, NY: *An
 Exhibition of Contemporary American
 Paintings and of the Permanent Collection*,
 no. 21, July–September

1920–21 Art Institute of Chicago: *Seven Special
 Exhibitions: Paintings by Guy Wiggins,
 Charles H. Woodbury, Alfred Juergens, John
 F. Stacey, Anna Lee Stacey, Gifford Beal,
 Eugene Speicher, and W. Elmer Schofield;
 Pastels by William P. Henderson; Sculpture
 by Jo Davidson*, no. 21, December 17, 1920–
 January 18, 1921

1982 The Trout Gallery, Dickinson College, Carlisle,
 PA: *A Selection of Landscapes*, fall

1995 The Trout Gallery, Dickinson College, Carlisle,
 PA: *The Grand Tradition: Nineteenth-Century
 Landscapes from the Permanent Collection*,
 February 3–March 4

PUBLISHED REFERENCE

"Added to the Memorial Gallery's Permanent
Collection." *Rochester Democrat and Chronicle*,
February 27, 1915

COMMENTARY

Dr. and Mrs. Rudolph H. Hofheinz purchased this
large canvas for $2,500 from a 1915 exhibition at the
Memorial Art Gallery in Rochester, New York, and
presented it to the gallery in memory of their son,
Rudolph Hofheinz Jr. Announcing the gift in the next
day's paper, a critic observed:

> Mr. Schofield calls it a problem in light and
> color, and feels that it typifies the thing he is
> trying to get in the great outdoors—the feeling
> of the vital quality of the light and the force of
> it. . . . The artist is said to have put the outdoor
> light, its luminosity and its feeling, onto the
> canvas with a fidelity that has seldom been
> approached.[1]

This painting offers an unusual depiction of
Bedfordshire and appears to have been created in
October 1914. *The White Frost* is the largest of a
group of paintings from 1914 and 1915 that display an
exceptionally luminous palette, dynamic brushwork,
and an almost abstract treatment of the landscape.
Lower Falls (1915; ill. p. 61) is another example from
this group. This stylistic phase was abruptly cut short
by Schofield's wartime service.

NOTES

1 "Added to the Memorial Gallery's Permanent Collection," *Rochester
 Democrat and Chronicle*.

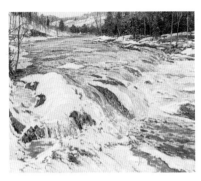

29
The Rapids
Alternate titles: **Bend in the River; Waterfall**
c. 1914
Oil on canvas
50 1/8 x 60 1/4 in.

Smithsonian American Art Museum, Bequest of Henry Ward
Ranger through the National Academy of Design, 1954.11.1.
Photograph courtesy of Smithsonian American Art Museum, Washington,
DC/Art Resource, NY

PROVENANCE/EXHIBITION HISTORY

Purchased by the National Academy of Design under
the terms of the Henry Ward Ranger Bequest, May 2,
1920

Placed on loan to the Brooklyn Art Museum under
the terms of the Henry Ward Ranger Bequest, 1920

Recalled from the Brooklyn Art Museum to the
National Collection of Fine Arts (now Smithsonian
American Art Museum) under the terms of the Henry
Ward Ranger Bequest, October 1954

Accepted into the collection of the Smithsonian
American Art Museum, December 1954

EXHIBITION HISTORY

1914 PAFA: *109th Annual Exhibition*, no. 303 (as
 Waterfall), February 8–March 29

 Anglo-American Exposition, American Fine
 Arts Section, London, no. 156 (as *Waterfall*)

1914–15 Corcoran Gallery of Art, Washington, DC: *5th
 Exhibition of Contemporary American Oil
 Paintings*, no. 74 (as *Waterfall*), December 15,
 1914–January 24, 1915

1915 Panama Pacific International Exposition,
 Gallery 68, San Francisco (as *Waterfall*),
 February 20–December 4 (awarded Medal
 of Honor)

1920 National Academy of Design, New York: *95th
 Annual Exhibition*, no. 548, April 6–May 9
 (awarded First Altman Prize) (acquired for
 the Brooklyn Art Museum under the terms of
 the Henry Ward Ranger Bequest)

 Buffalo Fine Arts Academy: *14th Annual
 Exhibition of Selected Paintings by American
 Artists*, no. 125, May 29–September 7

1929–30 National Gallery, Natural History Building,
 United States National Museum Washington,
 DC: *Exhibition of Paintings by Contemporary
 American Artists: Purchased by the Council
 of the National Academy of Design from
 the Henry Ward Ranger Fund Paintings in
 Accordance with the Provision of the Ranger
 Bequest*, December 10, 1929–January 31,
 1930

1958–59 National Academy of Design, New York:
 *Henry Ward Ranger Centennial Exhibition,
 1858–1959*, September 25–October 12, 1958.
 Traveled to National Collection of Fine Arts
 (co-organizer), Washington, DC, December
 2, 1958–January 5, 1959; Mint Museum of
 Art, Charlotte, NC, January 12–February
 8, 1959; Art League of Manatee County
 (now ArtCenter Manatee), Bradenton, FL,
 February 22–March 13, 1959; Jacksonville Art
 Museum (now Museum of Contemporary Art
 Jacksonville), FL, March 27–April 16, 1959;
 Gibbes Art Gallery (now Gibbes Museum of
 Art), Charleston, SC, April 27–May 27, 1959;
 and North Carolina Museum of Art, Raleigh,
 June 6–July 5, 1959

1983 Brandywine River Museum of Art, Chadds
 Ford, PA: *Walter Elmer Schofield: Bold
 Impressionist*, no. 36, September 10–
 November 20

1984–85 Allentown Art Museum, PA: *The Pennsylvania
 School of Landscape Painting: An Original
 American Impressionism*, September 16–
 November 25, 1984. Traveled to the Corcoran
 Gallery of Art, Washington, DC, December
 14, 1984–February 10, 1985; Westmoreland
 Museum of American Art, Greensburg, PA,
 March 2–May 5, 1985; and the Brandywine
 River Museum of Art, Chadds Ford, PA, June
 1–September 2, 1985

PUBLISHED REFERENCES

American Art News 18, no. 30 (May 15, 1920): 6

Blake, Wendon. *Creative Color for the Oil Painter*. New York: Watson-Guptill, 1983

Folk, Thomas. *The Pennsylvania Impressionists*. Madison, NJ: Fairleigh Dickinson University Press, 1997, 56–57

Folk, Thomas. *The Pennsylvania School of Landscape Painting: An Original American Impressionism*. Allentown, PA: Allentown Art Museum, 1984, 51–52

Folk, Thomas. *Walter Elmer Schofield: Bold Impressionist*. Chadds Ford, PA: Brandywine River Museum of Art, 1983, 20–21, cat. no. 36

Nelson, W. H. de B. "Pennsylvania Pre-Eminent." *The International Studio* 52, no. 205 (March 1914): 3–10 (ill., as *Waterfall*)

Neuhaus, Eugen. *The Galleries of the Exposition*. San Francisco: Paul Elder and Company, 1915 (ill.)

New York Sun and Herald, May 6, 1920

Peterson, Brian H., ed. *Pennsylvania Impressionism*. Philadelphia: James A. Michener Art Museum and University of Pennsylvania Press, 2002, 228

Second Annual Exhibition of the New Society of Artists. New York: The Society, 1920 (ill. 11, as *Bend in the River*)

See also National Academy Museum and School website, www.nationalacademy.org, for Henry Ward Ranger Bequest information.

COMMENTARY

The Rapids was first exhibited alongside *Hill Country* (c. 1913; ill. p. 58) in the *109th Annual Exhibition* at PAFA in 1914. The paintings are identical in size and they display areas of very similar brushwork, such as the rapidly applied strokes that delineate the brambles and weeds. Schofield's wife wrote of the paintings:

> Your sister sent a supplement to the Public Ledger with two perfectly lovely illustrations of your pictures in the academy—I am taking them down to be framed tomorrow. Really I think "The Hill Country" is splendid, and "The Waterfall" a masterly canvas. . . . They come out well, too, at least "The Waterfall" does in the Academy catalogue. . . . What do you think of [John Singer] Sargent's "Waterfall"? To my mind it is not a patch on yours—you may have to go to him for hints on portrait painting, but you can certainly teach him landscape work. . . . I am so glad you have had all the cold weather you wanted + could make such capital canvases. . . . It is worth a great deal to know you are "going strong" (to be slangy) and that you keep your ambition—now that you have almost cleaned up all the medals over in America.[1]

The preliminary study *The Falls in Winter* (illustrated below) is owned by Moravian College, Bethlehem, Pennsylvania.

The Falls in Winter, c. 1914, by Walter Elmer Schofield (Payne Gallery Permanent Collection, Moravian College) Photograph courtesy of Payne Gallery, Moravian College

NOTES

1 Muriel Schofield to Schofield, March 1914. Schofield Family Archive (formerly Godolphin House, Cornwall, United Kingdom).

30
Lower Falls
Alternate titles: Lower Falls, Genesee River; Lower Falls (Genesee River at Rochester, New York)
1915
Oil on canvas
25 1/2 x 29 1/2 in.

Memorial Art Gallery of the University of Rochester: Bequest of Mrs. Ernest R. Willard. Photograph courtesy of Memorial Art Gallery of the University of Rochester

PROVENANCE/OWNERSHIP HISTORY

Purchased by Ernest R. Willard, 1915

Memorial Art Gallery of the University of Rochester

EXHIBITION HISTORY

1915 Memorial Art Gallery, Rochester, NY: *Exhibition of Paintings by W. Elmer Schofield and a Collection of Paintings Representative of the Modern Art Movement in America* (as *Lower Falls, Genesee River*), February 16–March 7

1983 Brandywine River Museum of Art, Chadds Ford, PA: *Walter Elmer Schofield: Bold Impressionist*, no. 22 (as *Lower Falls [Genesee River at Rochester, New York]*), September 10–November 20

PUBLISHED REFERENCES

"Artist Braves March Weather to Paint Lower Falls." *Rochester Democrat and Chronicle*, March 3, 1915 (ill.)

Folk, Thomas. *Walter Elmer Schofield: Bold Impressionist*. Chadds Ford, PA: Brandywine River Museum of Art, 1983, 22, 41, cat. no. 23

COMMENTARY

Its rich, luminous color and expressive brushwork make *Lower Falls* one of Schofield's most remarkable small canvases. The Genesee River, which bisects Rochester, New York, cascades over three waterfalls as it descends into Lake Ontario. This view of the Lower Falls in Rochester was painted in early March 1915 from the now-demolished Driving Park Avenue Bridge.

The impressive waterfall and gorge remain to this day essentially as Schofield painted them. The mills at the head of the Lower Falls (midground right) have been destroyed, but the hydroelectric plant at foreground left survives and still generates power. The inclusion of the then–newly built Kodak Tower (background left) demonstrates that this painting was as much a depiction of modern, industrial Rochester as a celebration of natural beauty.

Lower Falls was placed in a Newcomb-Macklin frame and exhibited at the Memorial Art Gallery, where it was purchased by Ernest R. Willard, editor of the *Rochester Democrat and Chronicle*, on March 3, 1915, for $600. A photograph of Schofield beside the still-unfinished picture was reproduced that same day in Willard's paper, under the heading "Artist Braves March Weather to Paint Lower Falls." The painting was given to the Memorial Art Gallery by Willard's widow in 1940.

31

Marines Oct 3-18

1918

Ink and pencil on paper

Collection Brandywine River Museum of Art. Gift of Mary Schofield, 1990, in appreciation of the work of the Brandywine Museum. Photograph courtesy of Brandywine River Museum of Art

PROVENANCE/OWNERSHIP HISTORY

Estate of the artist

By descent in the family to Mary and Sydney E. Schofield

Gift of Mary Schofield to the Brandywine River Museum of Art, 1990

COMMENTARY

The 1918 sketchbook is Schofield's only known work from the duration of his service in the British Army during World War I. It covers only the final year of the conflict and it is not known whether Schofield kept a sketchbook previously. The first drawing depicts a railway line damaged by shelling. The following page contains a small, unfinished sketch of one of his unit's lorry-mounted anti-aircraft guns. Further pages include touching and comical portraits of his fellow officers. The remaining pages of wartime drawings, including the page reproduced here and on page 15, detail the action and the aftermath of the fighting, principally during the Hundred Days Offensive, which helped end the war. Schofield continued to use this sketchbook after the war. He filled several pages with studies of Cornwall, the last of these being dated June 30, 1921.

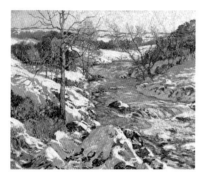

32

The Rapids in Winter

c. 1919

Oil on canvas

40 x 48 in.

Collection Jim's of Lambertville. Photograph courtesy of Jim's of Lambertville

PROVENANCE/OWNERSHIP HISTORY

Grand Central Art Galleries, New York

Purchased from Grand Central Art Galleries, 1923

Private Collection, NJ, c. late 1950s

Acquired by Collection Jim's of Lambertville, 2003

EXHIBITION HISTORY

1920 Buffalo Fine Arts Academy: *Exhibition of Paintings by W. Elmer Schofield, N.A.*, no. 20, January 10–February 15

Memorial Art Gallery, Rochester, NY: *Exhibition of Paintings by W. Elmer Schofield, N.A.*, no. 17, February 16–March 7

1920–21 Corcoran Gallery of Art, Washington, DC: *Paintings by W. Elmer Schofield*, no. 15, December 18, 1920–January 9, 1921

1923 Grand Central Art Galleries, New York: *Inaugural Exhibition*

1931 Corcoran Gallery of Art, Washington, DC: *Paintings by W. Elmer Schofield*, no. 22, October 24–November 26

1937 PAFA: *132nd Annual Exhibition*, no. 105, January 24–February 28

1945 Woodmere Art Gallery, Philadelphia: *Memorial Exhibition of Oil Paintings by W. Elmer Schofield N.A.*, no. 16, November 3–26

PUBLISHED REFERENCES

Alterman, Jim. *New Hope for American Art*. Lambertville, NJ: Jim's of Lambertville, 2005

"Winter Scene by Schofield Sold to Head of Art Museum." *American Art News* 21, no. 29 (April 28, 1923): 1

COMMENTARY

The Rapids in Winter is among the first major works of art that Schofield made upon returning to the United States after the end of World War I. It was purchased by the "head" of an art museum in 1923, as noted in *American Art Review* in April of that year, for the great sum of $3,500. Because it was shown several times at the Corcoran Gallery of Art in the 1920s and '30s, we can surmise that the buyer may have been Charles C. Glover, the president of the institution. It is known that Glover sent back to Schofield an earlier painting he owned, *March Snow* (1906; ill. p. 49), perhaps as part of an exchange in which the value of the earlier work offset a portion of the cost of the more recent canvas.

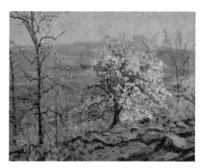

33

Wild Cherry Blossoms

Alternative title: **Breath of Spring, Housatonic River, Conn.**

1919–20

Oil on canvas

30 x 38 in.

Collection of Margaret E. Phillips. Photograph by Paul Rocheleau

EXHIBITION HISTORY

1920–21 Art Institute of Chicago: *Seven Special Exhibitions: Paintings by Guy Wiggins, Charles H. Woodbury, Alfred Juergens, John F. Stacey, Anna Lee Stacey, Gifford Beal, Eugene Speicher, and W. Elmer Schofield; Pastels by William P. Henderson; Sculpture by Jo Davidson*, no. 13, December 17, 1920–January 18, 1921

1921 Detroit Institute of Arts: *Exhibition of Paintings by Gifford Beal, Eugene Speicher and Elmer W. Schofield* [*sic*], no. 27, April 1–18

1938 Virginia Museum of Fine Arts, Richmond: *First Biennial Exhibition of Contemporary American Paintings*, March 12–April 24

1945 Woodmere Art Gallery, Philadelphia: *Memorial Exhibition of Oil Paintings by W. Elmer Schofield N.A.*, no. 19 (as *Breath of Spring, Housatonic River, Conn.*), November 3–26

COMMENTARY

The view depicted in this painting is the Housatonic River at Kent, Connecticut, close to both the home of Schofield's artist friend Ben Foster and the Schofield family's summerhouse near Great Barrington, Massachusetts.

The subject, a flowering cherry tree at the center of an expansive landscape, recalls similar compositions made in the 1920s by Schofield's one-time friend Redfield. Although the two artists had limited personal contact in the years after World War I, this painting suggests a continuing dialogue through their art and an ongoing cross-inspiration.

34
English Coast
c. 1920
Oil on canvasboard
11 1/2 x 13 1/2 in.
Private Collection

35
Morning Tide—Coast of Cornwall
Alternate title: **Morning Tide**
c. 1920
Oil on canvas
50 x 60 in.
Woodmere Art Museum: Gift of the Estate of the artist through Mrs. Herbert Phillips, 1952

EXHIBITION HISTORY

1921 PAFA: *116th Annual Exhibition*, no. 408 (as *Morning Tide*), February 6–March 26

1922–23 Buffalo Fine Arts Academy: *Exhibition of Paintings by Ben Foster, W. Elmer Schofield, Gardner Symons, and Douglas Volk*, no. 29, December 9, 1922–January 8, 1923

1923 Memorial Art Gallery, Rochester, NY: *Paintings by Ben Foster, W. Elmer Schofield, Gardner Symons and Douglas Volk*, no. 27, January–February

1924 Des Moines Association of Fine Arts: *Paintings by Elmer W. Schofield [sic], N.A. Presented by Des Moines Women's Club*, no. 17, January 16–February 18

Detroit Institute of Arts: *10th Annual Exhibition of Paintings by American Artists*, no. 126, April 23–May 31

Toledo Museum of Art, OH: *13th Annual Exhibition of Selected Paintings by American Artists*, no. 126, June–August

1926 Buffalo Fine Arts Academy: *20th Annual Exhibition of Selected Paintings by American Artists*, no. 104, April 25–June 21

Grand Central Art Galleries, New York: *New Society of Artists: 8th Annual Exhibition*, no. 158, November 13–December 4

1927 Scottish Rite Cathedral, Dallas: *Exhibition of Paintings and Sculpture by Leading Living American Artists under auspices of Dallas Art Association*, no. 128, February 5–25

1928 Montclair Art Museum, NJ: *Exhibition of Paintings by Gardner Symons and W. Elmer Schofield*, no. 3 (as *Morning Tide*), February 2–March 11

1929 Museum of Fine Arts, Houston: *Exhibition of Contemporary American Art by Members of the Grand Central Art Galleries*, January 13–27

Stendahl Art Galleries, Los Angeles, no. 40, March

1945 Woodmere Art Gallery, Philadelphia: *Memorial Exhibition of Oil Paintings by W. Elmer Schofield N.A.*, no. 21, November 3–26

2002 Woodmere Art Museum, Philadelphia: *Pennsylvania Impressionism from the Permanent Collection*, September 15–October 20

2002–3 Woodmere Art Museum, Philadelphia: *Pennsylvania Impressionism from the Permanent Collection*, November 28, 2002–March 16, 2003

2005–6 Woodmere Art Museum, Philadelphia: *Pennsylvania Impressionist Legacy*, September 25, 2005–January 8, 2006

PUBLISHED REFERENCES

Academy Notes (Buffalo) 18, no. 1 (January–June 1923): 24 (center of photograph)

Tovey, David. *Pioneers of St Ives Art at Home and Abroad (1889–1914)*. Tewkesbury, UK: Wilson Books, 2008

COMMENTARY

One of Schofield's greatest depictions of the cliffs of Cornwall, this painting was extensively exhibited until 1929.

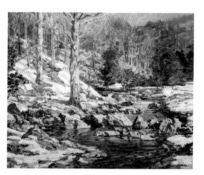

36
Wissahickon in Winter
Alternate title: **Cresheim Valley**
c. 1920
Oil on canvas
30 x 36 in.
Collection of Margaret E. Phillips

PROVENANCE/OWNERSHIP HISTORY

Estate of the artist

By descent in the family to Sarah and Herbert Louis Phillips

By descent in the family to Margaret E. Phillips

EXHIBITION HISTORY

1945 Woodmere Art Gallery, Philadelphia: *Memorial Exhibition of Oil Paintings by W. Elmer Schofield N.A.*, no. 20 (as *Cresheim Valley*), November 3–26

1984–85 Allentown Art Museum, PA: *The Pennsylvania School of Landscape Painting: An Original American Impressionism*, September 16–November 25, 1984. Traveled to the Corcoran Gallery of Art, Washington, DC, December 14, 1984–February 10, 1985; Westmoreland Museum of American Art, Greensburg, PA, March 2–May 5, 1985; and the Brandywine River Museum of Art, Chadds Ford, PA, June 1–September 2, 1985

1991 James A. Michener Art Museum, Doylestown, PA: *An American Impressionist: Walter Elmer Schofield*, June 22–November 3

PUBLISHED REFERENCE

Folk, Thomas. *The Pennsylvania School of Landscape Painting: An Original American Impressionism*. Allentown, PA: Allentown Art Museum, 1984, 11

COMMENTARY

This canvas was painted in the Wissahickon or Cresheim Valley, close to Schofield's brother's house and to Woodmere Art Museum. Schofield thought his son should paint there too: "I am going to New York tomorrow for a few days to arrange about some canvases—then back here [to] start to paint. Tell Sydney the park over near the Wissahickon [has] fine colour, forms of trees—all there."[1]

Along with *Covered Bridge over the Schuylkill at Norristown (The Red Bridge)* (by 1911; ill. p. 16), *Wissahickon in Winter* was thought by Schofield's daughter-in-law Mary to have been salvaged from the Delph Spinning Company mill by Sarah and Herbert Phillips. Mary described it as "a frozen stream with Elmer's treatment of snow."[2]

NOTES

1 Schofield to Muriel Schofield, November 22, 1928. Schofield Family Archive (formerly Godolphin House, Cornwall, United Kingdom).

2 Mary Schofield to Sydney Schofield, 1949. Schofield Family Archive (formerly Godolphin House, Cornwall, United Kingdom).

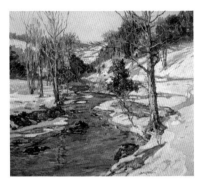

37
Nearing Spring
c. 1922
Oil on canvas
26 x 30 in.
Private Collection

PROVENANCE/OWNERSHIP HISTORY

Grand Central Art Galleries, New York

Acquired by a Private Collection, 1927

Private Collection

EXHIBITION HISTORY

1923 Memorial Art Gallery, Rochester, NY: *Paintings by Ben Foster, W. Elmer Schofield, Gardner Symons and Douglas Volk*, no. 46, January–February

PUBLISHED REFERENCE

Grand Central Art Galleries. *Year Book 1927*. New York: Grand Central Art Galleries, 1927, no. 3

COMMENTARY

Nearing Spring is a particularly fine example of the smaller scale snow scenes produced by Schofield in the 1920s.

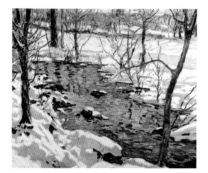

38
Untitled
c. 1922
Oil on canvas
25 x 30 in.
Collection of Marguerite and Gerry Lenfest

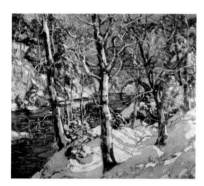

39
Winter in the Park
c. 1922
Oil on canvas
26 x 30 in.
Collection of Lucille and Walter Rubin

PROVENANCE/OWNERSHIP HISTORY

Collection of Enid and Seymour R. Schofield

Collection of Lucille and Walter Rubin

EXHIBITION HISTORY

2003 Boca Raton Museum of Art, FL: *America the
 Beautiful: 19th and 20th Century Paintings
 from the Walter and Lucille Rubin Collection*,
 January 22–March 30

PUBLISHED REFERENCE

Boca Raton Museum of Art. *America the Beautiful:
19th and 20th Century Paintings from the Walter and
Lucille Rubin Collection.* Boca Raton, FL: Boca Raton
Museum of Art, 2003, 60

COMMENTARY

I ike *Wissahickon in Winter* (c. 1920; ill. p. 17) and
Snow Stream (c. 1930; ill. p. 81), this canvas may
depicts the Wissahickon, where Schofield regularly
painted while staying with his brother Albert's family
in Chestnut Hill from the 1920s until the 1940s.

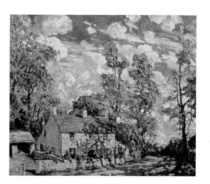

40
June Morning
c. 1923
Oil on canvas
50 x 60 in.
Collection of Karen and Thomas Buckley

PROVENANCE/OWNERSHIP HISTORY

Des Moines Association of Fine Arts purchase, 1924
(1924.2) (deaccessioned 1959)

Private Collection

Private Collection

Collection of Karen and Thomas Buckley

EXHIBITION HISTORY

1923–24 Corcoran Gallery of Art, Washington, DC: *9th
 Exhibition of Contemporary American Oil
 Paintings*, no. 83, December 15, 1923–January
 20, 1924

1924 Buffalo Fine Arts Academy: *18th Annual Exhibition of Selected Paintings and Small Bronzes by American Artists*, no. 187, April 20–June 30

1983 Brandywine River Museum of Art, Chadds Ford, PA: *Walter Elmer Schofield: Bold Impressionist*, no. 18, September 10–November 20

2011–12 James A. Michener Art Museum, Doylestown, PA: *The Painterly Voice: Bucks County's Fertile Ground*, October 22, 2011–April 1, 2012

PUBLISHED REFERENCES

Academy Notes (Buffalo) 19, no. 2 (July–December 1924): 47, 76

American Art Annual—Who's Who In Art 24 (1927)

American Magazine of Art 15, no. 2 (February 1924): 70

Folk, Thomas. *The Pennsylvania School of Landscape Painting: An Original American Impressionism.* Allentown, PA: Allentown Art Museum, 1984, 49

Folk, Thomas. *Walter Elmer Schofield: Bold Impressionist.* Chadds Ford, PA: Brandywine River Museum of Art, 1983, 25, 33, cat. no. 18

Peterson, Brian H., ed. *Pennsylvania Impressionism.* Philadelphia: James A. Michener Art Museum and University of Pennsylvania Press, 2002, 227

COMMENTARY

A number of artists wrote to James Sanson Carpenter, the first president of the Des Moines Association of Fine Arts, expressing their congratulations on the association's acquisition of *June Morning*. Carpenter made the purchase through Grand Central Art Galleries, possibly inspired by the 1924 exhibition *Paintings by Elmer W. Schofield [sic], N.A. Presented by Des Moines Women's Club*. Emil Carlsen declared it "an important canvas by Mr. Schofield," and Douglas Volk stated, "I have the greatest admiration for the Artist and for the man."[1] Cornelia B. Sage Quinton, director of the Buffalo Fine Arts Academy, wrote to ask if the picture could be loaned for the academy's forthcoming *Annual Exhibition*: "I should be undyingly grateful as I have no Schofield for my exhibition, and I consider the one you have just purchased one of the finest I have ever seen."[2]

Carpenter's private collection was widely admired and contained many pictures by important artists, including several by Henry Ossawa Tanner and George Bellows, and three by Schofield. Florence Carpenter donated Schofield's *Village of St. Ives in Cornwall* (date unknown) to the Des Moines Art Center in 1941.

NOTES

1 Emil Carlsen to James Sanson Carpenter, July 2, 1924; and Douglas Volk to Carpenter, December 2, 1924. Curatorial file for *June Morning*, Des Moines Art Center.

2 Cornelia B. Sage Quinton to James Sanson Carpenter, February 29, 1924. Curatorial file for *June Morning*, Des Moines Art Center.

41
Morning
c. 1923
Oil on canvas
50 x 60 in.
The Collections of Hobart and William Smith Colleges. Photograph courtesy of the Collections of Hobart and William Smith Colleges

EXHIBITION HISTORY

1923 National Academy of Design, New York: *Winter Exhibition*, no. 363, November 16–December 16

PUBLISHED REFERENCE

The New York Times Magazine, November 25, 1923

COMMENTARY

Morning is the largest of a group of winter landscapes Schofield produced in the early 1920s. The composition is closely related to *Morning Light* (1922; ill. p. 81), which was shown at the Buffalo Fine Arts Academy in 1922–23 and purchased directly from the exhibition by the French government. It

was first placed in the Musée du Luxembourg, and, decades later, was transferred to the Musée d'Orsay. It now resides in the Château de Blérancourt, France's museum of American art.

Schofield painted the hamlet alongside his son Sydney. The style of the canvas is comparable to others known to have been made in 1923.

42
Phillack Bridge
Alternate title: **Phillick Bridge**
c. 1923
Oil on canvas
20 x 24 in.
Collection of Margaret E. Phillips

PROVENANCE/OWNERSHIP HISTORY

Estate of the artist

By descent in the family to Sarah and Herbert Louis Phillips

By descent in the family to Margaret E. Phillips

EXHIBITION HISTORY

1929 Museum of Fine Arts, Houston: *Exhibition of Contemporary American Art by Members of the Grand Central Art Galleries* (as *Phillick Bridge*), January 13–27

1991 James A. Michener Art Museum, Doylestown, PA: *An American Impressionist: Walter Elmer Schofield* (as *Phillick Bridge*), June 22– November 3

COMMENTARY

This canvas depicts the hamlet of Undercliff, Phillack, at the head of the Hayle estuary in western Cornwall. The area would have been well known to Schofield— Lelant and St. Ives, where he visited and lived, are only a few miles further west, across the estuary.

43
A Rocky Shore
1924
Oil on canvas
35 1/2 x 40 in.
Private Collection

COMMENTARY

Schofield's eldest sister, Ellen, appears to have spent summers at Central Landing, Chebeague Island, Maine, in the later years of her life. In May 1924 Schofield decided to spend the summer in Maine with his sister. He also stayed with his friend the collector Dr. Conboy in Rochester for a week on the way. He was uncertain about this change of scenery, but his letters suggest that he was favorably impressed with the area.[1] He produced a considerable number of marines and several landscapes depicting the Maine coast.

NOTE

1 Schofield to Muriel Schofield, May 18, 1924. Letter no. 615, Schofield Family Archive (formerly Godolphin House, Cornwall, United Kingdom).

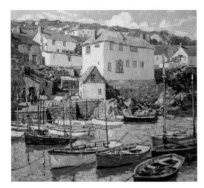

44
The Little Harbor
By 1925
Oil on canvas
36 x 40 in.
Collection of Karen and Thomas Buckley

PROVENANCE/OWNERSHIP HISTORY

Purchased by Hugo Koeffler, March 16, 1928

Private Collection

Collection of Karen and Thomas Buckley

EXHIBITION HISTORY

1925 Milch Gallery, New York: *Recent Paintings by W. Elmer Schofield*, no. 3, November 16–December 5

1926 Corcoran Gallery of Art, Washington, DC: *10th Exhibition of Contemporary American Oil Paintings*, no. 117, April 4–May 16 (awarded William A. Clark Prize and Corcoran Silver Medal)

Sesqui-Centennial Exposition, Philadelphia, no. 575, June 1–December 1 (awarded Silver Medal)

1927 Scottish Rite Cathedral, Dallas: *Exhibition of Paintings and Sculpture by Leading Living American Artists under auspices of Dallas Art Association*, no. 129, February 5–25

1928 Stendahl Art Galleries, Los Angeles: *Exhibition of Paintings by W. Elmer Schofield, N.A., and Gardner Symons, N.A.*, no. 28, March (purchased by Hugo Koeffler for $3,500)

2011–12 James A. Michener Art Museum, Doylestown, PA: *The Painterly Voice: Bucks County's Fertile Ground*, October 22, 2011–April 1, 2012

PUBLISHED REFERENCES

American Magazine of Art 17, no. 5 (May 1926): 227 (ill.)

The New York Times Magazine, April 11, 1926

Tovey, David. *Pioneers of St Ives Art at Home and Abroad (1889–1914)*. Tewkesbury, UK: Wilson Books, 2008, 325

COMMENTARY

The Little Harbor depicts Coverack, a fishing village at the southern end of the Lizard Peninsula, in the southwest of Cornwall. Schofield may have first traveled there in 1918 while on leave from the Front. Hugo Koeffler, an important collector from Los Angeles, purchased this work on March 16, 1928, for $3,500.

Coverack postcard, date unknown. Photograph courtesy of the Schofield Family

45
The Cottages
c. 1925
Oil on canvas
30 x 36 in.

Chrysler Museum of Art, Norfolk, VA: Museum purchase, 43.27.1.
Photograph courtesy of Chrysler Museum of Art, Norfolk, VA

PROVENANCE/OWNERSHIP HISTORY

Purchased for the Norfolk Museum of Arts and
Sciences (now the Chrysler Museum of Art), 1926

EXHIBITION HISTORY

1925 Concord Art Association, MA: *9th Annual
 Exhibition* (received Honorable Mention)

1926 Museum of Fine Arts, Houston: *Exhibition of
 Paintings and Sculpture by Leading Living
 American Artists*, no. 192, January 9-23

COMMENTARY

This canvas shows the Old Post Office, a medieval
hall house now owned by the National Trust, at
Tintagel, in northern Cornwall. The cliffs on the right
were added for dramatic effect, as the building is
not actually so close to the coast. From the 1920s
and after, Schofield sometimes invented landscape
elements for dramatic effect. Tintagel had been a
popular tourist destination since the Victorian era,
playing on its Arthurian associations; by the time of
Schofield's visit, the Old Post Office was surrounded
by the new town that had emerged to cater to these
visitors.

From May 5, 1966, to April 11, 1979, the painting was
on loan to Judge Linwood B. Tabb, who hung it in his
office in Norfolk, Virginia.

46
River Exe
1925-27
Oil on canvasboard
12 x 14 in.

Private Collection

COMMENTARY

It is known that Schofield traveled to this locale in
Devon, United Kingdom, in 1926, and that he mounted
an exhibition at the Milch Gallery, New York, titled
Paintings of Cornwall and Devonshire that next year.[1]
Aida, the wife of his friend Hayley Lever, had family
at Exmouth, and the train to Cornwall passes through
Exeter and along the Exe estuary, providing ample
opportunity for Schofield to have painted there.

NOTES

1 Milch Gallery, New York: *Paintings of Cornwall and Devonshire by W.
 Elmer Schofield*, January 24–February 12, 1927.

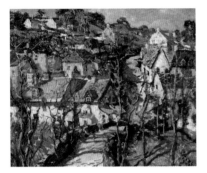

47
Bridge to Village
c. 1925–35
Oil on canvas
16 x 20 in.
Private Collection

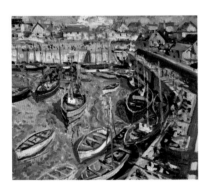

48
A French Harbor
c. 1927
Oil on canvas 22 1/2 x 26 1/2 in.
Collection of Maureen and Gregory Church

COMMENTARY

Schofield visited France with Lever in 1927. The two artists traveled the Normandy coast, visiting harbor towns such as Dieppe, Le Havre, and Honfleur. It seems likely that this bold composition was made during this trip, which would be Schofield's final visit to France.

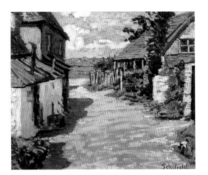

49
The Path to the Sea
c. 1927
Oil on canvas
16 x 20 in.
Private Collection

PROVENANCE/OWNERSHIP HISTORY

Estate of the artist

By descent in the family to Enid and Seymour R. Schofield

Acquired by the present Private Collection from Enid Schofield, 1979

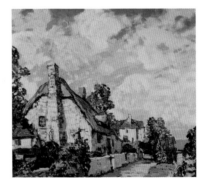

50
Under Summer Skies
c. 1928
Oil on canvas
26 x 30 in.
Collection of Lucille and Walter Rubin

EXHIBITION HISTORY

1928 Stendahl Art Galleries, Los Angeles: *Exhibition of Paintings by W. Elmer Schofield, N.A., and Gardner Symons, N.A.*, no. 44, March

PUBLISHED REFERENCE

The Clubwoman 18, no. 6 (March 1928): cover. Reel 2723, frame 88, Stendahl Art Galleries records, Archives of American Art, Smithsonian Institution

COMMENTARY

Based on comparison to other paintings made by Schofield in 1927 and 1928 in the area, we can identify *Under Summer Skies* (c. 1928; ill. p. 112) as a depiction of a thatched house close to the coast of Suffolk. In 1927, Elmer and Muriel Schofield left their home in Perranporth to purchase another historic home in Suffolk, dating back to the fifteenth century. A significant historic structure with a moat and a grand-scaled entrance hall, Otley High House was in great need of repair. Sydney Schofield, the artist's younger son, who was a trained, preservation-minded architect, carried out the renovations.

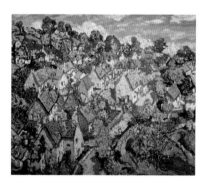

51
The Bridge Inn
By 1929
Oil on canvas
30 x 34 in.
Fine Arts Collection of The School District of Philadelphia

PROVENANCE/OWNERSHIP HISTORY

Estate of the artist

Acquired by Walter Baum after October 1949

Gifted to the School District of Philadelphia

EXHIBITION HISTORY

1929 Stendahl Art Galleries, Los Angeles, no. 41, March

1934 Stendahl Art Galleries, Los Angeles, no. 5, October

1935 Faulkner Memorial Art Gallery, Free Public Library, Santa Barbara, CA: *Exhibitions: Elmer W. Schofield* [*sic*]*, N.A.* no. 17, March 2–21

1945 Woodmere Art Gallery, Philadelphia: *Memorial Exhibition of Oil Paintings by W. Elmer Schofield N.A.*, no. 27, November 3–26

COMMENTARY

In the late 1920s and throughout the 1930s, Schofield became known for depictions of hillside villages in which the viewpoint is extremely elevated, so that the forms of the individual houses become a decorative pattern. *The Bridge Inn* is one such canvas. The work was given to the School District of Philadelphia by Walter Baum, a friend of Schofield's who assisted the family with placing paintings in local Pennsylvania collections after the artist's death. Mary Schofield listed *The Bridge Inn* in a letter to her husband, Sydney, in 1949, showing that it remained in the estate at the time, and was only acquired by Baum after that date.[1]

NOTES

1 Mary Schofield to Sydney Schofield, October 3, 1949. Schofield Family Archive (formerly Godolphin House, Cornwall, United Kingdom). The letter lists the painting as "The Bridge Inn 30 x 36 $150."

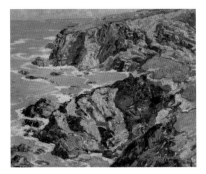

52
Cliffs at Bedruthan
Alternate title: **Cliffs of Bedruthan**
By 1929
Oil on canvas
30 x 36 in.
Private Collection. Photograph by Christopher Gardner

EXHIBITION HISTORY

1931 Corcoran Gallery of Art, Washington, DC: *Paintings by W. Elmer Schofield*, no. 14 (as *Cliffs of Bedruthan*), October 24–November 26

COMMENTARY

Bedruthan is a famously dramatic stretch of cliffs in Cornwall. This coastal scene was painted by 1929, as indicated by a submission label for the *42nd Annual Exhibition* at the Art Institute of Chicago, held that year. It was not accepted, emblematic of the more mixed fortunes Schofield had at the major annual exhibitions from the late 1920s onward.

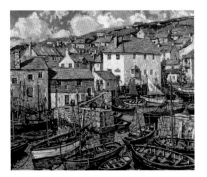

53
The Harbor, Sunday
By 1929
Oil on canvas
40 x 48 in.
Collection Jim's of Lambertville. Photograph courtesy of Jim's of Lambertville

EXHIBITION HISTORY

1929 Stendahl Art Galleries, Los Angeles, no. 36, March

1931 Corcoran Gallery of Art, Washington, DC: *Paintings by W. Elmer Schofield*, no. 3, October 24–November 26

1933 Carnegie Institute, Pittsburgh: *31st Annual International Exhibition*, October 19–December 10

1945 Woodmere Art Gallery, Philadelphia: *Memorial Exhibition of Oil Paintings by W. Elmer Schofield N.A.*, no. 17, November 3–26

PUBLISHED REFERENCE

Alterman, Jim. *New Hope for American Art*. Lambertville, NJ: Jim's of Lambertville, 2005

COMMENTARY

The prominent "FY" shipping registry marks on the boats in the lower right of this painting suggest that the scene depicts either Fowey or one of the smaller harbors in southeastern Cornwall for which Fowey is the port of registry. It may also be an amalgam of studies from several such locations.

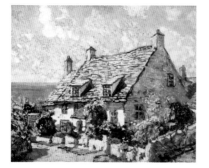

54
Cottage in Cornwall
c. 1930
Oil on canvas
20 x 24 in.
Collection of Margaret E. Phillips

PROVENANCE/OWNERSHIP HISTORY

Estate of the artist

By descent in the family to Sarah and Herbert Louis Phillips

By descent in the family to Margaret E. Phillips

EXHIBITION HISTORY

1945 Woodmere Art Gallery, Philadelphia: *Memorial Exhibition of Oil Paintings by W. Elmer Schofield N.A.*, November 3–26

1991 James A. Michener Art Museum, Doylestown, PA: *An American Impressionist: Walter Elmer Schofield*, June 22–November 3

COMMENTARY

Schofield's niece Sarah's home on West Moreland Avenue, Chestnut Hill, became his repository for paintings that were returned from US exhibitions. *Cottage in Cornwall*—which was made substantially earlier than its first known exhibition date, in 1945—is one of the framed pictures that Sarah decided to keep after it was returned. Both *Cottage in Cornwall* and *Phillack Bridge* (c. 1923; ill. p. 19) retain their original Newcomb-Macklin frames and glass.

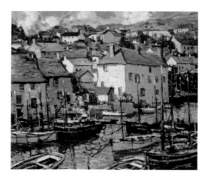

55
Newlyn Harbor, Cornwall
c. 1930
Oil on canvas
20 x 24 in.
Private Collection

PROVENANCE/OWNERSHIP HISTORY

Doyle New York, 2004

Acquired by a Private Collection from the above

Acquired by Jim's of Lambertville

Private Collection

PUBLISHED REFERENCE

Alterman, Jim. *New Hope for American Art*. Lambertville, NJ: Jim's of Lambertville, 2005

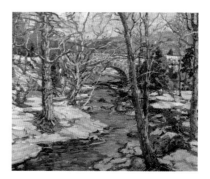

56
Snow Stream
c. 1930
Oil on plyboard
20 x 24 in.
Collection of Marguerite and Gerry Lenfest

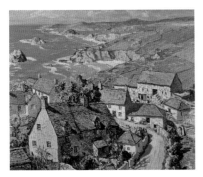

57
Trenwith—Cornish Farm
By 1932
Oil on canvas
40 x 48 in.
Woodmere Art Museum: Museum Purchase, 1946

PROVENANCE/OWNERSHIP HISTORY

Grand Central Art Galleries, 1945

Woodmere Art Museum, purchased from the above, 1946

EXHIBITION HISTORY

1931 Corcoran Gallery of Art, Washington, DC: *Paintings by W. Elmer Schofield*, no. 12, October 24–November 26

1933 PAFA: *128th Annual Exhibition*, no. 32, January 29–March 19

1940 Carnegie Institute, Pittsburgh: *Survey of American Painting*, no. 202, October 24–December 15

1945 Grand Central Art Galleries, New York: *Memorial Exhibition W. Elmer Schofield, N.A.*, March 27–April 7

 Woodmere Art Gallery, Philadelphia: *Memorial Exhibition of Oil Paintings by W. Elmer Schofield N.A.*, no. 13, November 3–26

1983 Brandywine River Museum of Art, Chadds Ford, PA: *Walter Elmer Schofield: Bold Impressionist*, September 10–November 20

2003 Woodmere Art Museum, Philadelphia: *Selections from the Permanent Collection*, April 13–July 6

2005-6 Woodmere Art Museum, Philadelphia: *Pennsylvania Impressionist Legacy*, September 25, 2005–January 8, 2006

PUBLISHED REFERENCES

Alterman, Jim. *New Hope for American Art*. Lambertville, NJ: Jim's of Lambertville, 2005

Folk, Thomas. *Walter Elmer Schofield: Bold Impressionist*. Chadds Ford, PA: Brandywine River Museum of Art, 1983, cat. no. 40

"Passing Shows." *ARTnews* 44, no. 4 (April 1–14, 1945): 26

Tovey, David. *Pioneers of St Ives Art at Home and Abroad (1889–1914)*. Tewkesbury, UK: Wilson Books, 2008, 325

COMMENTARY

The Trenwith family, whose farm and buildings are depicted, had been associated with St. Ives and the parish of Lelant for many centuries. With *Trenwith—Cornish Farm*, Schofield positions the viewer at an elevated vantage point, as he does with *The Bridge Inn* and other works of the early 1930s. It is possible that the entire composition was assembled, in the manner of a collage, from several independent studies.

58
The Canyon, Tujunga
1934
Oil on panel
24 1/4 x 30 in.
Gift of Muriel and Philip Berman, Permanent Collection of the Philip and Muriel Berman Museum of Art at Ursinus College

PROVENANCE/OWNERSHIP HISTORY

Collection of Philip and Muriel Berman

Placed on long-term loan at the Philip and Muriel Berman Museum of Art, October 1990

Donated to the Philip and Muriel Berman Museum of Art, June 1992

EXHIBITION HISTORY

1934 Stendahl Art Galleries, Los Angeles, no. 20, October

1988 Payne Gallery of Moravian College, Bethlehem, PA: *W. Elmer Schofield: Proud Painter of Modest Lands*, no. 10, November 3–December 11

1990 Philip and Muriel Berman Museum of Art, Collegeville, PA: October 19–November 25

1991 James A. Michener Art Museum, Doylestown, PA: *An American Impressionist: Walter Elmer Schofield*, June 22–November 3

1993 Susquehanna University Art Gallery, Selinsgrove, PA: *Walter Elmer Schofield: Proud Painter of Modest Lands*, March 19–April 18

PUBLISHED REFERENCE

Livingston, Valerie. *W. Elmer Schofield: Proud Painter of Modest Lands*. Bethlehem, PA: Moravian College, 1988, 37

COMMENTARY

Schofield painted a significant group of Western landscapes during an extended trip to California and Arizona in the mid-1930s. He discussed his visit and a possible exhibition with gallery owner Earl L. Stendahl prior to traveling west. In a letter dated 1934 Schofield explains, "After your [Stendahl's] letter arrived I made my mind up to come to Calif. and see how things turned out. You spoke about the teaching, starting about Sept 1 and then an Ex. later on—well that would be quite OK."[1] In October 1934, critic Otheman Stevens noted, "His [Schofield's] most recent work will be seen on exhibit in a few days at Stendahl's Gallery."[2] No records survive to confirm the exhibition; however, many of these Western paintings have Stendahl Art Galleries labels adhered to their backs. The composition of this painting, with the dramatic forked tree, is similar to two other works, *Tujunga Canyon* (c. 1934–35; illustrated below), now in the collection of the Los Angeles County Museum of Art, and *Spring Rain, Tujunga* (1934, location unknown), a work that appeared recently at auction. The signature and date on *Spring Rain, Tujunga* suggests that the other paintings, which are not dated, were likely made in the same year.

Tujunga Canyon, c. 1934–35, by Walter Elmer Schofield (Los Angeles County Museum of Art, Gift of Nancy M. Berman [M.2002.180] © The Heirs of W. Elmer Schofield 2014) Digital Image © 2014 Museum Associates / LACMA. Licensed by Art Resource, NY

NOTES

1 Schofield to Earl L. Stendahl, August 29, 1934. Reel 2722, Stendahl Art Galleries records, Archives of American Art, Smithsonian Institution.

2 Otheman Stevens, "Schofield Will Exhibit Art," *Los Angeles Examiner*, October 2, 1934.

59

In Arizona

1934

Oil on linen

30 x 36 in.

Gift of Muriel and Philip Berman, Permanent Collection of the Philip and Muriel Berman Museum of Art at Ursinus College

PROVENANCE/OWNERSHIP HISTORY

Collection of Philip and Muriel Berman

Placed on long-term loan at the Philip and Muriel Berman Museum of Art, October 1990

Donated to the Philip and Muriel Berman Museum of Art, June 1992

EXHIBITION HISTORY

1934 Stendahl Art Galleries, Los Angeles, no. 16, October

1988 Payne Gallery of Moravian College, Bethlehem, PA: *W. Elmer Schofield: Proud Painter of Modest Lands*, no. 10, November 3–December 11

1990 Philip and Muriel Berman Museum of Art, Collegeville, PA: October 19–November 25

1993 Susquehanna University Art Gallery, Selinsgrove, PA: *Walter Elmer Schofield: Proud Painter of Modest Lands*, March 19–April 18

PUBLISHED REFERENCE

Livingston, Valerie. *W. Elmer Schofield: Proud Painter of Modest Lands*. Bethlehem, PA: Moravian College, 1988, 42

60
Morning Light, Tujunga
1934
Oil on board
30 x 35 in.
Woodmere Art Museum: Gift of Leigh and Sally Marsh, 1992

EXHIBITION HISTORY

1934 Stendahl Art Galleries, Los Angeles, no. 30, October

2002 Woodmere Art Museum, Philadelphia: *Pennsylvania Impressionism from the Permanent Collection*, September 15–October 20

2002-3 Woodmere Art Museum, Philadelphia: *Pennsylvania Impressionism from the Permanent Collection*, November 28, 2002–March 16, 2003

2003 Woodmere Art Museum, Philadelphia: *Selections from the Permanent Collection*, April 13–July 6

2004 Woodmere Art Museum, Philadelphia: *Philadelphia Traditions*, September 18–October 3

2005-6 Woodmere Art Museum, Philadelphia: *Pennsylvania Impressionist Legacy*, September 25, 2005–January 8, 2006

2008 Ogunquit Museum of American Art, ME: *The New Hope School: Pennsylvania Impressionists*, August 25–October 31

COMMENTARY

Schofield made a group of paintings of Tujunga Canyon and the Grand Tujunga ranch, which lie to the northeast of Los Angeles. In a series of radio talks given in the autumn of 1934, the artist outlined the attractions of working and teaching in California, among which were the particular trees found there:

> There is no doubt in my mind that the State of California and particularly Southern California is a perfect Paradise for the out-of-doors painters. Coupled with the wonderful climate there is a great diversity of physical features. The numerous canyons each having a separate charm. The splendid coastline and the many natural parks with a wealth of trees, oak, pepper, sycamore, eucalyptus, etc. I have never seen finer sycamore trees than are to be found in Irvine Park, silvery white with far-flung limbs, intermingled with oaks, eucalyptus and many others. And a riot of color too. Could anything be more tempting to the landscape painter than these grand old sycamores against a sky of purest blue.[1]

The Grand Tujunga ranch was destroyed in the Los Angeles flood of 1938, when Big Tujunga Dam made emergency releases of floodwater. Schofield's art students Peggy and David Ayars wrote to him to describe the state of the area: "You know a lot of water has gone over the dam since we all used to go out to Big Tujunga together. In fact so much water went over the dam in one rainy spell there that Big Tujunga is no more. It took away the road, the trees, and the farmhouses and left only a large quantity of boulders."[2]

NOTES

1 Schofield Radio Transcript B, 1934. Schofield Family Archive (formerly Godolphin House, Cornwall, United Kingdom).

2 Margaret T. Ayars and David Ayars to Schofield, January 1, 1939. Schofield Family Archive (formerly Godolphin House, Cornwall, United Kingdom).

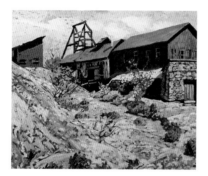

61
Old Shaft, Arizona
Alternate title: **Gold Shaft, Arizona**
1934
Oil on Masonite
30 x 36 in.
Gift of Muriel and Philip Berman, Permanent Collection of the Philip and Muriel Berman Museum of Art at Ursinus College

PROVENANCE/OWNERSHIP HISTORY

Collection of Philip and Muriel Berman

Placed on long-term loan at the Philip and Muriel Berman Museum of Art, October 1990

Donated to the Philip and Muriel Berman Museum of Art, June 1992

EXHIBITION HISTORY

1934 Stendahl Art Galleries, Los Angeles, no. 23, October

1983 Brandywine River Museum of Art, Chadds Ford, PA: *Walter Elmer Schofield: Bold Impressionist*, no. 14 (as *Gold Shaft, Arizona*), September 10–November 20

1988 Payne Gallery of Moravian College, Bethlehem, PA: *W. Elmer Schofield: Proud Painter of Modest Lands*, no. 12 (as *Gold Shaft, Arizona*), November 3–December 11

1990 Philip and Muriel Berman Museum of Art,

Collegeville, PA: October 19–November 25

1991 James A. Michener Art Museum, Doylestown, PA: *An American Impressionist: Walter Elmer Schofield*, June 22–November 3

1993 Susquehanna University Art Gallery, Selinsgrove, PA: *Walter Elmer Schofield: Proud Painter of Modest Lands*, March 19–April 18

PUBLISHED REFERENCES

Folk, Thomas. *Walter Elmer Schofield: Bold Impressionist*. Chadds Ford, PA: Brandywine River Museum of Art, 1983, 39, cat. no. 14

Livingston, Valerie. *W. Elmer Schofield: Proud Painter of Modest Lands*. Bethlehem, PA: Moravian College, 1988, 41, 43

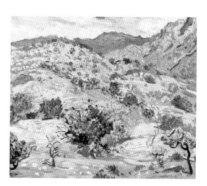

62
Purple Mountains
1934
Oil on panel
30 x 36 in.
Collection Brandywine River Museum of Art. Gift of Margaret E. Phillips, 2003. Photograph courtesy of Brandywine River Museum of Art

PROVENANCE/OWNERSHIP HISTORY

Collection of Mary and Sydney E. Schofield

Collection of Muriel and Philip Berman

Brandywine River Museum of Art

EXHIBITION HISTORY

1934 Stendahl Art Galleries, Los Angeles, no. 24, October

1983 Brandywine River Museum of Art, Chadds Ford, PA: *Walter Elmer Schofield: Bold Impressionist*, September 10–November 20

PUBLISHED REFERENCES

Folk, Thomas. *The Pennsylvania Impressionists*. Madison, NJ: Fairleigh Dickinson University Press, 1997, 59–60

Folk, Thomas. *Walter Elmer Schofield: Bold Impressionist*. Chadds Ford, PA: Brandywine River Museum of Art, 1983, 41, cat. no. 35

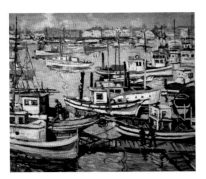

63
Fishing Fleet, San Pedro
1934–35
Oil on panel
30 x 36 in.
Private Collection

EXHIBITION HISTORY

1983 Brandywine River Museum of Art, Chadds Ford, PA: *Walter Elmer Schofield: Bold Impressionist*, September 10–November 20

PUBLISHED REFERENCE

Folk, Thomas. *Walter Elmer Schofield: Bold Impressionist*. Chadds Ford, PA: Brandywine River Museum of Art, 1983, 27, cat. no. 12

COMMENTARY

Stendahl Art Galleries invited Schofield to teach art courses in Los Angeles in 1934. He traveled to San Pedro to paint with the class and the local society portrait painter Frances Cranmer Greenman. "What a different world it is here!" he wrote to Muriel.

These people are hospitable—I'm out nearly every night, somewhere—and a lot of publicity—which they all seem to strive madly for—I have talked over the Radio three times— and could arrange for a weekly fixture if I so wished—I have sent articles to the papers on Modern art etc.—and spoken at two Clubs. . . . again the idea is—Publicity![1]

In one of his radio addresses, Schofield described the scene at San Pedro:

One of the greatest and most interesting fishing harbors in the world, and I have seen many here in the United States and abroad. . . . Not only is there industry but color and form as well. Every variety of boat, French, American, Swedish, Japanese, each peculiar in style with bright color that charms the eye. Red decks, white pilot houses, green and white hulls. One can readily picture what this means under the brilliant sun of California. The clear water blue and green, the figures of the men, some stripped to the waists unloading fish, handling the huge nets which are spread out on the roads and long wharves to dry and scores of men mending the rents in the nets torn by the sharks.[2]

One of Schofield's art students later reported that in the intervening years, San Pedro had changed beyond recognition: "A stylish yacht club now adorns the mole and the place has become so stylish and fashionable that you will need your tuxedo if you ever paint there again."[3]

While in California, Schofield continued his intermittent experimentation with printmaking; included in *International Impressionist* are a lithograph and an etching the artist made in San Pedro Harbor (illustrated below).

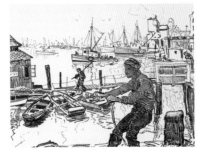

Untitled [California Harbor Scene], c. 1934, lithograph, by Walter Elmer Schofield (Collection of Karen and Thomas Buckley)

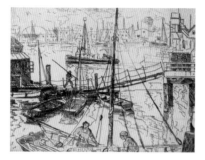

Untitled [California Harbor Scene] c. 1934, etching, by Walter Elmer Schofield (Collection of Karen and Thomas Buckley)

NOTES

1 Schofield to Muriel Schofield, October 27, 1934. Letter no. 171, Schofield Family Archive (formerly Godolphin House, Cornwall, United Kingdom).

2 Schofield Radio Transcript B, October 1934. Schofield Family Archive (formerly Godolphin House, Cornwall, United Kingdom).

3 Margaret T. Ayars and David Ayars to Schofield, January 1, 1939. Schofield Family Archive (formerly Godolphin House, Cornwall, United Kingdom).

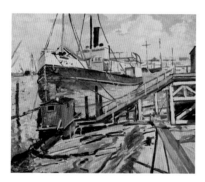

64
Large Boat at Dock
c. 1934–35
Oil on board
30 x 36 in.
Gift of Muriel and Philip Berman, Permanent Collection of the Philip and Muriel Berman Museum of Art at Ursinus College

PROVENANCE/OWNERSHIP HISTORY

Collection of Philip and Muriel Berman

Donated to the Philip and Muriel Berman Museum of Art, February 1989

EXHIBITION HISTORY

1990 Philip and Muriel Berman Museum of Art, Collegeville, PA: October 19–November 25

1991 James A. Michener Art Museum, Doylestown, PA: *An American Impressionist: Walter Elmer Schofield*, June 22–November 3

1993 Susquehanna University Art Gallery, Selinsgrove, PA: *Walter Elmer Schofield: Proud Painter of Modest Lands*, March 19–April 18

COMMENTARY

This painting's loose markings and brushstrokes give insight into Schofield's quick and fluid working method. It possibly depicts San Pedro Harbor, or another of the California ports he visited.

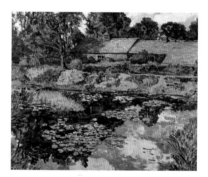

65
The Ponds, Godolphin
Alternate title: **The Farm House and Pond**
c. 1939
Oil on canvas
36 x 40 in.
Collection of Lucille and Walter Rubin

PROVENANCE/OWNERSHIP HISTORY

Collection of Enid and Seymour R. Schofield

Collection of Lucille and Walter Rubin

EXHIBITION HISTORY

1983 Brandywine River Museum of Art, Chadds Ford, PA: *Walter Elmer Schofield: Bold Impressionist* (as *The Farm House and Pond*), September 10–November 20

2003 Boca Raton Museum of Art, FL: *America the Beautiful: 19th and 20th Century Paintings from the Walter and Lucille Rubin Collection* (as *The Farm House and Pond*), January 22–March 30

PUBLISHED REFERENCES

Boca Raton Museum of Art. *America the Beautiful: 19th and 20th Century Paintings from the Walter and Lucille Rubin Collection*. Boca Raton, FL: Boca Raton Museum of Art, 2003, 60 (as *The Farm House and Pond*)

Folk, Thomas. *Walter Elmer Schofield: Bold Impressionist*. Chadds Ford, PA: Brandywine River Museum of Art, 1983, 27, cat. no. 11 (as *The Farm House and Pond*)

COMMENTARY

In 1937, the artist's son Sydney purchased the Godolphin estate, which covered approximately 550 acres of land and centered on a grand, seventeenth-century manor house that had once been home to Sidney Godolphin, Lord High Treasurer to Queen Anne. Schofield rarely painted the manor house itself, instead focusing on the surrounding woodlands and the extensive gardens.

This canvas depicts the carp ponds, part of the estate's historic gardens that date to the Middle Ages. Looking west, past the east pond, the view encompasses one of the ancient yew trees on the bank (upper left) with the more recent cowsheds beyond. A comparable painting looking east across this same pond, *Lily Pond, Godolphin* (1939; illustrated below) is currently on loan to the Penlee House Gallery and Museum, Penzance, United Kingdom; it shows the great row of giant sycamores that line the wall between the pond and the grazing field (an enclosed paddock). Godolphin's second famous yew tree is depicted in the middle left.

Schofield was greatly pleased with the paintings he made at Godolphin. He was working toward an exhibition at the Stendahl Art Galleries in Los Angeles, through the years of World War II and at the time of his death in 1944. He declared to Earl L. Stendahl, "Earl, I have a pretty good bunch of work—the best I have ever had and someday may show them when things are sane again."[1]

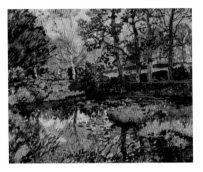

Lily Pond, Godolphin, 1939, by Walter Elmer Schofield (Private Collection, on loan to Penlee House Gallery and Museum, Penzance, Cornwall)

NOTES

1 Schofield to Earl L. Stendahl, September 22, 1941. Reel 2723, Stendahl Art Galleries records, Archives of American Art, Smithsonian Institution.

66
Gwedna Woods
Alternate titles: **Forest; The Forest**
1940
Oil on linen
26 1/2 x 30 in.
Gift of Muriel and Philip Berman, Permanent Collection of the Philip and Muriel Berman Museum of Art at Ursinus College

PROVENANCE/OWNERSHIP HISTORY

Collection of Philip and Muriel Berman

Placed on long-term loan at the Philip and Muriel Berman Museum of Art, October 1990

Donated to the Philip and Muriel Berman Museum of Art, June 1992

EXHIBITION HISTORY

1988 Payne Gallery of Moravian College, Bethlehem, PA: *W. Elmer Schofield: Proud Painter of Modest Lands*, no. 15 (as *Forest*), November 3–December 11

1990 Philip and Muriel Berman Museum of Art, Collegeville, PA (as *The Forest*), October 19–November 25

1993 Susquehanna University Art Gallery, Selinsgrove, PA: *Walter Elmer Schofield: Proud Painter of Modest Lands* (as *The Forest*), March 19–April 18

PUBLISHED REFERENCE

Livingston, Valerie. *W. Elmer Schofield: Proud Painter of Modest Lands*. Bethlehem, PA: Moravian College, 1988, 48 (as *Forest*)

COMMENTARY

Godolphin Count House, known at the time of the Schofields' residence as "Gwedna," was built in the early nineteenth century as an accounting house for the Duke of Leeds's copper mines. It was converted into a home for Elmer and Muriel Schofield after their son Sydney's marriage to Mary Lanyon in 1940. Here Schofield depicts the Gwedna Woods, which surrounded the house. The abandoned mine workings had long since been reclaimed by nature, and the result was an uneven terrain of great troughs and mounds.

67
Cornish Coast
c. 1940
Oil on canvas
46 x 46 in.

Philadelphia Museum of Art, Gift of Muriel and Philip Berman, 1989-70-1. Photograph courtesy of Philadelphia Museum of Art

COMMENTARY

Among the largest paintings of Schofield's later years, this panoramic view from above the Cornish coast demonstrates Schofield's continuing ambition.

68
The Hayricks
c. 1940
Oil on linen
30 x 30 in.

Gift of Muriel and Philip Berman, Permanent Collection of the Philip and Muriel Berman Museum of Art at Ursinus College

PROVENANCE/OWNERSHIP HISTORY

Collection of Philip and Muriel Berman

Placed on long-term loan at the Philip and Muriel Berman Museum of Art, October 1990

Donated to the Philip and Muriel Berman Museum of Art, June 1992

EXHIBITION HISTORY

1988 Payne Gallery of Moravian College, Bethlehem, PA: *W. Elmer Schofield: Proud Painter of Modest Lands*, no. 14, November 3–December 11

1990 Philip and Muriel Berman Museum of Art, Collegeville, PA: October 19–November 25

1993 Susquehanna University Art Gallery, Selinsgrove, PA, *Walter Elmer Schofield: Proud Painter of Modest Lands*, March 19–April 18

1997–98 Westmoreland Museum of American Art, Greensburg, PA: *An American Tradition: The Pennsylvania Impressionists*, April 13–July 13, 1997. Traveled to Florence Griswold Museum, Old Lyme, CT, October 5–November 30, 1997; Dixon Gallery and Gardens, Memphis, December 14, 1997–February 22, 1998; Gibbes Museum of Art, Charleston, SC, March 28–May 10, 1998; and Woodmere Art Museum, Philadelphia, June 6–August 5, 1998

2007 Cantor Fitzgerald Gallery, Haverford College, PA: *The Pennsylvania Landscape Colonial to Contemporary*, March 2–April 1

2011–12 James A. Michener Art Museum, Doylestown, PA: *The Painterly Voice: Bucks County's Fertile Ground*, October 22, 2011–April 1, 2012

PUBLISHED REFERENCES

Livingston, Valerie. *W. Elmer Schofield: Proud Painter of Modest Lands*. Bethlehem, PA: Moravian College, 1988, 45

Peterson, Brian H., ed. *Pennsylvania Impressionism*. Philadelphia: James A. Michener Art Museum and University of Pennsylvania Press, 2002, 235

COMMENTARY

In addition to its ancient house and woods, Godolphin, the estate purchased by Schofield's son Sydney, also included a working farm. Schofield himself managed it while Sydney served with the Royal Air Force Bomber Command in World War II.

This painting looks north from the mowhay barn toward the duck pond. The hayricks sit next to the farm drive, which runs along the L-shaped bank barn between the mowhay and piggery yards. The gateway was widened considerably in the late twentieth century.

69
Mid-Winter, Pennsylvania
c. 1940
Oil on canvas
30 x 36 in.
Private Collection

PROVENANCE/OWNERSHIP HISTORY

Collection of H. Price

Acquired from the above by Private Collection

Private Collection

PUBLISHED REFERENCE

Peterson, Brian H., ed. *Pennsylvania Impressionism*. Philadelphia: James A. Michener Art Museum and University of Pennsylvania Press, 2002, 227

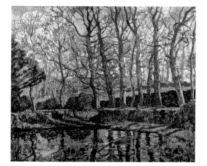

70
Ponds in Autumn, Godolphin
c. 1940
Oil on plywood
30 x 36 in.
Collection of Martin Stogniew

PROVENANCE/OWNERSHIP HISTORY

Estate of the artist

By descent in the family to Enid and Seymour R. Schofield

Collection of Martin Stogniew

COMMENTARY

Schofield made several paintings of the two ponds in the side garden at Godolphin. This particular view is taken from the neck between the eastern and western ponds, looking northeast across the western pond through the sycamore trees that run along the hedge to the garden paddock.

71
CHARLES GRAFLY
American, 1862–1929

Bust of Walter Elmer Schofield
1905
Bronze with brown patina
23 x 10 1/2 x 10 in.
Courtesy of the Pennsylvania Academy of the Fine Arts, Philadelphia. Gift of Dr. Charles H. Drummond. Photograph courtesy of Pennsylvania Academy of the Fine Arts

PROVENANCE/OWNERSHIP HISTORY

Indefinite loan from the estate of Charles Grafly, 1907

Formally accessioned into the collection of the Pennsylvania Academy of the Fine Arts, 1987

EXHIBITION HISTORY

1930 PAFA: *Memorial Exhibition of Work by Charles Grafly*, no. 19, January 26–March 16 (listed "W. Elmer Schofield. / Lent by W. Elmer Schofield")

1987 National Sculpture Society, Port of History Museum, Philadelphia: *54th Annual Exhibition*, September 17–November 8

PUBLISHED REFERENCES

Memorial Exhibition of Work by Charles Grafly. Philadelphia: Pennsylvania Academy of the Fine Arts, 1930

Philadelphia Public Ledger, April 1940 (ill.)

COMMENTARY

Grafly had been a friend of Schofield's since the days they studied together at PAFA. Schofield wrote to his wife in November 1905: "Filling in spare time by posing for Grafly who is making a bust—and which by the way promises to turn out a pretty good thing if it finishes as it has begun."[1]

NOTES

1 Schofield to Muriel Schofield, November 9, 1905. Reel 5043, Walter Elmer Schofield Papers, Archives of American Art, Smithsonian Institution.

BIBLIOGRAPHY

Alterman, Jim. *New Hope for American Art*. Lambertville, NJ: Jim's of Lambertville, 2005.

"American Art for So. America." *American Art News* 8, no. 29 (April 30, 1910): 6.

"American Art in Germany." *American Art News* 8, no. 23 (March 19, 1910): 1.

"American Oils Abroad." *American Art News* 9, no. 25 (April 1, 1911): 11.

"Annual Arts Club Members Display." *American Art News* 11, no. 14 (January 11, 1913): 6.

"Applied Art in Pittsburgh." *Art and Progress* 3, no. 6 (April 1912): 568.

"Art Exhibit Free to All Tomorrow." *The Harrisburg Telegraph*, April 14, 1911, 12.

"Art in Grand Rapids." *American Magazine of Art* 7, no. 3 (January 1916): 117–18.

"Art in St. Louis." *Art and Progress* 4, no. 1 (November 1912): 782–83.

"Artist Braves March Weather to Paint Lower Falls." *Rochester Democrat and Chronicle*, March 3, 1915.

Bateman, Arthur Z. "The Fine Arts in Philadelphia." *Brush and Pencil* 9, no. 5 (February 1902): 307–20.

"Beal, Schofield, Speicher Exhibition." *Bulletin of the Detroit Institute of Arts* 2, no. 6 (March 1921): 59–60.

Blake, Wendon. *Creative Color for the Oil Painter*. New York: Watson-Guptill, 1983.

Boca Raton Museum of Art. *America the Beautiful: 19th and 20th Century Paintings from the Walter and Lucille Rubin Collection*. Boca Raton, FL: Boca Raton Museum of Art, 2003.

Boyle, Richard J. *American Impressionism*. Boston: New York Graphic Society, 1974.

"Buffalo." *American Art News* 11, no. 2 (October 19, 1912): 5.

"Buffalo." *American Art News* 20, no. 30 (May 6, 1922): 10.

Caffin, Charles H. "Our Exhibit at the Paris Exposition." *The Artist: An Illustrated Monthly Record of Arts, Crafts and Industries (American Edition)* 28, no. 246 (July 1900): vii–x.

———, ed. "Seventy-Sixth Annual Exhibition of the National Academy." *The Artist: An Illustrated Monthly Record of Arts, Crafts and Industries (American Edition)* 30, no. 253 (February 1901): i–iii.

Castello, Eugene. "Works by Foreign-Born Artists." *American Magazine of Art* 7, no. 5 (March 1916): 204–5.

Catalogue of a Group Exhibition of Paintings by Ben Foster, W. Elmer Schofield, Gardner Symons, Douglas Volk. Buffalo: Buffalo Fine Arts Academy, Albright Art Gallery, 1922.

"Chicago." *American Art News* 9, no. 2 (October 22, 1910): 2.

"Cincinnati, (O.)." *American Art News* 7, no. 3 (October 31, 1908): 2.

Danly, Susan. *Light, Air, and Color: American Impressionist Paintings from the Collection of the Pennsylvania Academy of the Fine Arts*. Philadelphia: Pennsylvania Academy of the Fine Arts, 1990.

Dimond, Bushnell. "Philadelphia." *American Art News* 20, no. 10 (December 17, 1921): 8.

Dorr, Charles Henry. "Annual Exhibition Pennsylvania Academy of Fine Arts." *Fine Arts Journal* 30, no. 4 (April 1914): 178–86.

D'Unger, Giselle. "Chicago." *American Art News* 11, no. 14 (January 11, 1913): 9.

Folk, Thomas. *The Pennsylvania School of Landscape Painting: An Original American Impressionism*. Allentown, PA: Allentown Art Museum, 1984.

———. *Walter Elmer Schofield: Bold Impressionist*. Chadds Ford, PA: Brandywine River Museum of Art, 1983.

Gates, William D. "Fine and Applied Art at St. Louis Exposition." *Brush and Pencil* 13, no. 1 (October 1903): 55–62.

Gerdts, William H. *American Impressionism*. Seattle: Henry Art Gallery, University of Washington, 1980.

Glasier, Jessie C. "Cleveland." *American Art News* 20, no. 30 (May 6, 1922): 9.

"Gleanings from American Art Centers." *Brush and Pencil* 11, no. 6 (March 1903): 465–73.

Granville, Herbert S. "Paintings at the Pan-American." *Brush and Pencil* 8, no. 4 (July 1901): 223–32.

Greenman, Frances Cranmer. *Higher than the Sky*. New York: Harper, 1954.

Hind, C. Lewis. "An American Landscape Painter: W. Elmer Schofield." *The International Studio* 48, no. 192 (February 1913): 280–89.

Hoeber, Arthur. "W. Elmer Schofield: A Painter in the Open." *Arts and Decoration* 1, no. 12 (October 1911): 473–75, 492.

Hoopes, Donelson F. *The American Impressionists*. New York: Watson-Guptill Publications, 1972.

Howard, Harrison N. "Exhibition of the National Academy of Design." *Brush and Pencil* 13, no. 4 (January 1904): 300–313.

Livingston, Valerie. *W. Elmer Schofield: Proud Painter of Modest Lands*. Bethlehem, PA: Moravian College, 1988.

"London Letter." *American Art News* 5, no. 25 (April 6, 1907): 5.

M., L. "The Paintings in the Pennsylvania Academy Exhibition." *Art and Progress* 1, no. 5 (March 1910): 130–33.

M., L. M. "Chicago's Annual a Conservative Show." *American Art News* 20, no. 5 (November 12, 1921): 4.

"Macbeth Gallery Makes Propaganda." *American Art News* 20, no. 7 (November 26, 1921): 1.

McLean, Louise. "Cincinnati." *American Art News* 11, no. 20 (February 22, 1913): 10.

McGinty, Jon. "Rockford Art Museum Turns 100." *Northwest Quarterly* (Summer/Fall 2013): 120.

Merrick, L. "Inter'l Carnegie Show." *American Art News* 11, no. 28 (April 26, 1913): 1, 4.

Naeve, Milo M. *150 Years of Philadelphia Painters and Paintings: Selections from the Sewell C. Biggs Museum of American Art*. Introduction by John C. Van Horne. Philadelphia: Library Company of Philadelphia; Dover, DE: Sewell C. Biggs Museum of American Art, 1999.

"Oberlin, Ohio." *American Art News* 20, no. 12 (December 31, 1921): 11.

Pennsylvania Academy of the Fine Arts. *In This Academy: The Pennsylvania Academy of the Fine Arts, 1805–1976*. Philadelphia: Pennsylvania Academy of the Fine Arts, 1976.

Peterson, Brian H., ed. *Pennsylvania Impressionism*. Philadelphia: James A. Michener Art Museum and University of Pennsylvania Press, 2002.

"Philadelphia." *American Art News* 11, no. 25 (April 5, 1913): 10.

Poore, Henry Rankin. *Pictorial Composition and the Critical Judgment of Pictures*. New York and London: G. P. Putnam's Sons, 1903.

Rockford Art Museum. *RAM 100: Rockford Art Museum, 1913–2013*. Rockford, IL: Rockford Art Museum, 2013.

"Sales." *The Collector and Art Critic* 4, no. 8 (June 1906): 253.

"Schofield and Lathrop at Ferargil." *American Art News* 18, no. 13 (January 17, 1920): 5.

"Schofield at Katz's." *American Art News* 10, no. 27 (April 13, 1912): 3.

"Schofield to Paint Again." *American Art News* 17, no. 22 (March 8, 1919): 1.

"Springfield, Ill." *American Art News* 20, no. 35 (June 10, 1922): 8.

"St. Louis." *American Art News* 8, no. 13 (January 8, 1910): 2.

Stuart, Evelyn Marie. "Chicago." *American Art News* 19, no. 11 (December 25, 1920): 5.

"The Little Academy." *American Art News* 19, no. 5 (November 13, 1920): 4.

"The National Academy's Exhibition." *Art and Progress* 2, no. 7 (May 1911): 205-7.

"The Pennsylvania Academy's Annual Exhibition." *Art and Progress* 5, no. 6 (April 1914): 209-13.

"The Philadelphia Art Club Exhibition." *The Collector and Art Critic* 4, no. 2 (December 1905): n.p.

"The Pittsburg Exhibition." *The Collector and Art Critic* 4, no. 2 (December 1905): n.p.

"The Pittsburg Jury." *American Art News* 9, no. 25 (April 1, 1911): 3.

Tovey, David. *St Ives (1860-1930): The Artists and the Community—A Social History*. Tewkesbury, UK: Wilson Books, 2009.

Tovey, David. *Pioneers of St Ives Art at Home and Abroad (1889-1914)*. Tewkesbury, UK: Wilson Books, 2008.

Townsend, James B. "Annual Carnegie Display." *American Art News* 10, no. 29 (April 27, 1912): 4.

———. "Annual Carnegie Exhibit." *American Art News* 6, no. 29 (May 2, 1908): 4-5.

———. "Corcoran Gallery Exhibit." *American Art News* 11, no. 14 (January 11, 1913): 3-4.

———. "Penn. Academy Display." *American Art News* 8, no. 16 (January 29, 1910): 4, 6.

———. "Pittsburgh Internat'n'l Salon." *American Art News* 18, no. 30 (May 15, 1920): 1-2.

Townsend, M. E. "Pittsburg's Annual Art Exhibition." *Brush and Pencil* 16, no. 6 (December 1905): 199-205.

"Uruguay Buys Pictures." *American Art News* 9, no. 34 (August 19, 1911): 3.

"Washington (D.C.)." *American Art News* 7, no. 15 (January 23, 1909): 5.

"Washington, D.C." *American Art News* 19, no. 11 (December 25, 1920): 5.

Weinberg, H. Barbara, Doreen Bolger, and David Park Curry. *American Impressionism and Realism: The Painting of Modern Life, 1885-1915*. New York: Metropolitan Museum of Art, distributed by Harry N. Abrams, 1994.

"Winter Scene by Schofield Sold to Head of Art Museum." *American Art News* 21, no. 29 (April 28, 1923): 1.

Ziegler, Francis J. "Sixty-Eighth Annual Exhibition of the Pennsylvania Academy of the Fine Arts." *Brush and Pencil* 3, no. 5 (February 1899): 288-96.

INDEX